NEW SCULPTURE

Profiles in Contemporary
Australian Sculpture

NEW SCULPTURE

Profiles in Contemporary Australian Sculpture

Nevill Drury

CRAFTSMAN HOUSE

First published in 1993 by G+B Arts International Limited,
Distributed in Australia by Craftsman House,
20 Barcoo Street,
East Roseville, NSW 2069, Australia

Distributed internationally through the following offices:

EUROPE
Gordon and Breach
Parc Scientifique et Technologique
Chemin de la Sallaz
CH – 1400 Yverdon
Switzerland

UK
STBS Ltd.
5th Floor, Reading Bridge House
Reading Bridge Approach
Reading RG1 8PP
England

USA
STBS Ltd.
PO Box 786
Cooper Station
New York
NY 10276

ASIA
STBS (Singapore) Pte Ltd
25 Tannery Road
Singapore 1334
Republic of Singapore

ISBN 976 8097 72 8

Design *Nevill Drury and Caroline de Fries*
Printer *Kyodo, Singapore*

CONTENTS

ACKNOWLEDGEMENTS

I would like to thank all of the individual artists who submitted photographs and biographical material for this book, and also give special thanks to a number of gallery directors and personnel who have been particularly helpful. These include Paul Greenaway of Greenaway Art Gallery, Adelaide; Bryan Hooper and Jane Watters of Coventry Gallery, Sydney; Janet Bateman of Macquarie Galleries, Sydney; Brenda May and Courtney Kidd of Access Contemporary Art Gallery, Sydney, and Nellie Castan of Flinders Lane Gallery, Melbourne.

INTRODUCTION

This book is about new sculpture in Australia — work produced in this country since the mid-1980s — and about the particular artists who have created it. Most observers would agree that over the last decade Australian contemporary sculpture has acquired an increasing sense of individuality and self-confidence. At the same time, and no doubt as a natural consequence, its conceptual aims and underlying influences have diversified. Sculptors are now concerned with a wide range of philosophical perspectives and creative techniques, and this has even led in some instances to a blurring of the boundaries which previously distinguished sculpture from other forms of artistic expression. With this new plurality of interests has also come an eclectic re-examination of traditional concepts of aesthetics, form and function in the ongoing quest for meaning and relevance.

As one surveys the spectrum of contemporary sculptural practices in Australia — and this book includes a representative sampling, featuring established, mid-career and emerging sculptors alike — distinct areas of creative intent emerge.

At the more traditional end of the spectrum are sculptors who have retained their allegiance to figuration, but even here there is considerable scope for departure — some of these artists now find themselves challenging familiar notions of beauty and the human form, perhaps drawing on non-Western cultural motifs, or exploring spiritual and archetypal dimensions of the human condition. There are other artists in turn who regard their sculpture as a form of social, political or environmental commentary, or as an exploration of 'alternative' cultural values and priorities — perhaps bringing into focus symbolic or metaphysical world-views outside the mainstream tendencies of our modern technological world.

Some practitioners have moved beyond stone, wood and steel to incorporate within their sculpted works such materials as fabrics, resin, tar, plastics, wax, feathers, recycled manufactured materials and miscellaneous 'found' objects. In doing so, they have been able to make potent observations about aspects of Western society — sometimes by contrasting different facets of our largely urban lifestyle with other, more remote or exotic cultural forms and activities.

While contemporary sculpture has broadened its perspectives, departing from the more traditional preoccupations with beauty and formal representation, one can still find innovative sculptors who regard the aesthetic exploration of human, abstract and geometric forms as a valuable pursuit in its own right. One can also detect across the spectrum of contemporary Australian sculpture a feeling of guarded optimism; sculpture now seems less bleak and austere than it did just a few years ago. If the angst and deep soul-searching associated with German Expressionism made serious conceptual intent almost obligatory in the early 1980s, there are artists now who are not ashamed to make

humorous and whimsical statements through their sculpture — artists who remind us that there is also time for laughter and parody. So, if one is asked to reflect on the direction of contemporary Australian sculpture — one of those impossible tasks that nevertheless demands some sort of response — the question can in part be answered by pointing to various examples of diversity.

Aesthetics and Abstract Form

Several artists included here approach sculpture primarily as an aesthetic medium which explores abstract notions of texture, space and form. Marea Gazzard's sculptures are deceptively simple but evoke archetypal associations — her works in clay and bronze drawing inspiration from both the Australian landscape and the human head and torso. Inge King has similarly moved increasingly towards figurative abstraction in her steel sculptures, capturing in works like *Joie de Vivre* the 'search for exuberance and affirmation of life'. Robert Parr and John Gardner, meanwhile, have abstracted elements taken from the rural and urban landscape while Michael Nicholls' steel sculpture, *Tarantula*, has transformed a wolf spider into a more abstract symbol of menace.

Other sculptors have been drawn to geometric abstraction. Greg Johns' most recent figurative sculptures have developed from abstract, circular forms while Peter D. Cole's creations in steel and brass are like three-dimensional abstract drawings, enclosing space with both static and dynamic shapes. Dan Wollmering has long been fascinated by the elementary structures of matter and the conceptual implications of the New Physics — like Cole, he relies on space as much as on physicality and, as one observer has commented, often seems to be depicting the 'curvature of space-time'.

Sculptors like Arthur Ashby and Stephen Trethewey, on the other hand, seem to have been drawn to abstraction primarily through an appreciation of aesthetics and design. Ashby thinks of his sculpture as forming itself intuitively, and his elegant constructivist assemblages of brass and bronze rods have won international acclaim for their aesthetic qualities. Trethewey, meanwhile, delights in combining crisp minimalism with physical function — his abstract sculpted 'tables' and 'chairs' can actually be used as such, although they are also beautiful in their own right. For both artists sculpture is a way of making an aesthetic statement but there is also something unexpected about the way the particular abstract form arises. As Trethewey observes: 'I like to demonstrate the unlikely, the surprising and the paradoxical possibilities inherent in steel.'

Social and Cultural Elements

A number of sculptors included here employ their artforms as visual commentaries on social and environmental conditions or to make interesting observations about other cultures. The way they go about this, however, varies considerably from one artist to another.

Rodney Broad believes that there are no absolutes either in life or in art and his sculptures are therefore very much about the ever-changing, sometimes turbulent aspects of the social and natural environment. Keen to erode any perceptions of certainty we may

harbour about our relationship with the world, Broad's sculptures reflect his notions of chaos and his interest in the elemental 'unseen' forces like breath and wind which affect our lives: his current work reveals a particular fascination with volcanoes — a potent motif which has stayed with him since his childhood days in New Zealand.

Peter Tilley is an iconoclast of a different sort. His sculptures are concerned primarily with social and institutional aspects of culture and especially with the way power and religious beliefs can be abused. Essentially cynical, Tilley is distrustful of the way customs and religious traditions erect barriers between human beings and the natural world. His works reveal a fractured, alien culture out of step with the laws of Nature — a world where power and control have distanced humanity from spiritual values.

German-born Jutta Feddersen, Melbourne-based Brigid Cole-Adams and Iranian sculptor Hossein Valamanesh are also interested in themes like these. Feddersen seeks through her humanoid fibre-sculptures to depict the gulf between primeval spirituality and modern urban materialism — like Broad and Tilley she feels that humanity is often at odds with the environment rather than seeking a harmonious, holistic relationship. Brigid Cole-Adams' installations similarly address issues relating to the ephemeral and enduring aspects of humanity's relationship with Nature. Her special interest is in the connection between people and the spaces they inhabit, viewed from a feminist perspective.

Hossein Valamanesh has also alluded to the traditional cultural bonds with Nature but his particular emphasis in recent times has been on our apparent capacity as urban consumers to forget this vital connection with the natural world. While working in Berlin during the winter months a couple of years ago, he became aware of large numbers of discarded Christmas trees thrown away in the streets like ordinary rubbish. These trees still had the strong smell of the pine forest but no-one seemed to value their presence once the token ritual of Christmas festivities had passed. Valamanesh has incorporated fragments of these pine trees into his most recent works as reminders 'of our inter-connection with Nature in survival and destruction'.

Mona Ryder's sculptural works strike a chord somewhat closer to home. Living as she does on Queensland's Gold Coast, she has been intrigued by the ephemeral and disposable aspects of the culture fostered by the tourist industry, and many of her works have been conceived as parodies of a superficial lifestyle. She is also very much concerned with the social role of women generally, and with the quality of relationships between the sexes. Ryder's world view is underpinned by notions of violence and raw sexuality. 'Underneath a veneer of sophistication,' she notes, 'we are often primitive in our behaviour towards each other.'

If Ryder assembles her mixed-media works using mostly local symbols, other sculptors have drawn on imagery from exotic cultures to explore themes of universal relevance. Lyn Plummer spent many years in New Guinea, and her installations feature delicate anthropomorphic forms sheathed in membranes and veils: her approach is to analyse mythic concepts of the self and to consider the rituals and ceremonies which embody these ideas. Ann-Maree Reaney, on the other hand, has been influenced by her contact with women from North Africa, the Middle East and Aboriginal Australia, and her apparently incomplete

'anti-sculptures' are intended to challenge our assumptions about the social and cultural roles of women and art in society. Humanoid fragments hover in her installations like abandoned corpses or repressed memories from a nightmare world — her artforms are challenging and confronting, and linger in the mind long after one has seen them.

Humanity and Spirituality

Questions relating to the links between humanity and the environment inevitably lead us to consider what it actually means to be human and to explore further the many ways in which individual experiences and perceptions manifest in art.

Maria Kuczynska's headless torsos in bronze and ceramics embody the bleakness of her eastern European heritage — they are anonymous figures which have emerged from the wastelands of history. However if Kuczynska's remarkable sculptures capture the pain and anguish of human suffering, they are also very beautiful — her works celebrate the triumph of the spirit over adverse circumstances.

George Turcu similarly regards sculpture as 'an adventure of the spirit', Leslie Oliver calls his mixed-media pieces 'icons of hope', and figurative sculptor Joy Henderson says that the human form interests her as a subject because it is able 'to convey subtle attitudes and concepts of self and sexuality'. Other artists have extended their enquiry still further, to take in mythic and cosmological aspects of the human experience.

Mary Stimson's archetypal figures draw much of their inspiration from Assyrian, Etruscan and Roman bas-reliefs and relate archetypal imagery to the familiar, everyday world. Liz Williams' sculptures, on the other hand, have a strong affiliation with ancient Egypt and deal with the quest for spiritual self-awareness. 'For me, working is a discovery,' she has said, '… it's like going on a journey. Once my work dealt with harmony, wholeness and independence of the human spirit. Now it deals with disharmony, human failures, incompleteness and isolation. Perhaps this simply represents two aspects — two views — of the same journey.' Emanuel Raft has much the same idea. His recent bronze and mixed-media sculptures have drawn on classical mythic imagery and have a distinctly totemic quality. He too sees the creation of sculpture as an essentially spiritual venture: 'The process of a creative act and the finished product have to extend the mind and vision of the creator and the viewer, and elevate to that level of the sublime.'

Trevor Weekes similarly explores themes which connect the real and archetypal worlds. One of his most recent exhibitions linked the predatory symbol of the wolf with the perils of the angry sea, and earlier installations focused on imagery derived from the Fall of Icarus and the quest for the perfect Trojan Horse. However, if Weekes' installations tend to depict a less than optimistic view of life — *Sea Wolves* included the commentary 'As the winds come and the day fades into darkness, we exist as memories and dust …' — other sculptors have been drawn to the comical, paradoxical and farcical aspects of everyday existence. John Turier's bizarre creations, for example, are infected with a type of Zen-humour and have a wonderful feeling of optimism and spontaneity, while Manne Schulze uses amusing cartoon characters to depict what he calls the 'twists and ironies of daily life'.

A Diversity of Materials

These days sculptors seem at home with almost every conceivable material — if it exists, then art can be fashioned from it. Of the artists included here, Brigid Cole-Adams works with cane, wire, paper and sand; Michael Esson creates his maquettes from cardboard and cloth; Peter Randall builds his 'bridge' structures in crumpled sheet metal; Jutta Feddersen employs polyurethane, aerated concrete, hessian, twigs and feathers; Alick Sweet uses sections of polished bronze, rough-hewn sections of timber, stones, and pieces of ceramic, and Lyn Plummer employs steel, tissue, paint, wire and timber to produce her skin and membrane structures. Mona Ryder has included pieces of vinyl, chrome metal, fake flowers, fishing lures and sections from a washing machine in her most recent installation, while Manne Schulze's cartoon creation *Supamander* includes electronic parts — an indication of his interest in robots and cybernetics. But there is more besides …

Several of the sculptors whose work is illustrated in this book are recyclers of junk — the 'detritus of the industrial age', as Roger Noakes describes it. Noakes himself uses discarded and hand-forged metal objects in his sculptures, and James Rogers does much the same: jagged metal blades and rusty sheets of metal are very much a part of his artistic vocabulary. Alexis McKean uses aluminium, steel, resin and cast concrete to create her humorous figurative works and Anton Hasell's dramatic piece, *The Eagle and the Lamb*, was produced from recycled corrugated iron. A visit to Ted Jonsson's studio similarly reveals a passion for discarded materials. Intrigued by the endless creative possibilities presented by cast-off machinery parts and timber offcuts, he has recently produced a series of imaginative figurative works which make use of strips of metal cut from old pressed-tin ceilings. Jonsson enjoys rummaging in refuse to focus his artistic intent: 'I create the underlying image in a series of cultivated accidents and then clad them with all sorts of time-worn junk.'

Other sculptors use less likely materials. Tasmanian artist Garry Greenwood has gained international recognition for his creations in leather, some of them based on medieval musical instruments. Several of his sculpted pieces can actually be played musically but he does not produce only works of this type — his other creations include shoes, helmets, masks and sculptures based on the female form.

Polly MacCallum uses clear perspex in her mixed-media artworks 'to create a fourth dimension through shadowy images and reflections' while Tony Trembath draws on metal components, light globes, anatomical models and gold leaf for his mixed-media 'museum' pieces and Gothic mural panels. Stephen Skillitzi, meanwhile, incorporates both glass and metal in his figurative sculptures. In his 1990 work, *Monument to a Lost Culture* — a sculpture which derives its basic form from a Central American ziggurat — Skillitzi employed glass, copper and electric lighting, and in other works has also made use of nickel and gold. Mention should also be made here of Colin Reaney's extraordinary architectural installations: often brightly coloured in dazzling reds, yellows and blues, they include structures derived from Classical Greek and Roman architecture and evoke what the artist has called 'a mixture of past and present … personal and collective memories'.

In Summary ...

I think it will be obvious to anyone perusing this collection of artworks that contemporary Australian sculpture is both rigorous and inventive. Sculptors in this country would appear to draw their inspiration from every imaginable source — past, present and future — and the originality in the work itself is self-evident. Michael Esson has said of his own approach to sculpture that his intention is 'to develop a visual language which describes the human condition — and how to explore an art which does not deal with how we see art, or how we see the world, but how we see ourselves'. I feel this can also be said of contemporary Australian sculpture as a whole. Far from being a cultural outpost mimicking events initiated elsewhere, Australia can now justifiably claim that in the field of contemporary sculpture it has well and truly come of age.

Nevill Drury

THE SCULPTORS

ARTHUR ASHBY

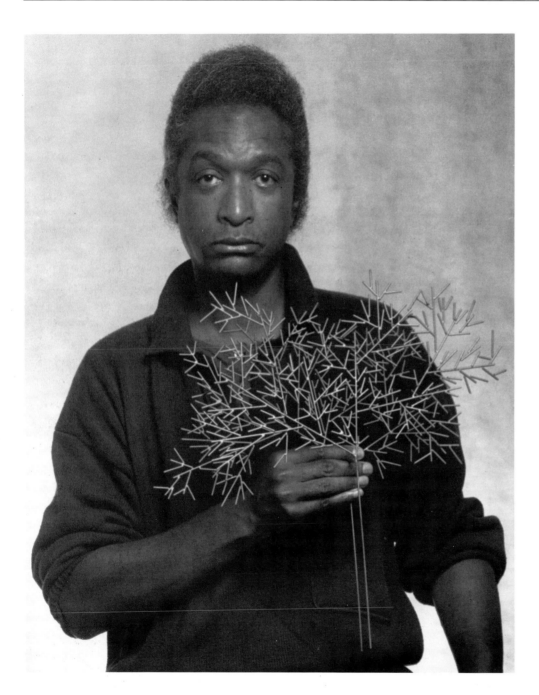

Portrait photograph: Michael Miconi

ARTHUR ASHBY was born in Brooklyn, New York, in 1942. He studied painting with Robert Steed and sculpting at the School of Visual Arts, New York where he gained a Diploma in Art. Since 1973 he has lived and sculpted in Rome and Sydney.

Ashby was originally a painter but soon found that this medium did not suit his creative expression. In the late 1960s he switched instead to sculpture. 'The way I paint, there is always something I want to change once the canvas is finished,' he has said. 'With metal sculpture I am absolutely fulfilled because, while I may start with a basic design, the piece almost forms itself and it is completed when I am satisfied with it.'

Ashby is now internationally regarded for his elegant constructivist assemblages of fine brass and bronze rods, many of which seem somewhat similar to geometric puzzles. Some works are pedestal pieces, others intended for display on walls. There is invariably a crispness of design, an intriguing formality which nevertheless contains its own dynamic qualities.

The sculptor held his first one-man exhibition at Gallery 88 in Rome and has since had individual shows in Basel, Cheltenham (England), and Australia — the most recent at De Gruchy, Melbourne, in 1989 and the School of Architecture, University of Melbourne, in 1992. Owners of his work include Jacqueline Kennedy Onassis, Peggy Guggenheim in Venice, the noted architect I.M. Pei, the renowned film director Federico Fellini, and the Norwegian artist Ferdinand Finne.

Artist's Comment

By doing, I find what I am seeking. I work guided by an inner impulse, a longing for certain forms. The meaning of forming and constructing — the act of creation — is the greatest possible freedom. Many aspects of my life, both conscious and unconscious, have led me towards an artistic freedom. I work in metal, directly with the material, without the intermediaries of foundries, etc. I like sculpture to look as if it happened naturally and to express an idea as simply as possible. Above all, I believe that an artist reveals more of himself in the way that he works than by stating his intentions or his ideas on art.

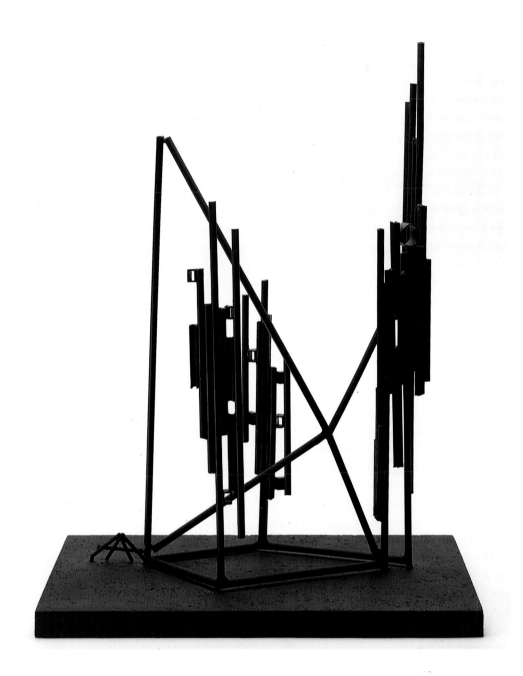

Untitled, 1988,
Painted brass and marble,
43 x 35 x 20 cm.
Photograph: Paul Green
Courtesy of Coventry Gallery,
Sydney

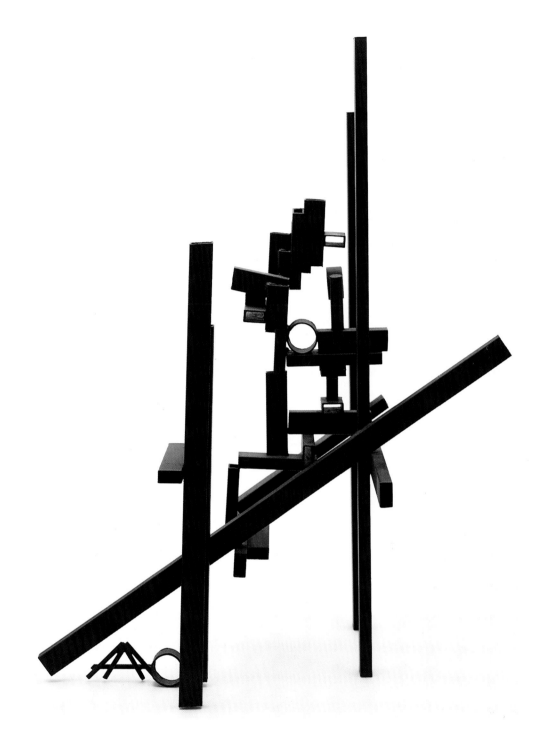

Untitled, 1988,
Painted brass,
42 x 33 x 28 cm.
Photograph : Paul Green
Courtesy of Coventry Gallery,
Sydney

RODNEY BROAD

RODNEY BROAD was born in Dannevirke, New Zealand in 1947. He studied at the University of Canterbury between 1965–68, gaining a Diploma of Fine Art with honours in sculpture, and also attended Christchurch Teachers College in 1969. That year he won the Guthrie Travel Award to study art in Australia. In Sydney he worked with Stephen Walker, casting a commissioned fountain for the Royal College of Surgeons, Melbourne. He returned to New Zealand in 1970 but came back to Australia a year later, sculpting full-time. He has resided here since 1971.

Broad began working at the Tasmanian School of Art and was commissioned in 1973 to produce a sculpture for the University of Tasmania Bio-Medical Library Barnett Memorial. In 1975 he received a Visual Arts Board Grant to establish a foundry, and in 1978 travelled widely in Europe, developing a special affinity with Spain. He taught Sculpture at the Tasmanian School of Art from 1971–88 and has received several commissions, including sculptures for the Commonwealth Supreme Court in Hobart, 1984, and for the State Superannuation Board, Governor Phillip Tower, Sydney 1992.

Stylistically Broad's sculpture is heavily textured and richly layered with metaphorical meaning — one of the artist's principal aims is to show the futility of man's quest for power and scientific certainty. Broad is convinced that there are no universal truths and that the creative artist can offer only a personal interpretation of events in a flexible and ever-changing world. His work has been described by art critic Mary Dineen as 'pictorial philosophy in three dimensions …', the sculptor representing 'the theme of intelligence as raw energy which may be used for good or evil'. Broad has been strongly influenced by such artists as Rodin, Brancusi, Matisse and Giacometti and likes to think of his work as 'extending what sculpture does best rather than being involved in sidetracks of performance and conceptualism'.

Broad held his first exhibition with Allan Strathern in Christchurch in 1969 and has exhibited widely in Tasmania, Melbourne and Sydney since that time. He featured in *Perspecta* at the Art Gallery of New South Wales, 1986, and was also included in 'Contemporary Australian Painters and Sculptors' at Queensland Art Gallery and the Museum of Modern Art, Saitama, Japan, in 1987. He has had six one-person exhibitions at Macquarie Galleries since 1986 — the most recent in 1991 — and is represented in numerous private and institutional collections, among them the Australian National Gallery, Newcastle Region Art Gallery, Queensland Art Gallery, Christchurch City Art Gallery, and the Tasmanian Museum and Art Gallery.

Artist's Comment

Since 1989 I have been involved with forms derived from unseen forces such as breath and wind. The idea of mass as the solidification of a chaotic fluid material is also an important antithesis of my interest in vortices and spiralling forms, partly inspired by my involvement with Maori art since a child and the meaning the sea and volcanic activity have for New Zealanders.

As I am a modeller, sculpture for me is a sensuous palpable medium. It is important to assert oneself on the material, to transfer energy to inert substances like clay, plaster and wax so that every part of the form has life, and has been worked on to evoke an object with a wholly new existence.

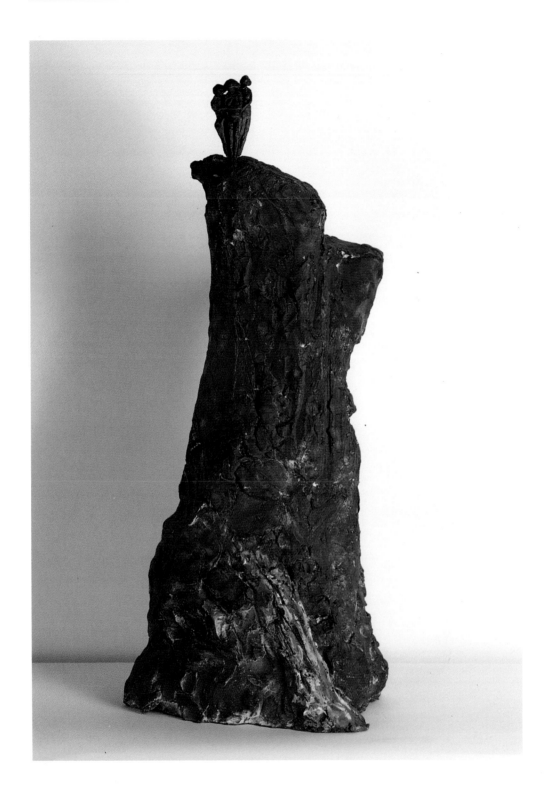

Fire and Rock, 1990,
Bronze, 76 x 25 x 30 cm.
Courtesy of Macquarie Galleries,
Sydney

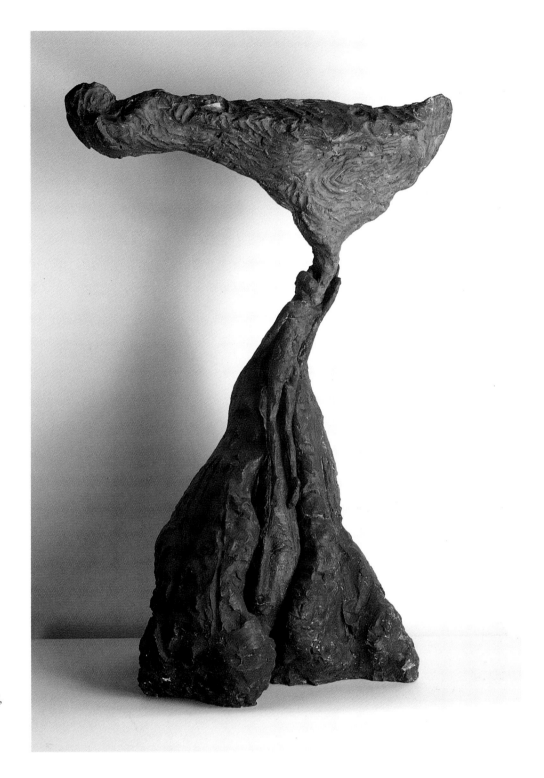

The Moon and the Blacksmith, 1990,
Bronze, 84 x 40 x 32 cm.
Courtesy of Macquarie Galleries,
Sydney

PETER D. COLE

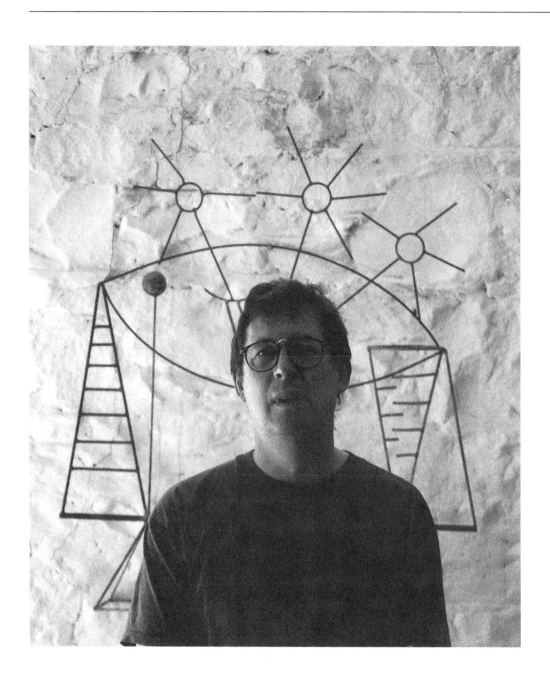

PETER D. COLE was born in Gawler, South Australia, in 1947. He studied at the South Australian School of Art from 1965–68, graduating with a Diploma in Fine Art, and received the H.P. Gill Medal and CAS Drawing Prize in 1968. He moved to Melbourne in 1970 and held his first one-person exhibition at the Pinacotheca Galleries the same year.

Cole is highly regarded both as a sculptor and as an abstract artist working in paint and pastel. His sculptures, constructed in welded steel, copper, brass and bronze, are usually painted and often seem like three-dimensional drawings — combining geometric forms and simple, stylised allusions to the landscape. Works like his *Modes of Building*, 1985 — a 'linear' structure made of painted steel, patinated copper and brass — have also drawn strongly on the language of architecture. 'The architectural references are many,' he noted in an interview for *Craft Arts*. 'They are a literal way of using or referring to a grid or sense of grid. Architecture is a symbol of mathematical balance and volume. A cone can represent a regular volume or the archetype of a primitive structure, depending on how it is used.'

Cole's recent sculptures continue to reflect his interest in both organic and geometric forms and depend for their impact on their ability to encompass visual space in intriguing and innovative ways. *Metaphysics of a Winter Landscape* has both static and dynamic qualities — enclosing and defining through the triangular form while also offering a sense of liberation through the ladder and outstretched branch motifs. Similarly in *Waiting for Spring*, Cole allows his forms to hover delicately in space, in a manner reminiscent of works by Calder and Miro.

The artist participated in the Mildura Sculpture Triennial, 1970, 1985, and 1988, and the Australian Sculpture Triennial, Melbourne 1981, 1984, 1987 and 1990. He has held several individual shows at Macquarie Galleries, Sydney, since 1984 and also had one-person exhibitions at William Mora Galleries, Melbourne 1990, and the Chicago International New Art Forms Exposition, 1992. He is represented in the collections of the Australian National Gallery, Monash University, Artbank, Parliament House, Canberra, the Mildura Regional Gallery, Wollongong Regional Art Gallery and the Philip Morris Corporation.

Artist's Comment

My sculpture is usually a reaction to the landscape I am in at the time. I react to the permanence and all the changes that occur in the landscape through the changing of the seasons or man's intervention. I manifest my sculpture through using symbols that represent this.

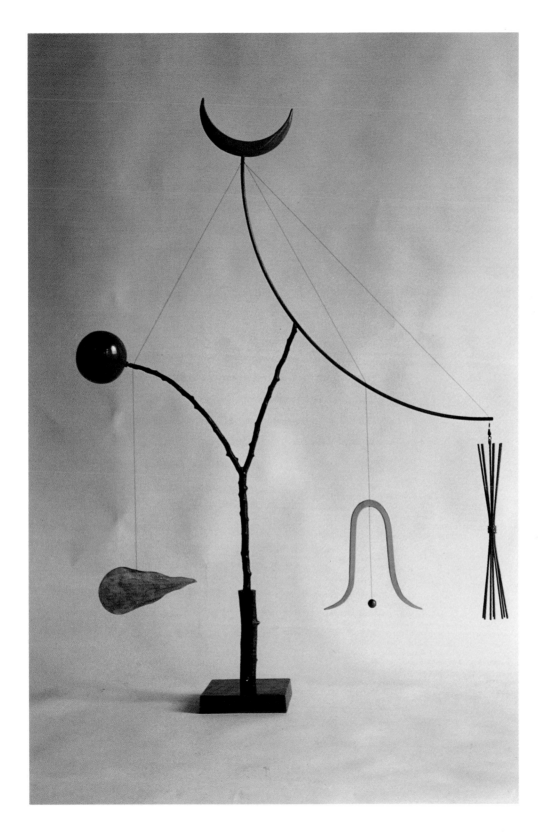

Waiting for Spring, 1992,
Painted and patinated bronze, brass
and copper,
107 x 82 x 19 cm.
Courtesy of Macquarie Galleries,
Sydney

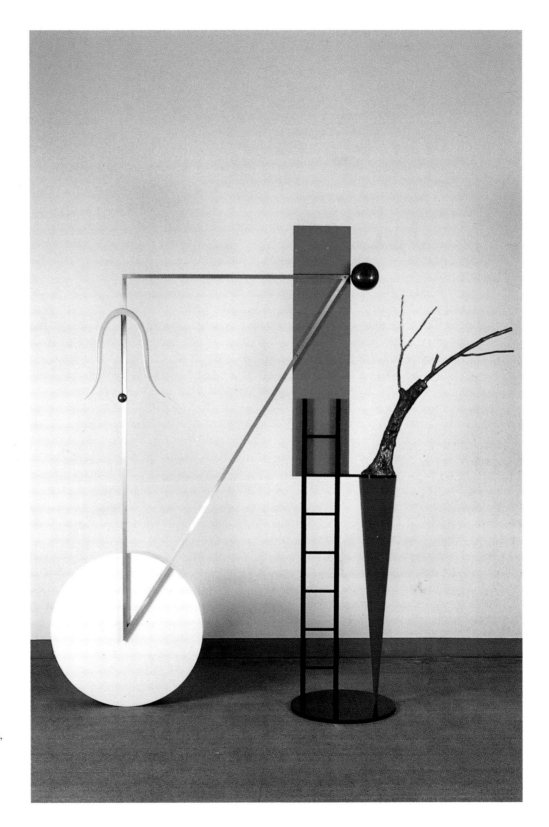

Metaphysics of a Winter Landscape,
1991,
Painted and patinated wood, bronze,
aluminium and steel,
251 x 244 x 35 cm.
Courtesy of Macquarie Galleries,
Sydney

BRIGID COLE-ADAMS

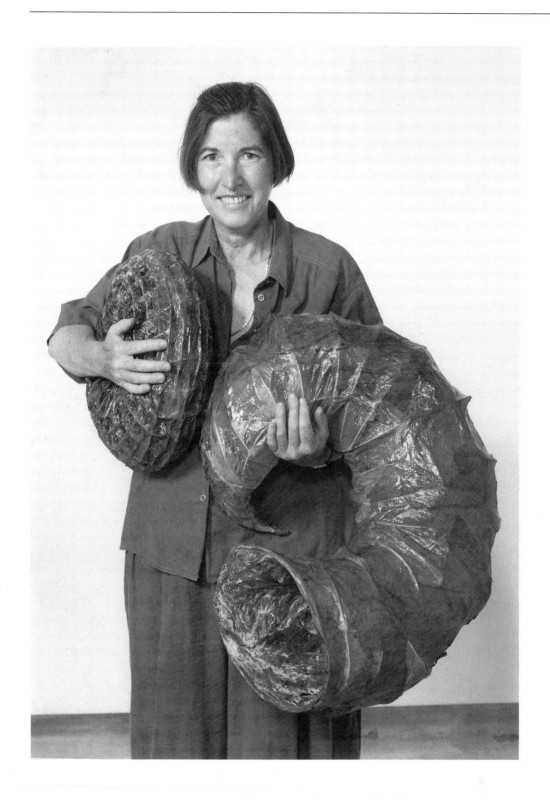

BRIGID COLE-ADAMS was born in Brisbane in 1938. She first trained in Occupational Therapy and later, in 1984, completed a Bachelor of Fine Arts degree at the Corcoran School of Art, Washington DC. On graduation she was awarded the Ethel Lorraine Bernstein Memorial Award for Painting and the Mary Lay Thom Sculpture Award. In 1985–86 she completed a Postgraduate Diploma in Sculpture at the Victorian College of the Arts, Melbourne.

Her work centres on landscape and the relationship between people or objects and the spaces they inhabit. She presents work in installation — either as a temporary construction for a particular occasion or place, or as a grouping of objects to create a sculpture. Light-weight materials are used for objects that refer to the natural world without trying to recreate it. They are essentially artifacts —the products of a culture.

The artist has constructed site-specific temporary installations at Gallery 10, Washington DC, Maryland Artplace in Baltimore, Judith Pugh Gallery, Melbourne, and at the 1991 and 1992 Port Fairy Spring Music Festivals in Victoria. She has exhibited consistently since 1986 in Victoria and other States. Her most recent installation at Port Fairy was created as a performance space for soloists of the Praetorius Wind Quartet, a group comprised of musicians from the Melbourne Symphony Orchestra. During 1992 she exhibited at Judith Pugh Gallery and at the Ecopolitics VI Conference at the Royal Melbourne Institute of Technology. She also participated in a seminar on Environmental Art at the Caulfield Arts Complex.

The artist received an Asialink grant to be artist-in-residence at the MARA Institute of Technology in Kuala Lumpur, Malaysia, in 1993.

Artist's Comment

I am intrigued with landscape not as something to view but as a place in which to travel. My relief paintings are contoured for exploration and in setting out sculpture, or structuring an installation, I strive for a sense of place. I work in light but resilient materials such as cane, wire, paper, cloth and sand to catch the ephemeral/enduring, fragile/tough contradictions in Nature.

Environmental and feminist attitudes underlie my work but I rarely use explicitly political imagery, preferring to imply these philosophical issues through my choice of form or materials. I often group a number of elements to compose a large sculpture.

Coil is an enlargement of something very small that I might find while out walking. It is part of an other *world that we overlook and carelessly damage. The materials of its construction are strong but vulnerable. Passage was designed for a narrow dead-end corridor in a gallery. It was a space without an identity. I placed objects in it to highlight its elegant dimensions and tried for a point of balance where the space and the objects were in equilibrium. Although the passage was physically blocked, the installation 'opened' it to our imagination.*

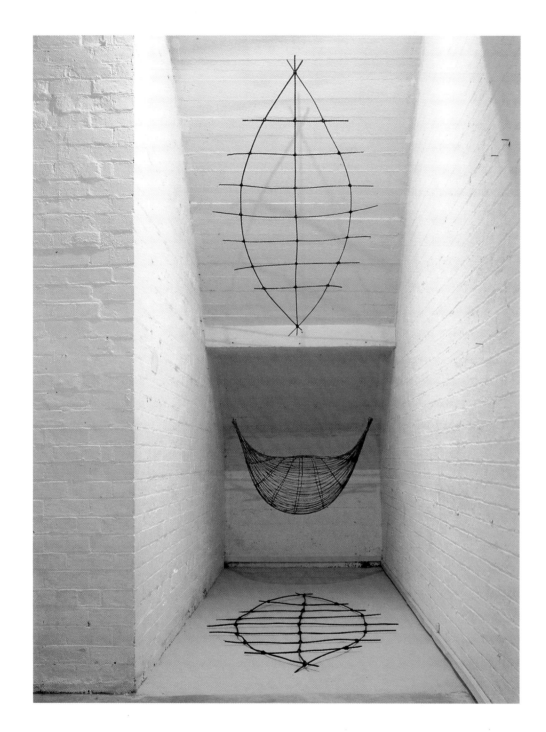

Passage, 1990,
Cane and shellac installation,
152 x 488 x 366 cm.
Courtesy of the artist and Judith
Pugh Gallery, Melbourne

Coil, 1990,
Cane, paper, paint and shellac,
165 x 165 x 30 cm.
Courtesy of the artist and
Judith Pugh Gallery, Melbourne

MICHAEL ESSON

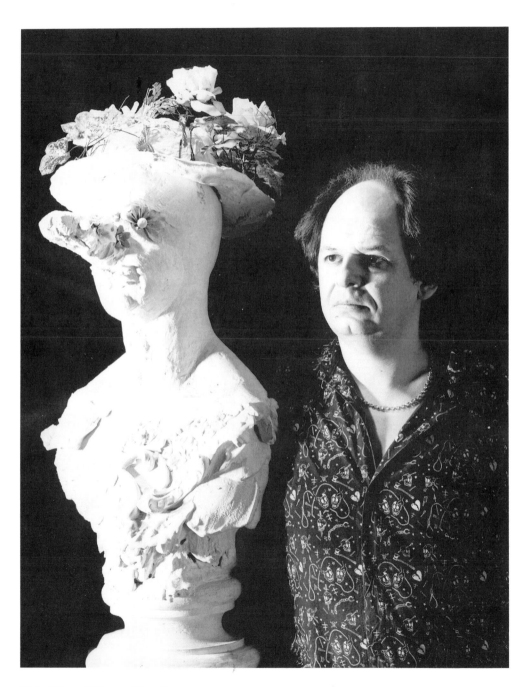

Michael Esson with Ornate Physician

MICHAEL ESSON was born in Aberdeen, Scotland in 1950. He studied at Grays School of Art in Aberdeen from 1968–70, and at Edinburgh College of Art from 1970–73, where he gained a Diploma of Art and postgraduate scholarship. He travelled to Australia in 1974 to lecture at Caulfield Institute of Technology. Returning to London in 1975, Esson spent the next two years at the Royal College of Art where he gained his Master of Arts Degree. In 1977 he returned to Australia and since then he has been lecturing in drawing and sculpture at City Art Institute in Sydney. For twelve months during 1989–90, Esson returned to work and live in his native Scotland. He is presently lecturing at The College of Fine Arts, University of New South Wales.

The following is a commentary on the artist's work by Martin Kemp:

'Michael Esson's art is concerned with the anatomy of evocative associations. This is true both in a metaphorical sense, in that he is searching for a "body" of physical components that will be rich in emotional allusion (particularly by death and its rituals), and in the literal sense in as much as he constructs images which are.either based directly upon human anatomy or assume body-like configurations of a more general kind. Even in his less overtly figurative inventions, whether his huge "drawn sculptures" or actual three-dimensional objects, he consistently uses structural skeletons to provide the armature for a variety of softer "organs" that would otherwise be unsupported. Although this subject matter is rich in connotations — often of a primitive and archetypal kind — he is not an expressionist. His graphic technique, which contains his description of plastic form with his compelling sense of interior and exterior spaces, is exploited to maintain an air of dispassionate detachment or even displacement. He becomes a clinical analyst, much like the surgeons he depicts, exercising cool power over material of the most highly charged kind — or distanced like the photographer of a war scene. However, the detachment is counterbalanced by his strong sense of bodily self-identification with his engineered organisms —to the extent that a concealed self-portrait, given in the form of an elusive profile, is covertly concealed within a number of images. Esson is able to work equally effectively in both two and three dimensions. The drawings reflect the understanding of space and volume that sculptors come to accept as routine. His sculpture is very much an extension of the drawings, not only in subject matter but also in technique. His careful manipulation of image and idea, structure and surface, combine together to create eloquent and powerful forms.'

Esson has had one-man exhibitions in the UK and Australia, and has contributed to numerous group exhibitions in the USA, Japan, France, UK and Australia. Selected public collections include The Scottish Arts Council; Corning Museum, New York; Ararat Regional Gallery, Victoria; the Museum of Contemporary Art, Brisbane; Aberdeen Art Gallery; the Art Gallery of New South Wales and the University of New South Wales.

Artist's Comment

My intention is to develop a visual language which describes the human condition — and how to explore an art which does not deal with how we see art, or how we see the world, but how we see ourselves.

Maquette for
Our Identity is our Discomfort, 1990,
Cardboard and cloth,
120 x 60 x 45 cm.
Photograph: Robin Wilson
Courtesy of Coventry Gallery,
Sydney

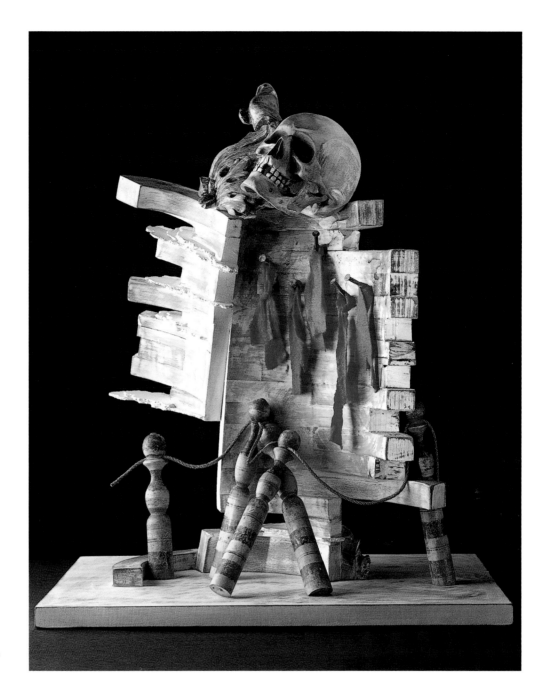

Forgotten Wishes, 1991,
Wood, cloth and copper,
50 x 45 x 30 cm.
Photograph: Paul Green
Courtesy of Coventry Gallery,
Sydney

JUTTA FEDDERSEN

JUTTA FEDDERSEN was born in Germany in 1931 and arrived in Australia in 1957. From 1953–56 she studied textiles and restoration, gaining a Diploma in Fibre Art at the Handwerkskammer, Bremen, and in 1974 she studied textiles in Africa on an Australia Council grant. She has been a lecturer at the National Art School, East Sydney, 1962–67, at Alexander Mackie College of Advanced Education, Sydney, 1977–80, and at Hunter Institute of Higher Education, Newcastle, 1980. In 1988 she gained her Master of Arts (Visual Arts) degree from the City Art Institute, Sydney. She is now Lecturer-Co-ordinator in Studio Area Fibre Art in the Department of Fine Arts at the School of Visual and Performing Arts, University of Newcastle, a position she has held since 1981.

Widely recognised, both nationally and internationally, as a leading exponent of fibre sculpture, Feddersen first showed her large-scale constructions at the Bonython Galleries, Sydney, in 1970. In 1987 she presented a remarkable display of 80 white-plastered, life-size organic forms — each surmounted by twigs, bones and feathers and suggestive, in a totemic way, of the birds and horned animals of Eastern European mythology. Two years later her focus had switched to polyurethane pigs. *Pigs Populace*, a collection of pig-heads mounted on wooden posts, seemed somewhat reminiscent of *Animal Farm*.

In her most recent exhibition, in 1991, Feddersen presented an installation titled *The Ailing World*, consisting of 22 works based on grindstones. These circular stones were created in aerated concrete but each piece had a slice cut off so that, collectively, they could not rock or advance, despite the iron legs and feet that emerged from the centre of each piece. The feet were made with hessian, wax, feathers and horse-hair and, in some instances, featured artificial eyes.

While one might assume that Feddersen's sculptures are primarily satirical, they are in fact motivated by a wide range of creative impulses. Her humanoid forms contrast primeval spirituality with contemporary urban materialism, and provide a telling reminder that Feddersen is very much concerned with the sanctity of human life everywhere. In terms of aesthetics she is also keen to convey an elegance of form, and uses light and shadow very effectively as part of her creative intent.

Feddersen has gained numerous national commissions, including major works for the Sydney Opera House and Westmead Hospital. She held her first one-person show at the Hungry Horse Gallery, Sydney, in 1967, and has had several individual exhibitions since then, most recently at the New England Regional Art Museum in 1988–89 and at Coventry Gallery in 1989 and 1991. She is represented in the collections of the Art Gallery of Western Australia, the National Gallery of Victoria, Queensland Art Gallery and the Ballarat Art Gallery as well as in major corporate and institutional collections in Australia and overseas.

Artist's Comment

My interest is in human beings: how they function, their sufferings, their basic needs and their intellect have always interested me. Consequently these feelings play into my work. My aim will always be to surprise others and myself with the installations and large works I produce.

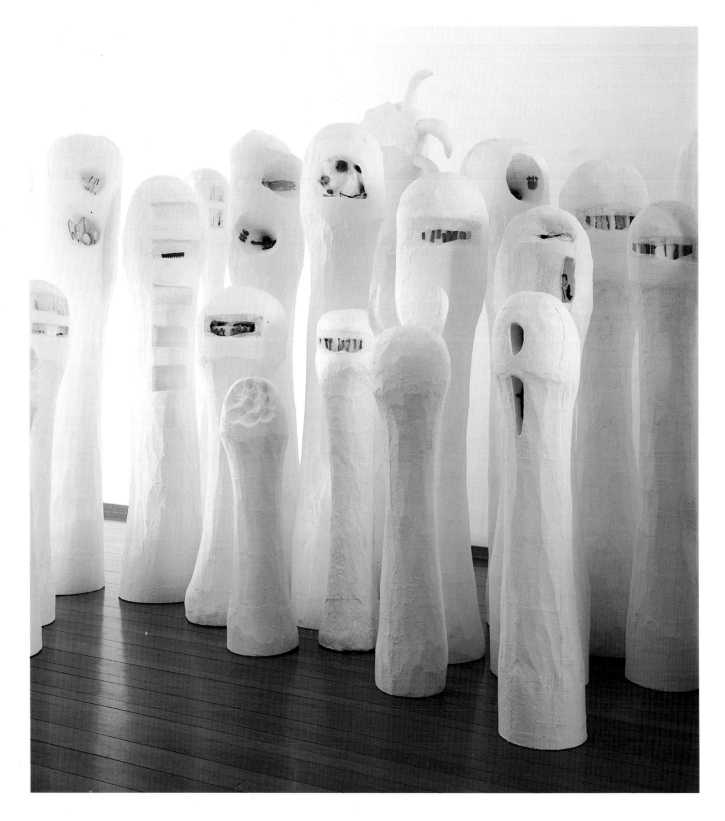

Representing Early Man, 1987,
Installation view, Polyurethane foam, plaster bandages, paint
and found objects, Various sizes (50–230 cm.)
Photograph: Fenn Hinchcliffe
Courtesy of Coventry Gallery, Sydney

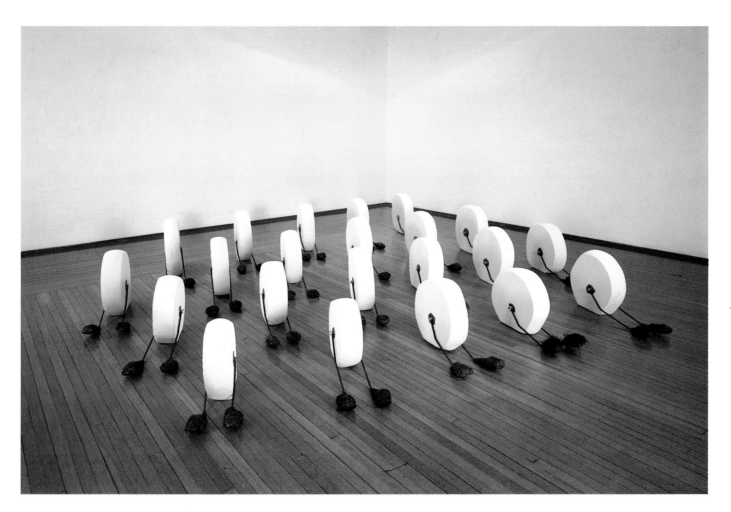

Die Kranke Welt (The Ailing World), 1991,
Aerated concrete, stone, steel, hessian, tar and wax,
Installation of 22 works of various sizes: 74–104 x 30–70 x 40 cm.
Photograph: Paul Green
Courtesy of Coventry Gallery, Sydney

JOHN GARDNER

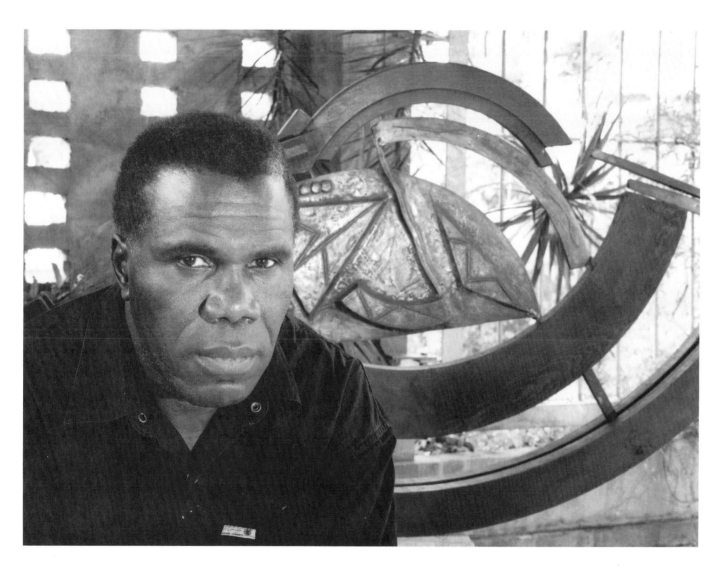

Portrait photograph: Paul Green

JOHN GARDNER was born in New York in 1942 and studied at the National Academy of Fine Arts from 1961–64. He was an instructor in the Sculptors' Workshop, New York, 1961–67, graduated with a Bachelor of Arts degree from the University of Connecticut in 1966, and was a designer in the Excaliber Bronze Foundries, New York, from 1966–68. After a year spent assisting Irving Marantz at New York University in 1968 he ran the Gardner/Bailey Art Foundry from 1969–72. He arrived in Australia in 1972.

Gardner lectured on Sculpture at Prahran College of Advanced Education, Melbourne, from 1973–76 and in 1975–76 was also a visiting artist at the Sydney University Summer Art Workshop. He designed and built bronze sculpture foundries at East Sydney Technical College and Gippsland and Alexander Mackie Colleges of Advanced Education, and also owned and operated the Bronze Sculpture Workshop/Gallery at Bondi between 1986–91. During that time he was a consultant to the National Trust.

The strength and immediacy of Gardner's work is conveyed well by the natural materials like bronze, wood and stone with which he works. His pieces range in size from monumental works to smaller gallery sculptures and reflect his ongoing fascination with Australia — as an artist he is intent on exploring the relationships between mind and matter and the iconography of different cultures.

Gardner has been included in several group exhibitions since his first show at Bowery Gallery, New York, in 1969. He was selected for the Mildura Sculpture exhibitions in 1973 and 1975, was included in shows at the Opera House Exhibition Centre and Sydney's Bloomfield Gallery in 1983, and also featured in a group exhibition held at Holland Fine Art, Sydney, in 1989. Gardner held his first solo exhibition at the Mulhern Townhouse, Brooklyn, New York in 1970 and had his first Australian shows at the Sculpture Centre, Sydney, and the Toorak Gallery, Melbourne, in 1976. His most recent exhibition was at Access Contemporary Art Gallery, Sydney, in 1991.

Awarded first prize in the 1980 Austral Bronze Crane Copper Award, Sydney, and also in the 1985 Easter Art Prize given by the Blue Mountains Arts Council, Gardner is represented in the collections of the National Gallery of Victoria; the State College of Victoria, Frankston, and in corporate and private collections in Australia and the United States.

Artist's Comment

These works represent two aspects of my style — from the totemic to a portrayal of the energies contained in natural forces. One is more static or material, the other dynamic and intuitive.

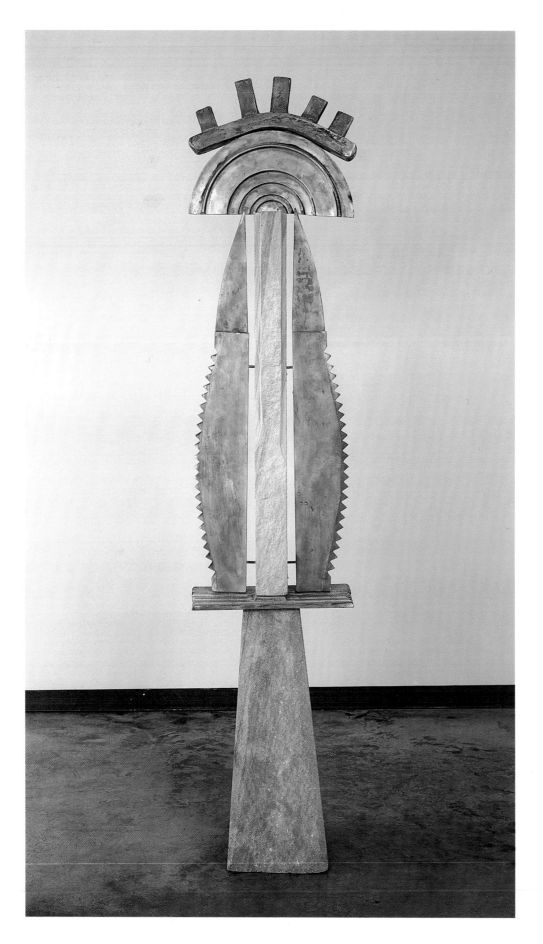

Empire City, 1991,
Sandstone and cast aluminium,
174 x 36.5 x 245 cm.
Collection of the artist
Courtesy of Access Contemporary
Art Gallery, Sydney

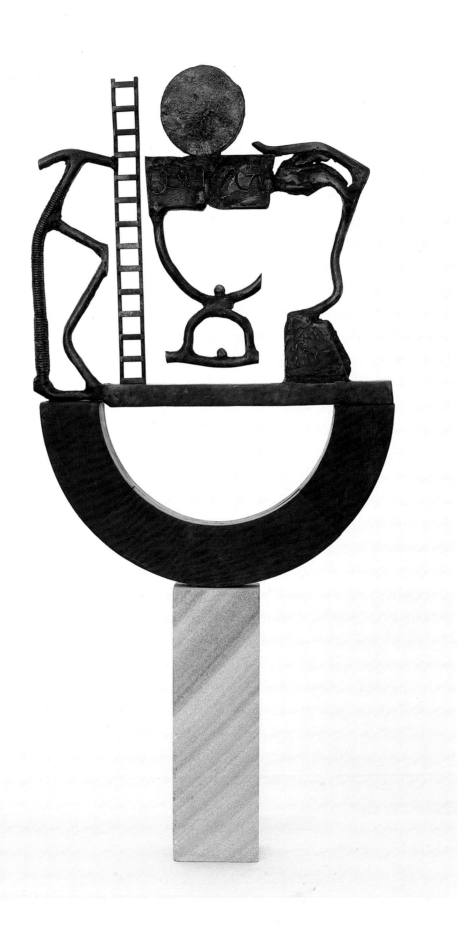

Ego, 1991,
Cast bronze, timber, sandstone base,
99 x 47 x 10 cm.
Private collection
Courtesy of Access Contemporary
Art Gallery, Sydney

MAREA GAZZARD

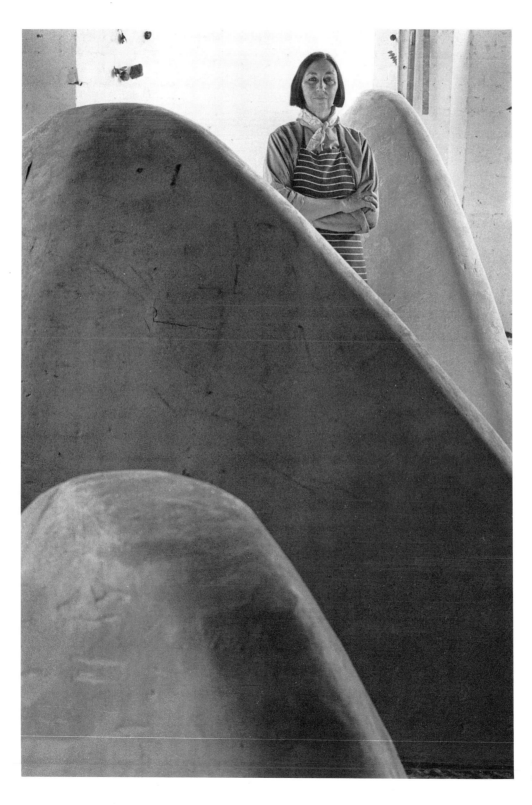

Portrait photograph: David Moore,
Parliament House Construction Authority

MAREA GAZZARD was born in Sydney in 1928. She studied at the National Art School, East Sydney, and then at the Central School of Art and Design, London. A part-time lecturer at what is now the Fine Arts Institute, University of New South Wales, Gazzard has also been guest artist at Haystack Mountain School of Crafts and Design, Maine, and a guest lecturer at the Renwick Gallery, Smithsonian Institute, Washington DC. She was awarded the Residency of the Denise Hickey Studio, Cité Internationale des Arts, Paris, 1988, and an Australian Creative Fellowship 1990–1993. She became a Member of the Order of Australia in 1979.

Gazzard has been a prime mover in involving Australia in international cultural activities. From being elected Australian representative to the World Crafts Council in 1968, she became Vice-President for Asia in 1972 and World President in 1980. These activities involved her in considerable travel on behalf of the arts. She has been a member of the Australian Commission for UNESCO, inaugural President of the Crafts Council of Australia and inaugural Chair of the Crafts Board of the Australia Council.

As a sculptor, Gazzard has exhibited nationally and internationally over a period of thirty years. Her prime material is clay which is sometimes modelled for bronze casting — a long process. She also produces works on paper, using charcoal, pastel or oil. However, it is her evocative and deceptively simple structures in bronze which have earned her international recognition. As Robert Bell has noted: 'Like wind-eroded classical statuary, her works are reduced to archetypal torso, head and mound forms, visually identifiable in an instant despite the erosion or omission of any other informing detail.'

Gazzard's *Mingarri* group, commissioned for the new Parliament House in 1988 and illustrated here, take their name from the Aboriginal term for 'the little Olgas' — remarkable rock formations in the central Australian landscape. The bronze forms are located in the Executive Court flanked by the Prime Minister's suite, the Ministerial suites and the Parliamentary library.

Gazzard has been included in numerous group exhibitions since 1964 — in Sydney, Adelaide, Auckland, Mildura, Perth and Melbourne. She had an individual show at Westmount Gallery, Montreal, in 1980 and had a succession of regular one-person shows in Sydney, Brisbane and Melbourne from 1963–1973. After a six-year gap she then had a solo show at Coventry in 1979 and exhibited there again in 1987 and 1990. She is represented in the collections of the Australian National Gallery, the Art Galleries of New South Wales, South Australia, Queensland, Victoria and Western Australia, the High Court of Australia and several regional galleries.

Artist's Comment

I enjoy the three to four years in preparing a solo exhibition but I like to react to the challenge of a commission, whether large or small.

My father came from Greece and my contact with my 'other country' is important to me. I am influenced by many things; our aboriginal people and their culture, and the Australian landscape.

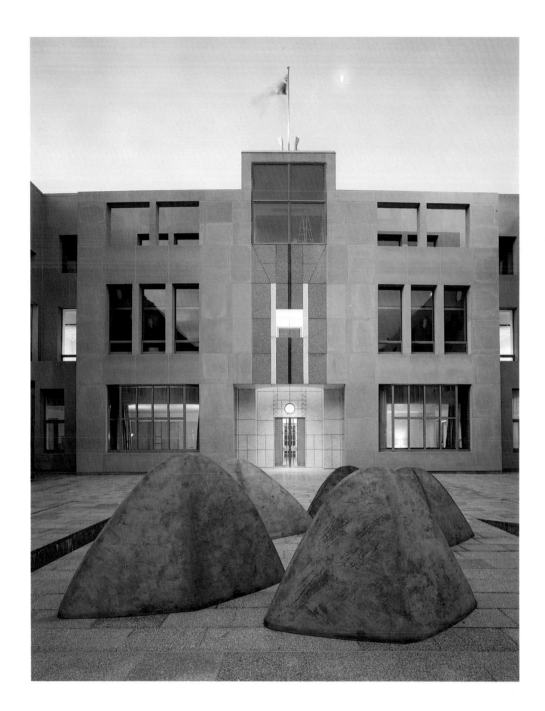

Mingarri, 1986,
Bronze (group of five),
Various sizes (130–167 cm.,
230–350 cm., 130–165 cm.)
Parliament House Construction
Authority
Photograph: John Gollings
Courtesy of Coventry Gallery,
Sydney

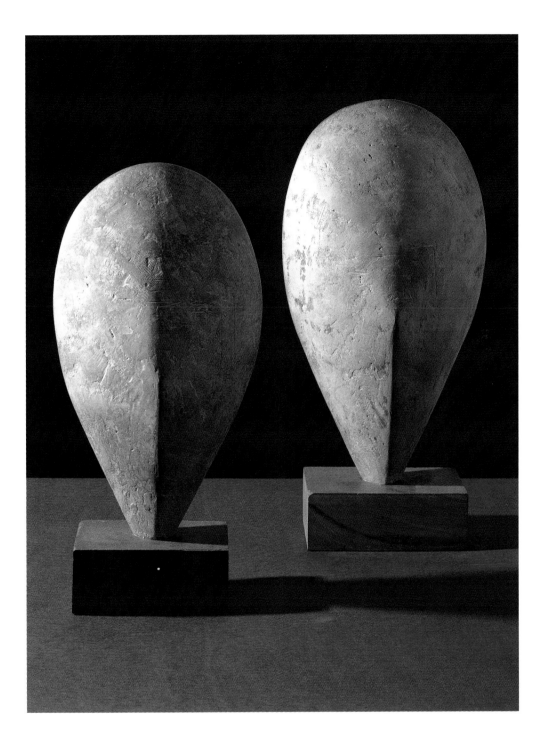

Personage I and II, 1990,
Bronze and slate,
(I) 41 x 20 x 12 cm.
(II) 36 x 18 x 11 cm.
Photograph: Paul Green
Courtesy of Coventry Gallery,
Sydney

GARRY GREENWOOD

GARRY GREENWOOD was born in England in 1943 and arrived in Australia in 1962. He had studied at Reigate School of Art in Surrey and when he came to Sydney he worked initially as an artist/designer. In December 1972 he moved to Tasmania and established a studio and gallery in the Bowerbank Mill in Deloraine.

Greenwood is a sculptor who works with leather in a way that is quite possibly unique. Fascinated by organic forms generally, and in particular by musical instruments developed in the 12th, 13th and 14th centuries, Greenwood began to produce actual leather instruments — some of which could be played musically. He was interested both in the acoustic properties of leather and also in expressing in visual form his emotional response to the sounds such musical forms could produce. He found that some early musical instruments made dreadful sounds but had a visual presence that was quite beautiful. He has since gone on to produce such remarkable pieces as his 1987 *Horn Hat*, fashioned in free-formed leather; a leather harp with playable strings; his *Strung Hat*, which resembles a top hat combined with a one-string violin; and the colourful *Horn Hat* which is reproduced here. Sometimes Greenwood also adds fingers to his leather instruments, providing the sense that the sculptured piece is engaged in a performance. *Keyboard for Little Fingers*, a dramatic work some 140 cm high, looks remarkably futuristic: Greenwood has added several clusters of fingers on the keyboard for surreal impact.

Greenwood has not focused only on musical instruments. His other works include shoes, helmets, masks and sculpted pieces based on the female form. Basically Greenwood likes to experiment, and the result is a range of stylish and original creations which are both imaginative and colourful.

The artist was a member of the Tasmanian Arts Advisory Board from 1977–81 and from 1985–89 was Head of the Leather Workshop at Canberra School of Art. Since 1972 he has held numerous individual exhibitions in Sydney, Melbourne, Canberra and Adelaide and various locations in New South Wales and Tasmania. His most recent show was held at the Holdsworth Gallery, Sydney, in 1992. Greenwood is represented in the Australian National Gallery, the National Gallery of Victoria, the Tasmanian Museum and Art Gallery, Hobart, the Queen Victoria Museum and Art Gallery, Launceston, the Australian Embassy, Washington, the Western Australian Art Gallery, and numerous other institutional and private collections in Australia, the USA, Japan and Europe. His works are also included in the musical instrument collections of Barry Tuckwell and Don Burrows.

Artist's Comment

My work is an attempt to produce working sculptural forms which reflect the aesthetic qualities and tradition of objects which are of interest to me, be they musical instruments, shoes or hats and most recently, saddles. The construction techniques employed in producing these works have created an opportunity to explore the acoustic nature of leather as well as to take a humorous look at tradition. I leave it to the viewer to continue this exploration.

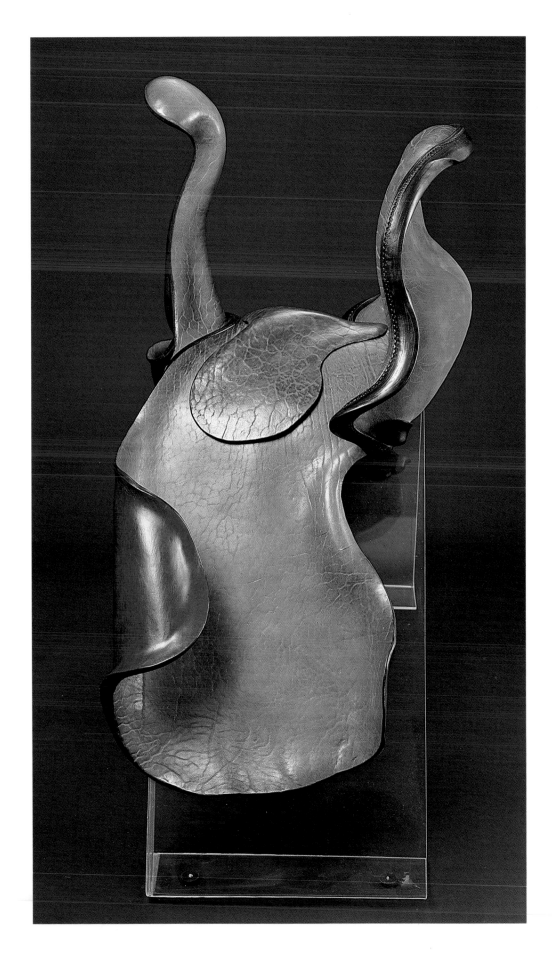

Floral Saddle 1, 1988,
Embossing hide and suede, wet
formed, laminated and carved,
80 x 50 x 60 cm.
Photograph: W. Mobbs
Collection: Mary Jacobs
Courtesy of the artist

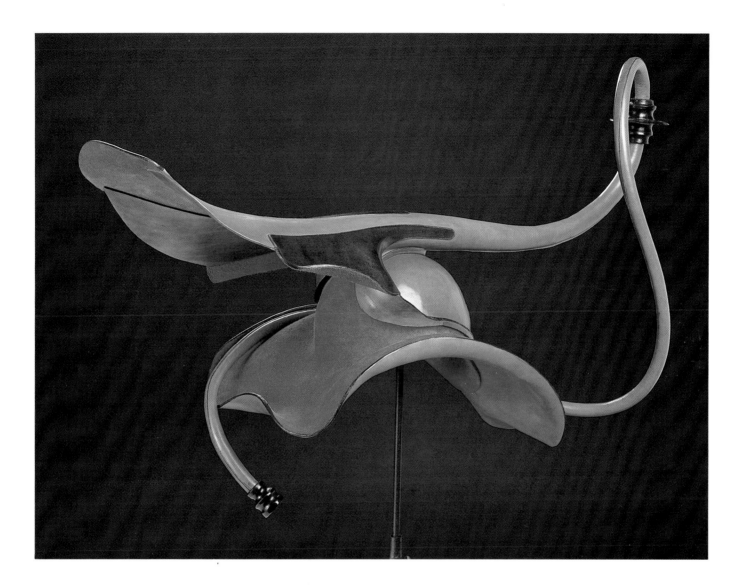

Horn Hat, 1988,
Embossing hide and suede, wet
formed, laminated and carved,
40 x 60 x 30 cm.
Photograph: W. Mobbs
Collection: Bill Wensell
Courtesy of the artist

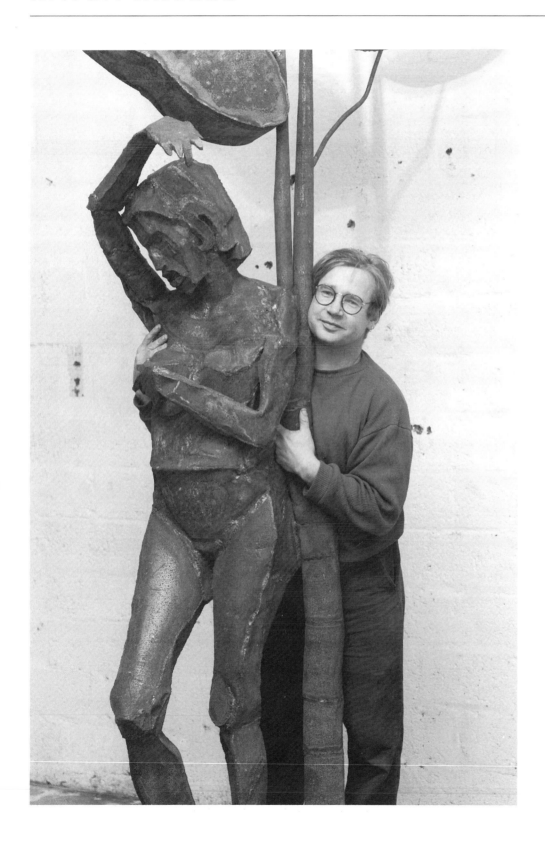

ANTON HASELL was born in Warrnambool, Victoria, in 1952. He gained his Bachelor of Economics degree and Diploma in Education from La Trobe University in 1974 and 1975 respectively, and was awarded a Bachelor of Fine Arts (Sculpture) from Royal Melbourne Institute of Technology in 1982. He studied for his Postgraduate Diploma of Art at the Victorian College of the Arts in 1985.

Now well known for his dramatic and sometimes eccentric constructions in metal, Hasell began working with second-hand and recycled materials out of sheer economic necessity. 'As a student', he recalls, 'I remember dreaming about the time when I should be able to afford new timber and freshly rolled metal sheet — how I then could more exactly build that which I imagined so clearly!' Meanwhile, Hasell began to construct his sculptures using discarded bits and pieces and this approach has stayed with him: 'I have grown to appreciate that an integral part of my work is concerned with the qualities and spirit of re-inventing used material.'

As an undergraduate, Hasell's earliest interest was in bicycle parts which in turn were recycled into unicycles, tricycles and other composite works. Later he used three-ply to build a 'Shark Boat' and crumpled advertising tin sheet to construct a 'Submarine'. A number of other sculptures followed, including the *Economic Car Series*, the *Bike Plane* and *Rumourmonger*. In 1987 he began to work on a series of sculptures fashioned in corrugated iron. These works explored the qualities of dangerous Australian animals and included *Red Running Tiger* (the Tasmanian Tiger), *Shark*, *The Eagle and the Snake*, *The Eagle and the Lamb* (reproduced here), *The Ram* and *The Crocodile Canoe*. His most recent creations have been built out of used and battered 44-gallon drums and include his half actual size *Warplane*, based on an imagined desperate attempt in 1943 to replace Spitfires lost in battle over Darwin. He has also completed two recent commissions: a bronze *Lucky Touch* sculpture for the southern stand at the Melbourne Cricket Ground and six bluestone and bronze *Bollards* for the City of Yarraville.

Hasell has exhibited in numerous group exhibitions since 1979 and was included in such shows as 'Coming to Terms with Sculpture' at the National Gallery of Victoria, 1984, 'Sculpture and Works on Paper' at 70 Arden Street, North Melbourne, 1986, and 'Voyage of Discovery: Australian Painting and Sculpture' at the Crescent Gallery, Dallas, in 1987. He held his first one-person show, 'Hung Drawn and Sculpted', at Judith Pugh Gallery, in 1990. Hasell won the Tina Wentscher Sculpture Prize in 1985 and the Andor Meszaros Sculpture Prize in 1986 and was awarded a Visual Arts Board Grant in 1988 to attend the Paretaio Studio in Italy. He is represented in the collection of St Kilda Council and in various private collections.

Artist's Comment

My work is specially interested in mechanical machinery into which people fit (or do not fit): a sort of aesthetic ergonomics. A concern I feel (and want to share) about a world increasingly more rigid in its definition of how it is, a world to which humans are expected to fit, such contortionists as we are. Through my sculpture I am asking us all: Is it not time we considered our positions and discussed quietly, seriously, humanely, how the 'known' world is, and how it should become?

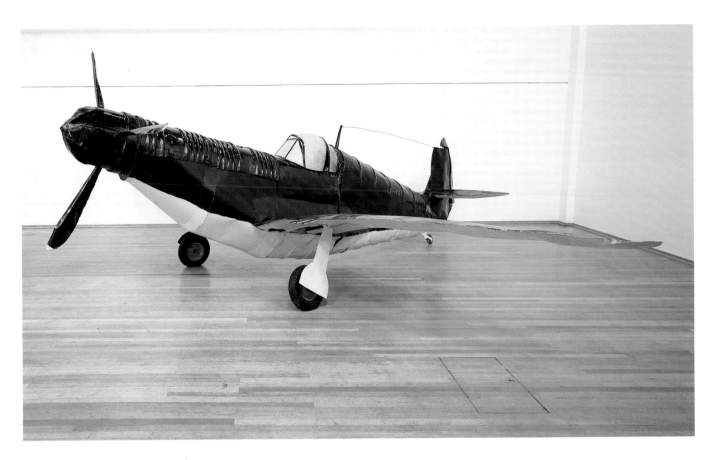

Warplane, 1989,
Sheet metal,
Wingtip to wingtip: 710 cm.
Nose to tail: 610 cm.
Ground to top of propeller: 214 cm.
Courtesy of the artist and Judith Pugh Gallery, Melbourne

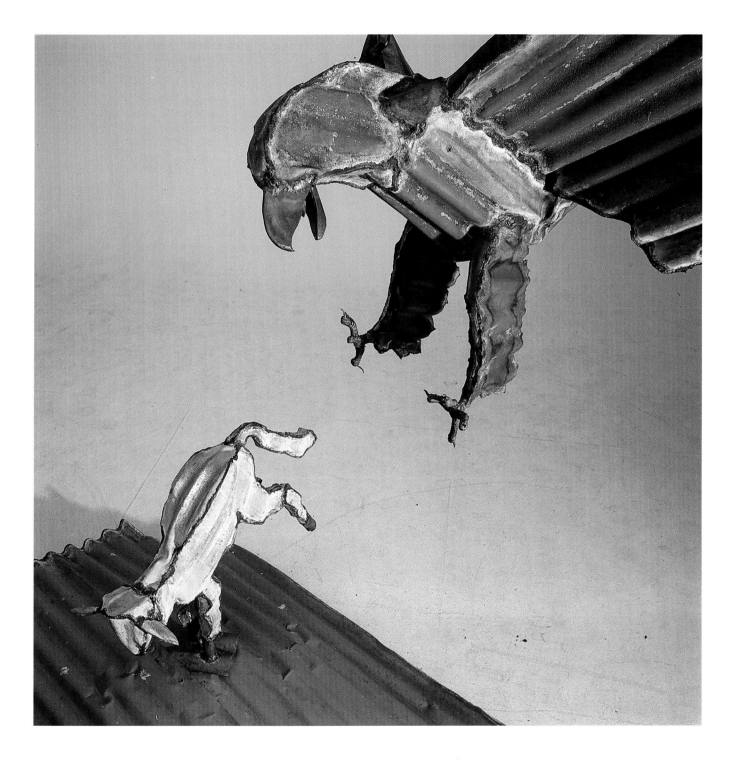

The Eagle and the Lamb, 1989,
Corrugated iron, 272 x 290 x 260 cm.
Courtesy of the artist and Judith Pugh Gallery, Melbourne

JOY HENDERSON

JOY HENDERSON was born in Perth in 1957. She attended Murdoch University, 1976–80, gaining her Bachelor of Arts degree and majoring in social and political theory, and then studied at Claremont School of Art, 1980–82, graduating with a Diploma of Fine Arts (Sculpture). Two years later she helped to establish a Western Australian Sculptors Co-operative.

Henderson moved to Sydney in 1985, obtained a Diploma of Education (Secondary Art) from Sydney College of Advanced Education, and the following year studied Post-Certificate Sculpture at the National Art School/East Sydney Technical College. She later travelled extensively in Europe, visiting Britain, Holland, France and Italy.

The artist learnt traditional techniques of sculpting in art school — specifically, sculpting from the figure. This involved modelling in clay, mould making and bronze casting. She says that the figure interests her as a subject because as a vehicle it is able to convey subtle attitudes and concepts of self and sexuality. Figurative sculpture has traditionally been used to express certain beliefs about beauty and morality and, in so doing, reveals the biases of the maker within a given social context.

Henderson won First Prize for Sculpture and Photography in the South Perth Heritage Art Exhibition, 1981, and the following year featured in her first group exhibitions, at North Fremantle Community School and Waterway Farm Gallery. She was included in the Fringe Festival Sculpture Exhibition at Gomboc Gallery, Perth 1984, 1988 and 1992, was selected for the Wynne Prize at the Art Gallery of New South Wales in 1989, and participated in survey exhibitions at Access Gallery, Sydney, in 1990, 1991 and 1992. She also had one-person exhibitions of bronze sculptures at Access Gallery in 1988 and 1989 and won First Prize for Sculpture in the South Perth Heritage Art Exhibition, 1992.

In recent years Henderson has received several commercial commissions for different productions and promotions including the feature film *Birdsville*, a Glenrowan/Ned Kelly tourist exhibition, and commissions for Status Marketing and Laserlight Expressions. She is represented in the Robert Holmes à Court and Alan Burns Collections and in private and corporate collections in Australia and the United Kingdom.

Artist's Comment

In my work I approach the concepts of beauty, masculinity and femininity from a different perspective — female — using models and poses not usually associated with figurative sculpture, in an attempt to expose our preconceptions about the perfect body.

The sculpture Figure 7, *with its small breasts and muscular physique, was the beginning of my examination of alternative forms of beauty and sexuality in the female form. It is introverted and self-contained, as opposed to the traditional voluptuous models in coy, seductive poses.*

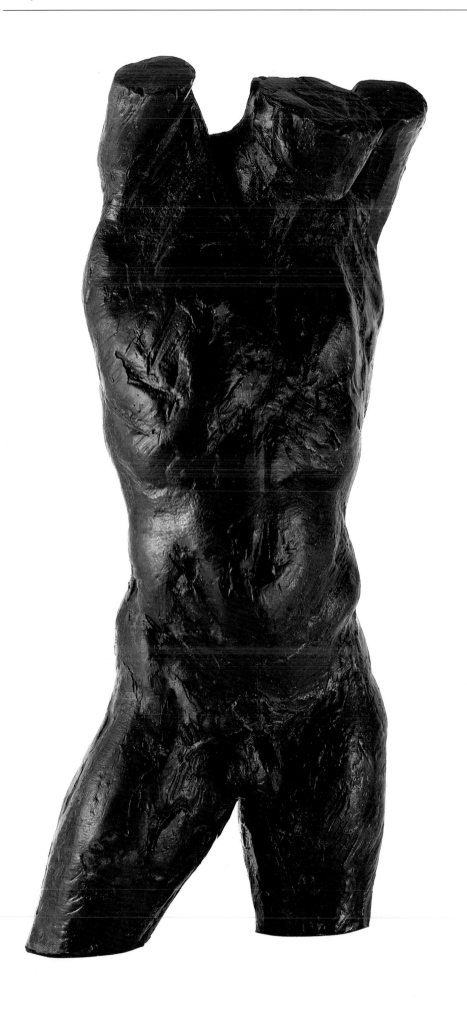

Surrender, 1989,
Cast bronze, 46.5 x 20 x 21 cm.
Collection of the artist
Photograph: Paul Green
Courtesy of Access Contemporary
Art Gallery, Sydney

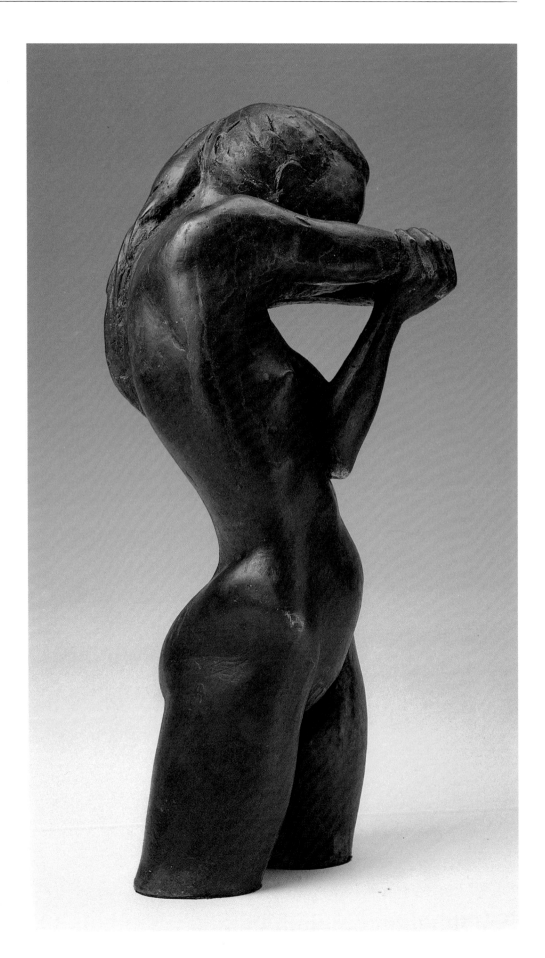

Figure 7, 1987,
Cast bronze, 40.5 x 19 x 16 cm.
Private collection
Photograph: David Roche
Courtesy of Access Contemporary
Art Gallery, Sydney

GREG JOHNS

GREG JOHNS was born in Adelaide in 1953 and studied for his Diploma of Fine Arts, Sculpture, at the South Australian School of Art from 1975–78. Since graduating he has worked full-time as an artist, completing major commissions for various councils, art galleries, private companies, and World Expo '88. While much of his time has been spent liaising with architects, engineers, steel fabricators and other professional people, Johns has had a completely 'hands-on' approach to his creations in metal, personally carrying out the steel fabrication on a number of large and small sculptures. He says that as an artist this approach has engaged him in a process of acquiring 'both academic and pragmatic skills'.

Over the last decade Johns has been primarily concerned with large-scale Austen steel sculptures for outdoor areas and finds it especially interesting when certain considerations of scale and form are involved in relation to the demands of a particular site. He sees his work as a dynamic balance between conceptual and formal qualities and has been influenced as much by sculptural traditions of the past, as by contemporary styles and inclinations. Johns' personal interests are far-ranging. He reads widely in the fields of anthropology, mythology and the New Physics and admits to being influenced by the important engineer/inventor Buckminster Fuller. Artists like Brancusi, Noguchi, Kandinsky, Bert Flugelman and Heather Ellyard have also had a major impact on his thinking.

A recipient of the Whyalla Sculpture Prize, Johns held his first individual exhibition at Adelaide's Bonython Gallery in 1980 and has had nine further solo shows since then, the most recent in 1992. A new exhibition with Greenaway Gallery, Adelaide, is planned for 1993.

Artist's Comment

While I am still developing aspects of the circular forms I worked with until late 1988, there has also been a major figurative development. These abstract figures have evolved from the circular forms. They are perhaps more related to this place, but I feel the themes are not restricted to Australia.

Continuous Division is a large work, as necessitated by the surrounding environment. Important decisions were involved in the scale, exact placement and orientation of this sculpture and it reflects my interest in interconnected systems and the creative relationship of opposites. It is a sculpture which, I hope, functions on several levels — conveying conceptual content, working with and adding to the given environment, and encouraging people to explore and enjoy it both physically and visually.

Forgotten-Remembered Figures was the first major commissioned work where there was a move from the abstract, rounded forms I had investigated during the 1970s and 1980s to a figurative approach (without totally abandoning the earlier work). It was totally unexpected — although in retrospect I can see how the figures evolved from earlier forms. I feel that the work deals specifically with mythology and importantly with the notion that a common world mythology exists — perhaps forgotten at present, but one which can be remembered. The forms of the figures are influenced by different cultures — different on the surface, but possessing many common, essential links. This piece, I believe, is somewhat more localised to Australia than earlier work.

Continuous Division, 1988,
Austen steel, 510 x 416 x 312 cm.
Photograph: Anthony Tugwell
Collection: Brisbane City Council
Courtesy of the artist

Forgotten-Remembered Figures, 1989,
Austen steel, height 3.5 m.
Photograph: Greg Johns
Collection : Manchester Unity
Courtesy of the artist

TED JONSSON

TED JONSSON was born in Stockholm, Sweden, in 1935 and spent most of his childhood and teenage years travelling in Europe and Scandinavia with his parents, who were performing acrobats with circus companies. He has worked as a seaman in both the Swedish Navy and Swedish Merchant Navy, and was also employed as a chef. He attended the School of Commercial Art in Stockholm from 1951–53 and was apprenticed as a carpenter from 1958–62. Between 1968 and 1971 he was a teacher for trades schools in Stockholm, and then migrated to Sydney in 1971. Two years later he moved to Adelaide and worked as a sub-contract carpenter until 1991. Meanwhile he painted and sculpted in his spare time.

Jonsson creates sculptures from the things other people discard. The traditions and subtleties of two-dimensional art hold less fascination for him than animating cast-off pieces of machinery and improvising with timber offcuts and junk — objects which he is able to transform into intriguing new forms with great facility. Strips of metal cut from old pressed tin ceilings are assiduously woven and clad, and riskily assembled with other unlikely objects making for leering, fun-packed manifestations that might shock and certainly surprise the unsuspecting viewer. There is sophistry in Jonsson's obsessive sculptures, that deftly weaves humour and the darker side of the collective unconscious. His 'junk' sculptures are more about the refuse in the human mind that what is or isn't 'good'.

The artist has been included in a number of individual and group exhibitions in Adelaide since his first solo show at the Contemporary Art Centre in 1986. He featured in exhibitions at the Jam Factory Gallery in 1987 and 1988, and at the Chesser Gallery in 1989, 1990 and 1991. His most recent individual exhibition was at the Greenaway Gallery in Adelaide in 1992.

Artist's Comment

If the aim of any artist is the creation of a new memorable image, I like to think that my art does that. I create the underlying image in a series of cultivated accidents and then clad them with all sorts of time-worn junk. I want the work to bear some mark of physical and psychological struggle. Scars are drama. Time is comedy.

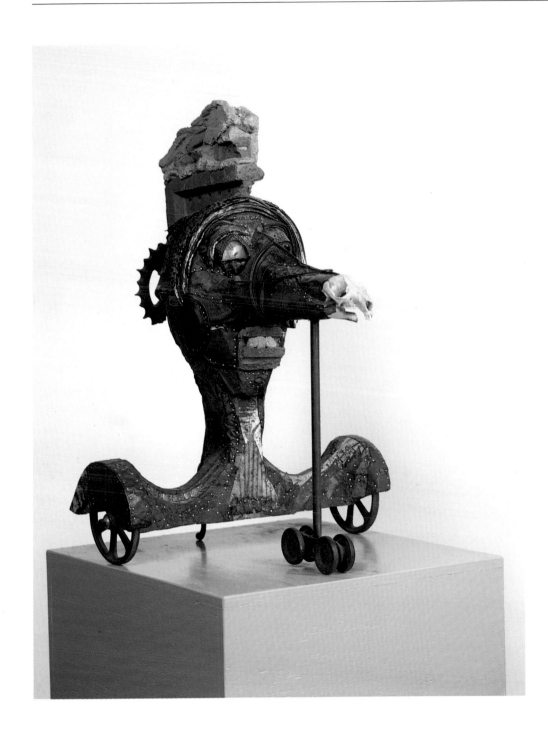

Pontiac '89, 1989
Mixed media,
90 x 60 x 60 cm.
Photograph: Michal Kluvanek
Courtesy of Greenaway Art Gallery,
Adelaide

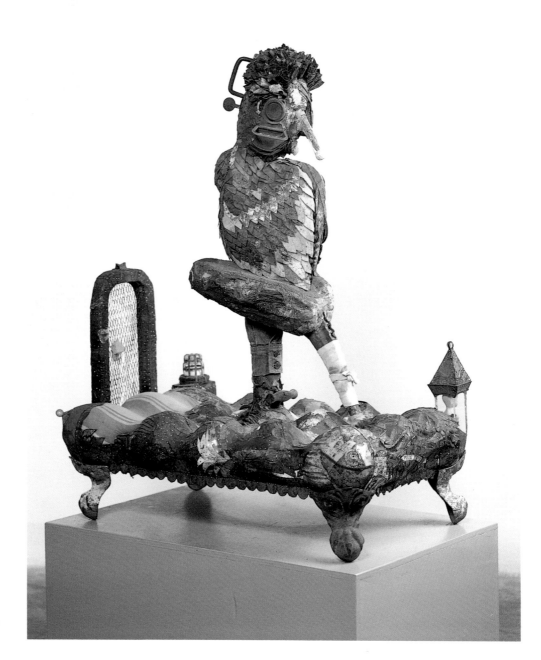

Birdie, 1989
Mixed media,
120 x 95 x 60 cm.
Photograph: Michal Kluvanek
Courtesy of Greenaway Art Gallery,
Adelaide

INGE KING

Portrait photograph: Grahame King

INGE KING was born in Berlin in 1918 and trained in Germany and the United Kingdom. From 1947–50 she had her studio at The Abbey in London — an artists' colony established by art dealer William Olhy, and in 1949 had her first solo exhibition of carvings and drawings at the London Gallery run by Belgian surrealist painter E.L.T. Mesens. Between 1949–50 her time was divided between Paris and New York. She participated in several group shows, was involved in the Grace Borgenicht Gallery Clay Club, saw the first exhibition of Jackson Pollock at the Betty Parson Gallery, and also met Mark Rothko and Barnett Newman, who were then hardly known outside New York. During this period in New York she also became fascinated by metal sculpture although she would not pursue this medium herself for another ten years.

Inge emigrated to Australia in 1951 with her husband Grahame King, well known in his own right as a painter and printmaker. For the next 11 years she focused on creative jewellery, working mainly with silver. However, in 1960 her first steel sculptures began to evolve and it is for this style of work that she has become widely recognised.

An artist working in clay builds the work from the inside, and in wood or marble proceeds from the outer surfaces inward. With steel sculpture it is a matter of assemblage, 'of putting bits together', and Inge King found this was more to her liking. Steel sculpture is also an especially *modern* medium — welding equipment first became available just prior to the First World War — and King found that working with contemporary materials had considerable appeal. Inge King says, too, that the Australian landscape 'gripped her imagination' and became the main source of her inspiration — her monumental sculptures could become part of her adopted environment. While formulating her steel structures she found herself, as she puts it, 'measuring my work against the vast spaces of this country'. However, she emphasises that size alone is not the distinguishing characteristic of her sculpture. 'It is the simplicity and clarity of form expressing inner strength and tension that is the motivating force.'

King is perhaps best known for her *Forward Surge*, a sculpture consisting of four huge waves of steel that resides on the lawn between the concert hall and performing arts complex of the Victorian Arts Centre. The work was intentionally massive so that viewers would be forced to walk round it, thereby perceiving and evaluating it as a 'three-dimensional image'. *Jabaroo*, shown here, is also an outdoor work, beautifully sited in the Sculpture Park of the McClelland Gallery at Langwarrin, Victoria. In similar fashion it contrasts dramatically with the surrounding landscape.

Inge King has held numerous individual exhibitions since her first show in London in 1949. She held a survey show, 1945–82, at the University Gallery, Melbourne University, in 1982 and has exhibited widely in Melbourne, Sydney, Brisbane and Adelaide.

Artist's Comment

The element of humour in Jabaroo *relates to the incongruity of the ancient landscape and fauna in contemporary Australia.* Joie de Vivre *is of a different nature. It emphasises movement, and arises from a search for exuberance and affirmation of life.*

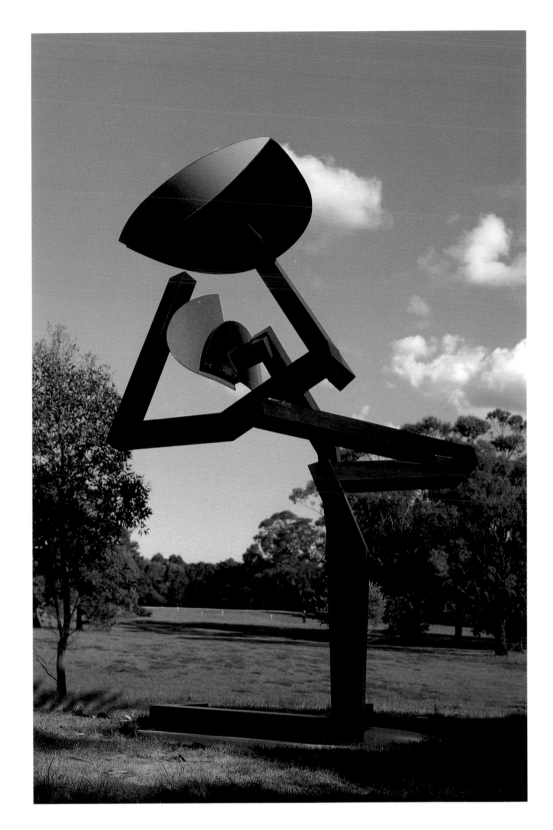

Jabaroo, 1985,
Polychrome steel,
375 cm. high
Photograph: Inge King
Collection: McClelland Gallery,
Langwarrin, Victoria
Courtesy of the artist

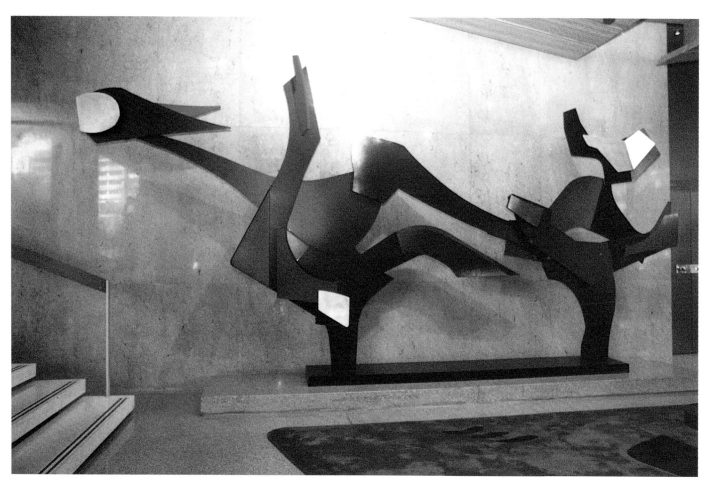

Joie de Vivre, 1990,
Sculpture for foyer of ICI House, Melbourne,
Main section : 275 x 525 x 49 cm.
Photograph: Grahame King
Collection: ICI, Melbourne
Courtesy of the artist

MARIA KUCZYNSKA

Portrait photograph: John Ford

MARIA KUCZYNSKA was born in Poland in 1948 and arrived in Australia in 1982, when she took up a position as artist-in-residence at Canberra School of Art. Prior to this she had studied sculpture at the Academy of Fine Art, Gdansk, between 1965–71, graduating with a Masters degree. Her specialisation was in sculpture for architecture.

Now well known for her powerful, if somewhat enigmatic, figures, the sculptor first showed her work locally in a travelling exhibition which toured Canberra, Sydney, Perth, Adelaide, Geelong and Mornington in 1982–83. Her porcelain sculptures made a strong impact on viewers — ambiguous figures staring bleakly out on the world through a solitary slit, powerful forms suggested by tortuous yet undeniably beautiful folded planes of clay. One of these figures was named *Guard*, another *The Warrior*, still another *The Witness*. And yet these figures were disturbingly anonymous, suggestive of the harsh European environment she had left behind her.

In 1986 the sculptor held her first Sydney exhibition at Macquarie Galleries — a show which prompted art critic Elwyn Lynn to describe the sculptor as an heir to the late Alberto Giacometti. 'Giacometti's theme' wrote Lynn in *The Australian* (26 April 1986) 'though more varied in form than Maria Kuczynska's, is rather much the same: humans as survivors, beleaguered, wounded, worn and completely isolated.' The sculptor's forms were clearly an extension of her earlier preoccupation with hooded warriors — solemn figures in black or dark grey — but now, in a somewhat discouraging development from the earlier work, the figures were headless rather than disguised by swathes and folds. There remained in her work, nevertheless, a sense of magnificent courage, of survival at all costs. It is an heroic theme which few other Australian sculptors could hope, or wish, to emulate.

Maria Kuczynska's reputation was well established before she came to Australia. In 1978 she won the Gold Medal at the Faenza International Ceramic Art Competition, following it with the Grand Prize a year later. She also won second prize in the National Competition for the Wyspianski monument in Cracow, Poland, in 1979 and the ASER Award for Bronze Sculpture in 1992. She was artist-in-residence at Meridian Sculpture Founders, Melbourne 1989–90.

Kuczynska works both in ceramics and bronze and her work is included in the collections of the Museum of International Ceramics, Faenza; the Museum of Art and Culture, Ghent; the Wurttenbergische Landesmuseum, Stuttgart, and the Polish National Museums in Gdansk, Warsaw and Wroclaw. In the Southern Hemisphere, her work is represented in the Auckland Museum, the Newcastle University Collection, the National Gallery of Victoria, the Art Gallery of Western Australia, and the Canberra School of Art.

Artist's Comment

My work is concerned with the place of man in the contemporary world — the contrasts between the individual and the cosmos, between morality and immorality, and the importance of the individual's contribution to that history of which he is a major component.

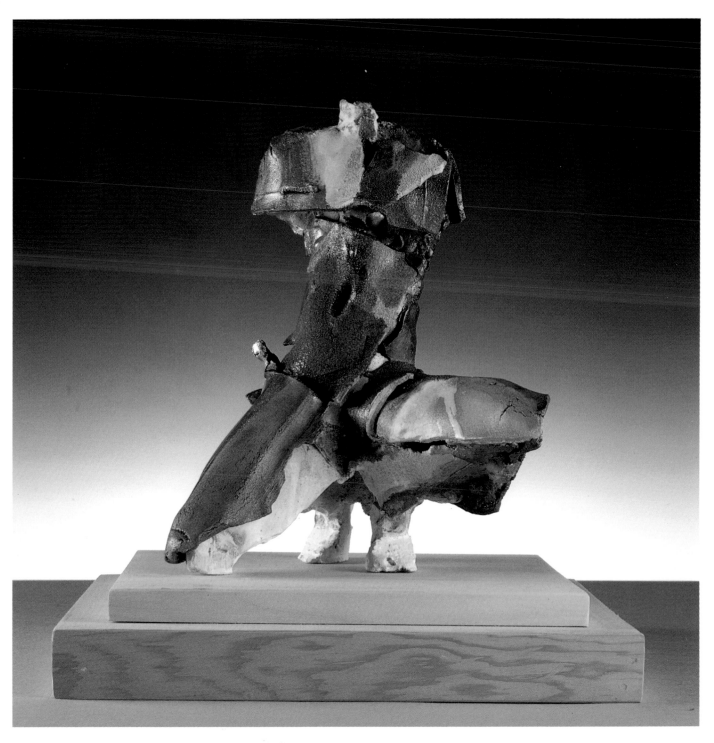

Samurai, 1992,
Ceramic, 36 cm. high
Courtesy of Macquarie Galleries, Sydney

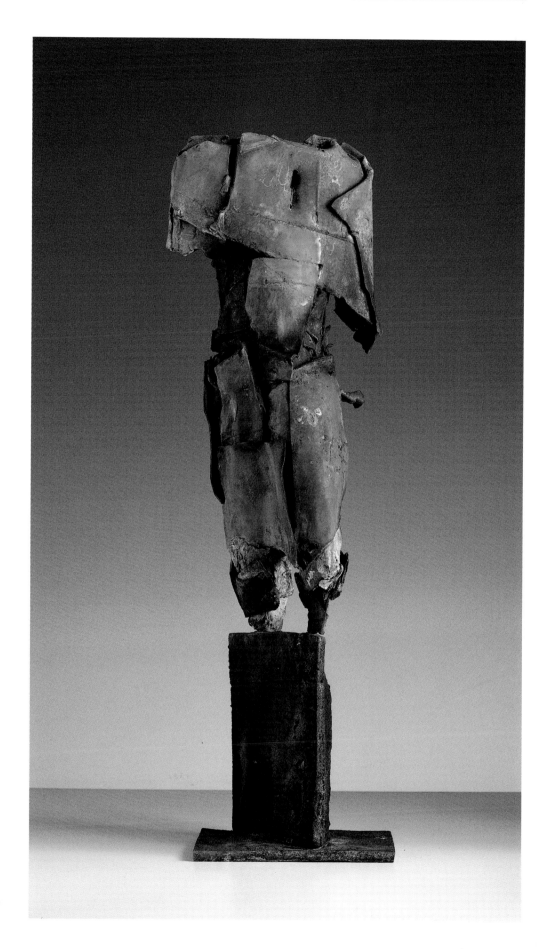

Bronze Age, 1988,
Bronze, 94 cm. high
Courtesy of Macquarie Galleries,
Sydney

POLLY MacCALLUM

Portrait photograph: Mungo MacCallum

POLLY MacCALLUM was born and educated in England, including part-time studies at Willesden Art School and the Royal Academy of Music (Speech and Drama). She came to Australia in 1960 and after working in Perth for ten years, mainly in Arts advertising and promotion, moved to Sydney.

During the seventies she decided to do a refresher course in art studies which resulted in a Diploma in Art (Alexander Mackie College of Advanced Education). In 1983 she was artist-in-residence at the Besozzo Studio in Italy and was awarded a Master of Arts (Visual Arts) Degree in 1986 by the City Art Institute in Sydney. Throughout this period she also worked as a professional artist, exhibiting in Fremantle, Wollongong and Mildura and regularly in Sydney.

MacCallum's work has moved from mainly painting in the '70s and early '80s through collage, wall constructions and free standing sculpture. She has been very much aware of the emphasis on violence apparent in recent years. For a time she countered this with a contemplative inward view, focusing on geometric symbols and using clear perspex to create a fourth dimension through shadowy images and reflections. But her 1990 series began to look at individual violence in an historic context from mythical figures to martyrs: especially women. Later work has been based on Cockatoo Island and its history as the first penal settlement and women's reformatory in New South Wales.

The artist has been included in several important group exhibitions concerned with contemporary collage and also took part in the 1988 Mildura Sculpture Triennial. She had her most recent individual exhibition at Coventry Gallery, Sydney, in 1992 and is represented in the Fremantle and Wollongong City Art Galleries, Artbank, City Art Institute (NSW), Mildura Arts Centre, Parliament House (Canberra) and Wollongong University as well as many private and corporate collections both in Australia and overseas.

Artist's Comment

For me work is a means of creating some sort of order out of chaos. To pluck from the multitude of images, messages, political upheavals, theories of the universe and global catastrophies some graspable concept to worry through to a final form of visual expression. The medium is dictated by the concept: the concept can be modified by the medium. When both are right they complement each other.

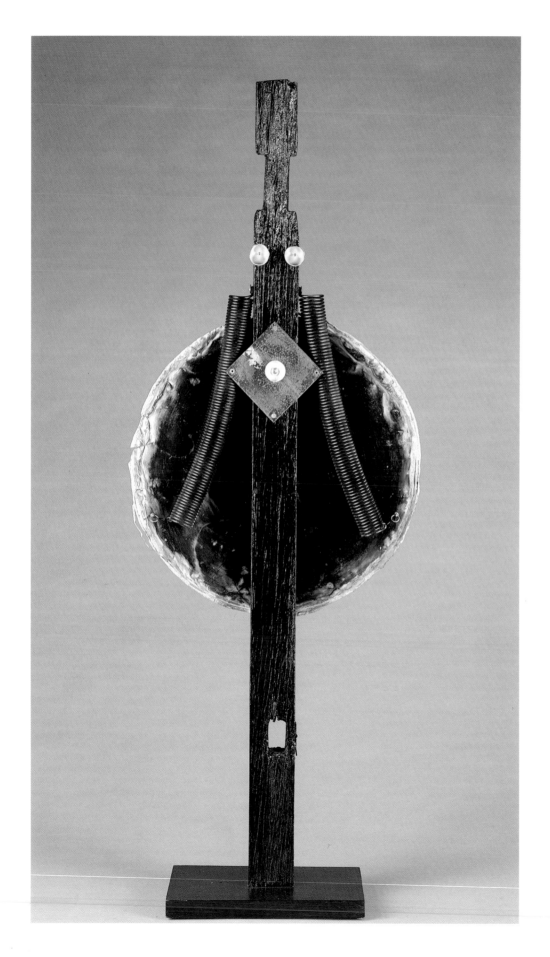

Hecuba, 1990,
Mixed media, 200 x 80 cm.
Photograph: Paul Green
Courtesy of Coventry Gallery,
Sydney

Brunhilde, 1990,
Mixed media, 36 x 29 cm.
Photograph: Paul Green
Courtesy of Coventry Gallery,
Sydney

ALEXIS McKEAN

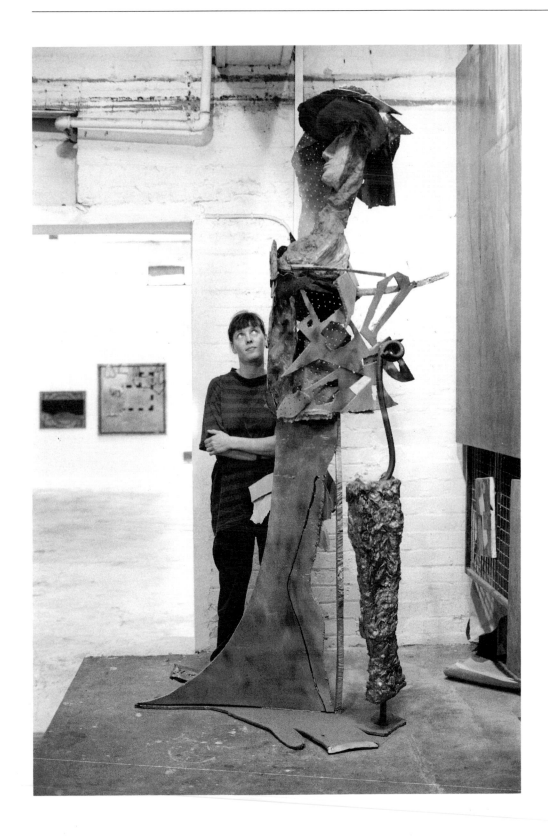

ALEXIS McKEAN was born in Scotland in 1961 and arrived in Australia in 1974. She studied Sculpture at Prahran Faculty of Art and Design at the Victorian College of the Arts, gaining a Bachelor of Arts (Fine Art) degree in 1985.

McKean's sculptures utilise a variety of media, including steel, cast concrete, resin and aluminium and on some occasions — as with *The Painting Class*, illustrated here — also feature fabric and acrylic. Her works have a distinct presence, and are not without an aspect of humour. The painting seems to be slipping from its frame in *The Painting Class* and the somewhat aloof *Woman with Umbrella*, at almost twice human size, manages to be both dignified and ridiculous at the same time.

McKean won the Diamond Valley Art Award in 1988 and has exhibited in several group exhibitions since 1985, including the Ninth Mildura Sculpture Triennial, 1985, 'Sculpture for Melbourne' at the Gryphon Gallery, 1986, 'Change' at Judith Pugh Gallery, 1990, and 'Humour and Satire in Contemporary Australian Art' at Heide Park and Art Gallery, 1992. She has also had two individual exhibitions to date — at 70 Arden Street, 1987, and with Judith Pugh Gallery, August 1990.

The artist is represented in the Diamond Valley Collection, the National Gallery of Victoria and in several private collections.

Artist's Comment

Sculpture for me is an evolution of forms one lending itself to another, depicting a timeless involvement in the discovery and development of the sum of the human condition. Above all, my approach to sculpture is summarised in Rilke's ideas, which include these statements: 'Sculpture (is) a separate thing … It (is) an object that (exists) for itself alone.'

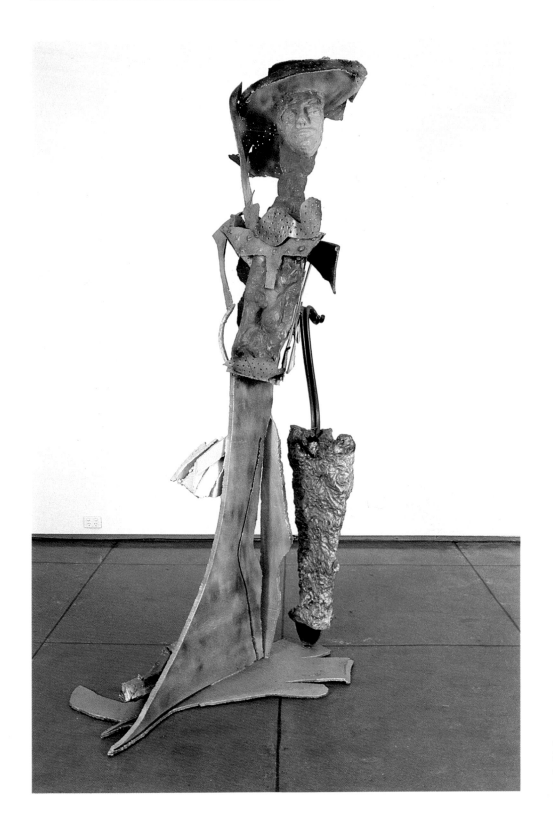

Woman with Umbrella, 1990,
Aluminium, steel and resin,
242 x 128 x 94 cm.
Courtesy of the artist and Judith
Pugh Gallery, Melbourne

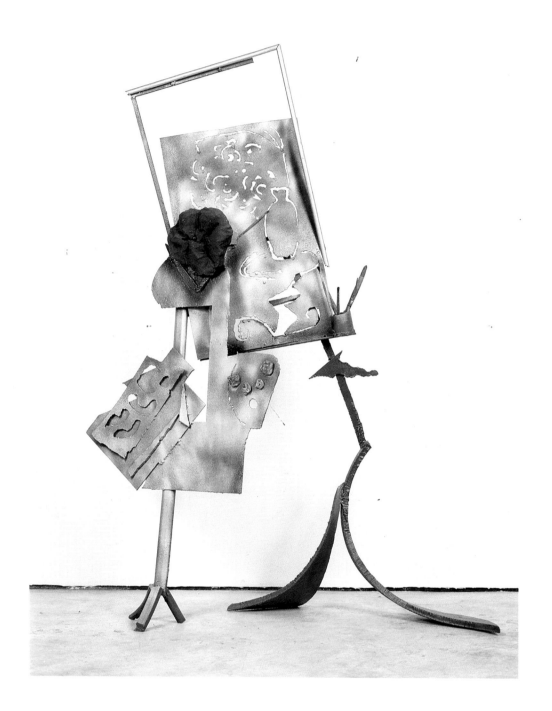

The Painting Class, 1990,
Steel, cast concrete, mixed media,
197 x 154 x 72 cm.
Courtesy of the artist and Judith
Pugh Gallery, Melbourne

MICHAEL NICHOLLS

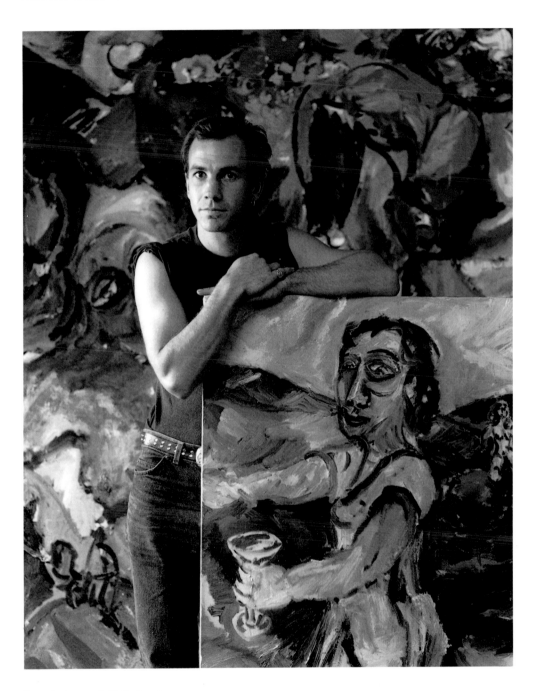

Portrait photograph: Heike Bartels

MICHAEL NICHOLLS was born in Melbourne in 1960 and studied at Caulfield Technical College. Melbourne, from 1980–83. Between 1982 and 1984 he also spent much of his time travelling in northern Africa, Indonesia and Europe, and in 1990 visited Turkey.

An artist with a multiplicity of skills, Nicholls works as a sculptor, painter and printmaker and is also well known for his drawings. He is personally committed to experimenting with as many visual media as possible.

Nicholls was a founding member of the Roar Studios in Melbourne and has pursued a variety of artistic styles — including strong, expressionist paintings and different types of sculptural work, as exemplified by the two works reproduced here. His sculpture in wood, *Family Picnic*, shows the strong influence of primitive African art but the figures themselves appear more introspective than is often the case in tribal art. The family members have intriguing, quizzical expressions on their faces, and seem puzzled by the nature of their very existence. *Tarantula*, on the other hand, evokes a strong sense of menace and barbarity. A formidable work created in steel, it owes its title to the venomous wolf spider and looks poised to strike. Nevertheless, it has been constrained by its masters — it normally resides close to the side fence in the sculpture garden at Sydney's Coventry Gallery.

Nicholls has been included in numerous group exhibitions since 1982, among them three shows at Roar Studios between 1982 and 1984, 'The First Look: Philip Morris Arts Grant Purchases 1983–1986' at the Australian National Gallery, 1986, and 'The Age of Collage' at the Holdsworth Contemporary Gallery, Sydney, in 1987. He also featured in two group shows in Dallas, Texas, in 1987 — 'Voyage of Discovery' at the Crescent Gallery and 'Australian Works on Paper' at Aion Fine Art — and was once again among the Philip Morris Art Grant Purchases at the Australian National Gallery in 1988.

The artist had his first individual show at Coventry Gallery, Sydney, in 1986 and his first solo show in Melbourne at 13 Verity Street in 1987. His most recent one-man exhibitions have been at 13 Verity Street in 1992 and at Coventry in 1993.

Nicholls is represented in the Australian National Gallery, the Robert Holmes à Court Collection, the Myer Collection, Grafton Regional Gallery, the Sir William Dobell Art Foundation and Shepperton Art Gallery.

Artist's Comment

My approach to art is to be as honest (open-minded) as possible, to create art using the basic principles, line, form and colour (light), to achieve spontaneity with my medium. Now that I have an understanding of the basic principles, art has become a form of gradual enlightenment in itself Figures can be abstracted, line varied and colour emphasised to give a particular work uniqueness.

To me, as an artist, it is a step-by-step process where I find myself knowing there is more to be explored.

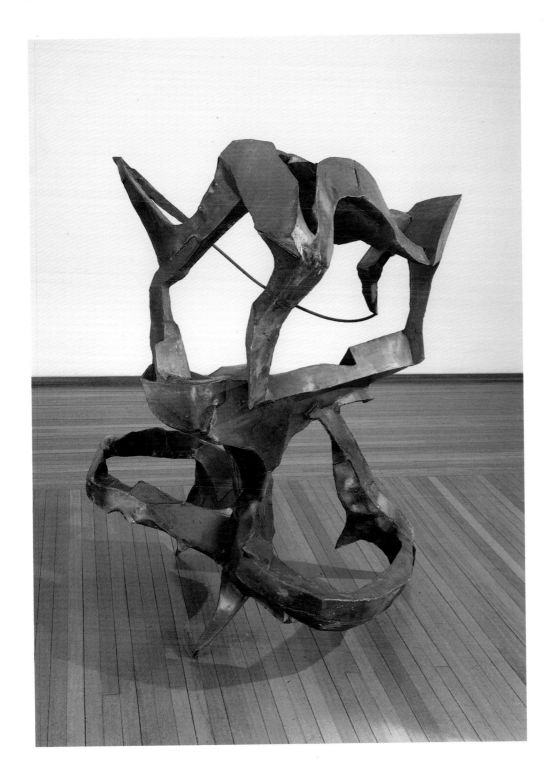

Tarantula, 1986,
Steel, 210 x 148 x 158 cm.
Photograph: Paul Green
Courtesy of Coventry Gallery,
Sydney

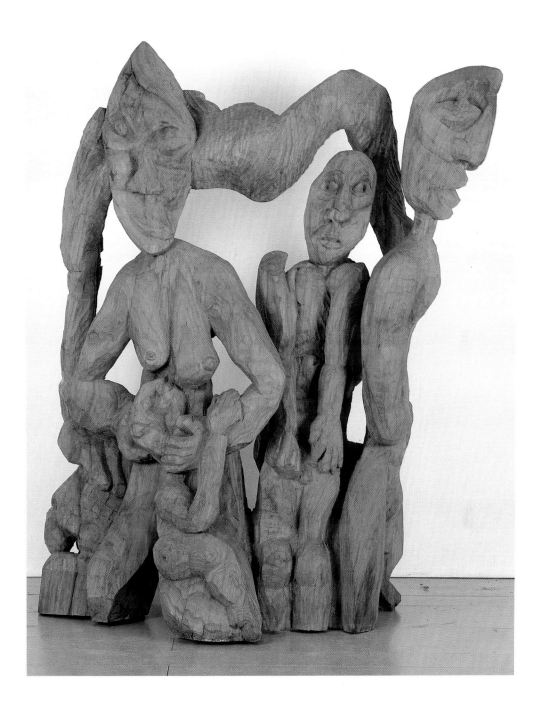

Family Picnic, 1987,
Carved wood, 142.7 x 119.7 x 63 cm.
Photograph: Jeff Busby
Collection of the artist
Courtesy of 13 Verity Street Gallery,
Melbourne

ROGER NOAKES

Portrait photograph: Michal Kluvanek

ROGER NOAKES was born in Sydney in 1954 and moved to Adelaide in 1974. After graduating from the South Australian School of Art in 1977, he was one of the major forces behind the establishment of the South Australian Workshop (S.A.W.) — an artists' co-operative designed specifically for the needs of sculptors. For a decade — from 1978–88 — Noakes worked at S.A.W. until moving to a studio at his home. During this period large scale installations dominated his art practice, including floatile works exhibited in the sea, installations in the parklands during the Adelaide Festival, and temporary works shown at Carrick Hill. More recently, Noakes' public sculptures and commissions have received high critical acclaim, as have his object-based sculptures. In 1993 he won a Samstag International Scholarship enabling him to further his studies for a year abroad.

Noakes held his first individual exhibition — a floatile sculptural installation — at South Glenelg Beach in 1977, and has had several further one-man shows, the most recent at Space Studios, London, in 1988. He has also been included in a number of group exhibitions over the last five years, among them 'Monuments' at the Contemporary Art Centre, Adelaide Festival of Arts, 1988, the 4th Australian Sculpture Triennial, Melbourne 1990, and a mixed show at Greenaway Art Gallery, Adelaide, in 1992. He is represented in the collections of the Australian National Gallery, the Art Gallery of South Australia, Mildura Arts Centre, the University of South Australia and Flinders University, as well as in private collections in Australia and the USA.

Artist's Comment

The visual physicality of form and the context and diversity of materials have always intrigued me. Working in a three-dimensional mode provides more opportunity to innovate and challenge, and to discover a different language amongst the ephemeral visual signs and cliches thrown up by mass media culture.

My early works were of an environmental nature and used the colour, light and physicality of the Australian landscape. In my recent work the thematic interests are concerned with invoking a human spirituality and context to found and hand-forged steel/metal objects and other detritus of the industrial age. The presentation of this work is in formal sculptural styles. To make artworks that are visually interesting, with a focus on a conceptual context, is very important to me.

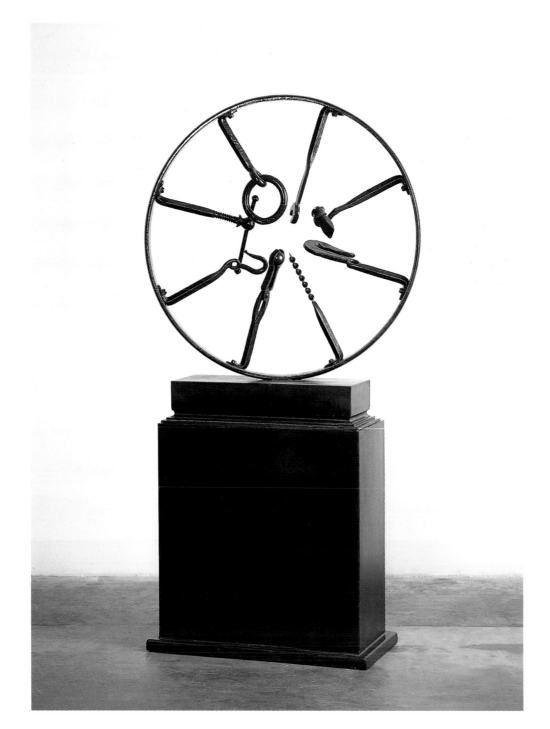

An Illustrated History of Things, 1992,
Found objects, steel and metal
lacquer,
78 x 32 x 22 cm.
Photograph: Michal Kluvanek
Courtesy of Greenaway Art Gallery,
Adelaide

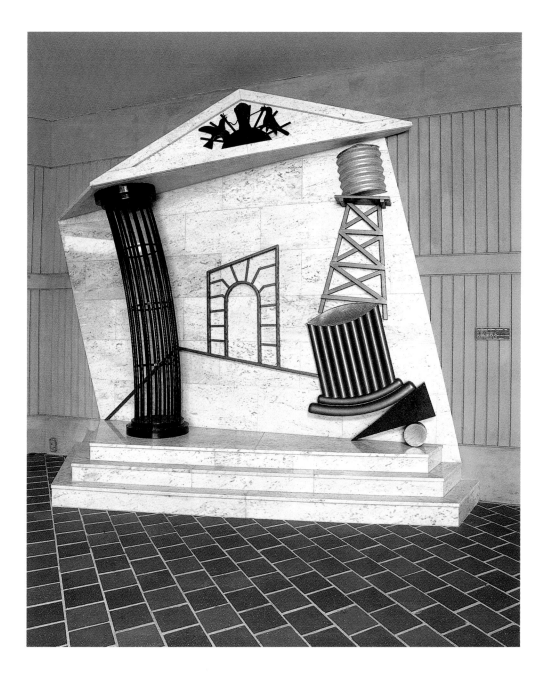

Unchartered Monument: Pastoral,
1990–1991,
Marble, steel, paint and granite,
4 x 3.8 x 1.2 m.
Photograph: Michal Kluvanek
Courtesy of Greenaway Art Gallery,
Adelaide

LESLIE OLIVER

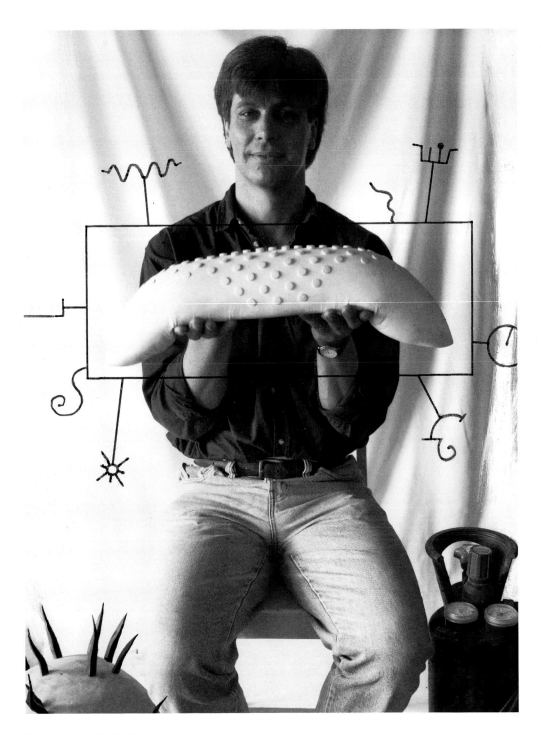

Portrait photograph: Eva Stoop

LESLIE OLIVER was born in Leeton, New South Wales, in 1954. After finishing school he studied architectural and mechanical draughting for four years and then attended Alexander Mackie College of Advanced Education from mid 1977–81, graduating with a Diploma in Art. From 1982–85 he studied at the Australian Film and Television School for his Bachelor of Arts degree in Film and Television Directing, and in 1984 also worked as a guest lecturer in Video at the Gloucestershire Institute of Art and Technology.

Since then Oliver has worked as an art teacher at St Aloysius College Sydney, 1987–88; as a part-time lecturer at the Catholic College of Education, Sydney; and as a part-time tutor in Sculpture at Waverley-Woollahra Arts Centre, 1990. He was awarded a script development grant from the Australian Film Commission in 1990 and in 1992 directed the feature film, *You Can't Push the River*. However, he still finds time to exhibit his innovative and imaginative sculptures. He has featured in a number of mixed and two-person exhibitions since 1973, including 'A Survey of Australian Sculptors' at Sydney's Irving Sculpture Gallery in 1981 and 'Four in Hand' at New South Wales House, London, in 1984, and has had three individual shows at Access Gallery, Sydney, the most recent in May 1993. He is represented in the collections of the University of New South Wales' Fine Arts Department, Artbank and in private and corporate collections in Australia and the United Kingdom.

Artist's Comment

I aim to construct or form objects that have an aura of flux about them — that allude to our tangle with time. I like embodying items collected from a lost past and fusing them into a fixed moment that projects some future action. By doing this I am seeking to create a drama where time, matter and space combine to shuffle our thoughts and expectations: I say 'drama' because of the narratives these objects play out across the surface of the table, as if they were in a landscape or on a stage. These dramas encourage empathy as we follow or imagine the course of the objects' struggle or feel their tenuous balance. The narratives are circular — contained within the works — though through allegory or associations they touch on our own personal stories.

I feel it is important that the sculptural works make good use of the material world to form their status. These elements include the surface on which they rest, glide or stand; the gravity against which they push, or rise, or to which they succumb; the space in which they swim, stir or languish, and the materials from which they are wrought. These are the stresses which bind these materials into form.

My films and sculptures attempt to be icons of hope. I celebrate the eternal in mortality.

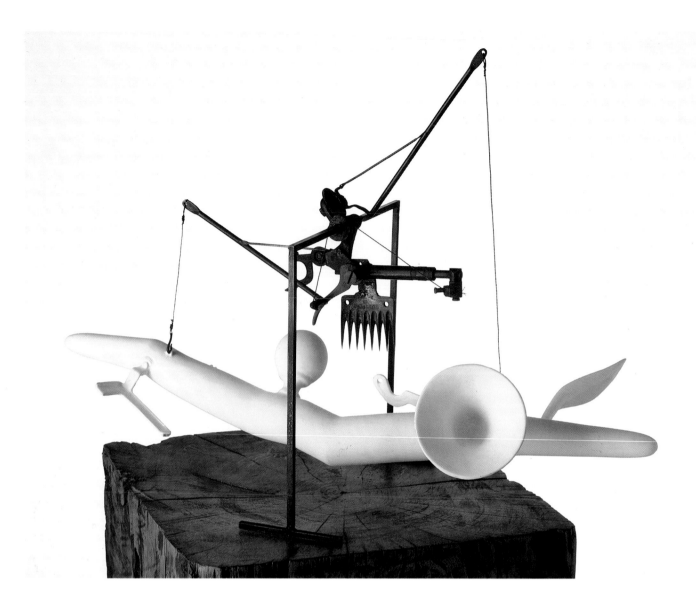

Cradle, 1991,
Copper plated welded steel, wood, epoxy resin,
35.5 x 50 x 30 cm.
Photograph: Paul Green
Collection: Artbank
Courtesy of Access Contemporary Art Gallery, Sydney

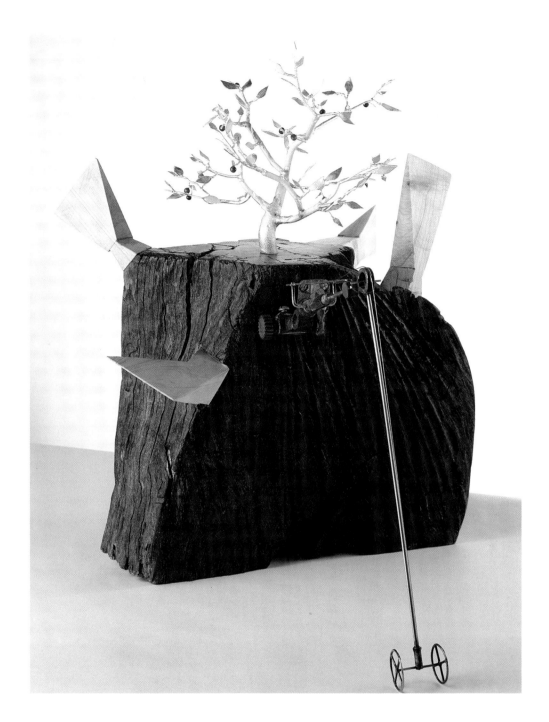

Seeking Roots, 1991,
Gold plated welded steel, agates,
brass, stainless steel and mixed
timbers, 46 x 45 x 40 cm.
Photograph: Paul Green
Collection: Artbank
Courtesy of Access Contemporary
Art Gallery, Sydney

ROBERT PARR

Portrait photograph: Martin Pieris

ROBERT PARR was born in Adelaide in 1923. In 1966 he became a part-time teacher of sculpture at Wollongong Technical College and in 1970 took up an appointment as part-time teacher at the National Art School, Sydney. Since 1972 he has been a lecturer in sculpture at Canberra School of Art.

Reflecting his early training in general engineering, Parr works in mild steel, copper, bronze and mixed media. His sculptures have a pleasing economy of form but are also imaginative — often parodying different art styles in a charmingly surreal way. Umbrellas, wheels and even plastic lemons have been incorporated into his sculptures along the way, and he has been known to produce rag dolls from sheetmetal and trees from steel posts.

Parr held his first one-person show at Barry Stern Galleries, Sydney, in 1964 and has since exhibited extensively around Australia, especially through Pinacotheca in Melbourne and Watters Gallery, Sydney. He has also been included in numerous group exhibitions, among them 'Sculpturescape 73' at Mildura; 'Australia 75' at the Australian Sculptors Gallery, Canberra; the 1976 'Ocker Funk' exhibition at Realities, Melbourne; the 7th, 8th and 9th Sculpture Triennials at Mildura, 1978, 1982, 1985; and the 'Sculpture Survey 1975–1985' at the South Australian School of Art, 1985. His most recent individual exhibitions were at Pinacotheca and Watters in 1991.

Parr is included in several collections, among them the Australian National Gallery, the Art Gallery of New South Wales, the National Gallery of Victoria, New Parliament House, Canberra, the Art Gallery of South Australia, the Art Gallery of Western Australia, the Museum of Contemporary Art, Brisbane, and most Regional Galleries in New South Wales.

Artist's Comment

I like to express my own experiences, and make the most of these experiences in a sculptural form.

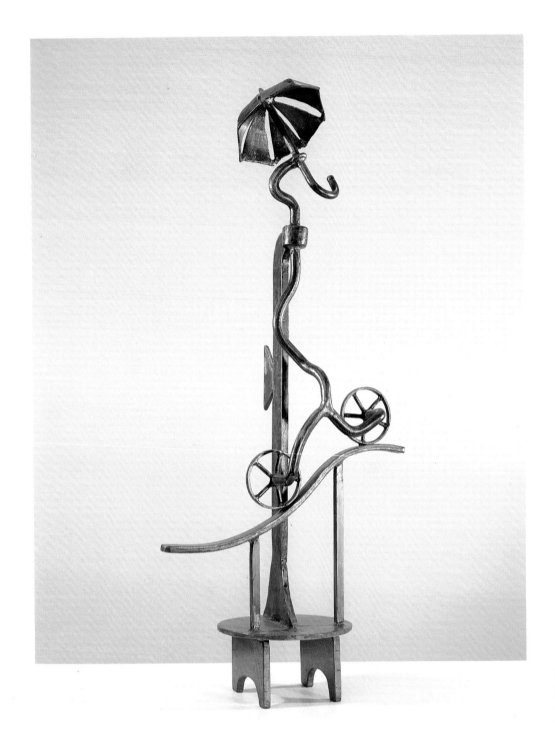

Balance, 1987,
Mild steel, 96 x 44 x 22 cm.
Photograph: Jill Crossley
Collection: G. Hassall
Courtesy of Watters Gallery, Sydney

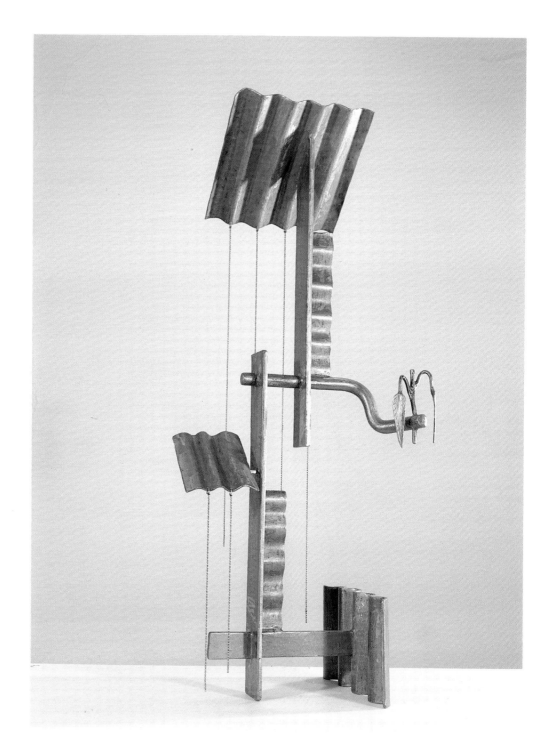

Lean To and Run Off, 1986,
Mild steel, 105 x 46 x 31 cm.
Photograph: Jill Crossley
Collection: Zoe Legge
Courtesy of Watters Gallery, Sydney

LYN PLUMMER

Portrait photograph: Rodney Browne

LYN PLUMMER was born in Brisbane in 1944 and studied initially at the Brisbane School of Art. After living in Papua New Guinea for several years, where she exhibited and taught, she resumed her studies at the Canberra School of Art, graduating in 1981. During her years in Papua New Guinea she was awarded a number of prizes, including the 1974 Rabaul Art Prize. In 1979 she was accepted into the Victorian College of the Arts' two-year Graduate Diploma to study sculpture. While at the VCA she also produced work for two solo exhibitions, at Ray Hughes Gallery in Brisbane and at Gallery A in Sydney, and developed a large installation for 'Sculpture Siege' at Heide Park and Art Gallery, Melbourne. After graduating she was invited to lecture part-time at the Victorian College of the Arts and was offered a lecturing position at the Charles Sturt University, School of Creative Arts, in Albury in 1985. She has been instrumental in developing the Degree in Visual Arts at the school as well as establishing a studio for regional and overseas contemporary artists. She was artist-in-residence at Cheltenham School of Art, England, in 1988, and in 1990 assisted in the establishment of a contemporary art gallery in Albury. She is currently undertaking a Masters degree through Monash University which investigates, among other things, the ways in which high ceremony is constantly underpinned by reference to sacrifice and the body.

Plummer's sculptural installations are fragile and elegant. The work is involved with the deconstruction of ceremony to provide a tableaux which analyses the myths surrounding the activities of the modern self. It deals with the concept that sexual instinct, tempered by its relationship with the threat of death and therefore sacrifice, is cloaked in rituals which provide it with a sense of legitimacy and a reason for perpetuating its needs. The fragile membranes which are juxtaposed against metallic, geometric forms, expand the notion that shrouds, veils and lusciously decorated raiments can be considered a substitute for the skin — the skin into which memory is embedded. Plummer's recent installations have included a sound component and those currently being developed will incorporate specially composed and performed scores.

The artist has had twelve solo exhibitions to date, and in 1990 was invited to prepare an installation for Gallery 14 at the Queensland Art Gallery. Director and composer Stephen Leek and VoiceArt executed a number of vocal performances in conjunction with this installation. Plummer has been included in a number of keypoint group exhibitions since 1982 and is currently preparing for two large installations at The Exhibitions Gallery, Wangaratta, and Benalla Art Gallery, Victoria.

Artist's Comment

The works explore the nature of, and underlying meanings enmeshed in, high ceremony — the ephemerality of the cognition of ritual. They explore the culturally received understandings of femininity and masculinity. The body is the keypoint of reference, both for the relationship to scale and to the concepts relating to skin — skin revealing the notion of sacrifice, sexuality and sensuality embedded in our myths and ceremonies.

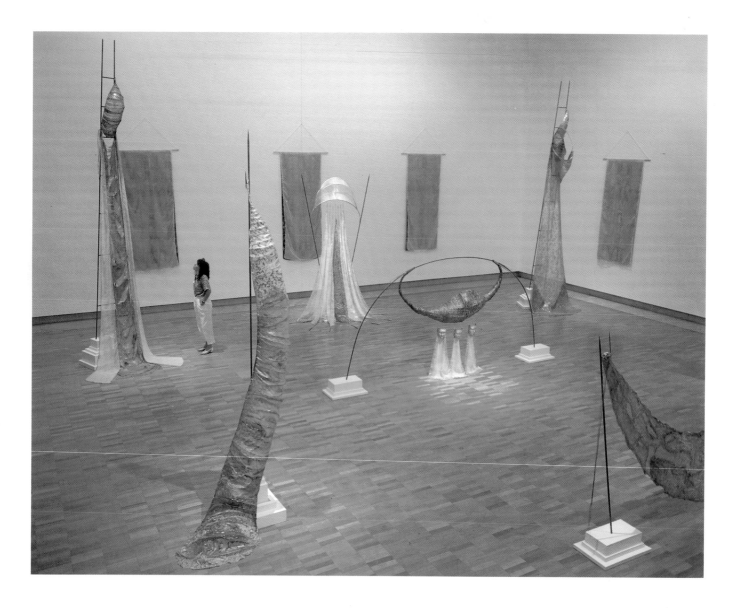

Endgame: A Simple Matter of Balance, 1990,
Seven sculptures, 2.0–5.2 metres in height,
Banners: 240 x 130 cm.
Photograph: Rodney Browne
Courtesy of the artist

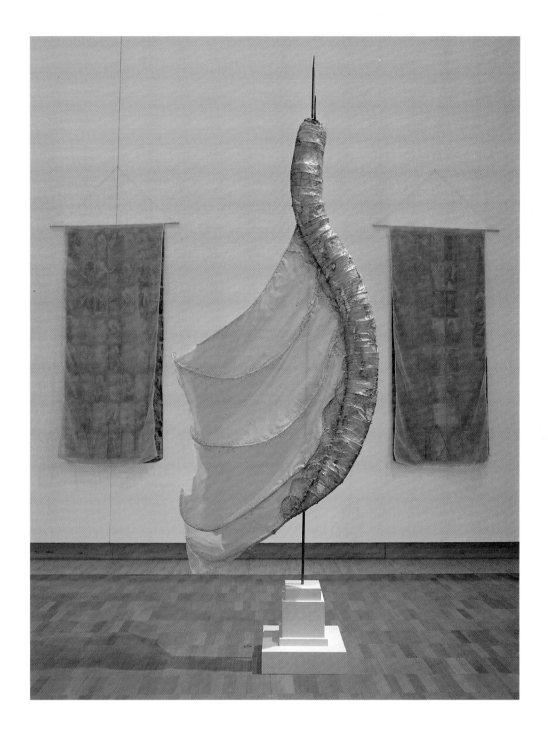

Knight of Aurelia, 1990,
Steel, tissue, fabric paint, wire,
timber base,
370 x 130 x 100 cm.
Photograph: Rodney Browne
Courtesy of the artist

EMANUEL RAFT

Portrait photograph: Sebastian Thaw

EMANUEL RAFT was born in Suez, Egypt, in 1938 and arrived in Australia in 1955. From 1956–59 he studied painting at the Bissietta Art School, Sydney, and in 1959–60 attended the Brera Academy, Milan, where he studied sculpture under Luciano Minguzzi. He gained a Master of Arts degree from the City Art Institute, Sydney, in 1986 and in 1989 was a studio resident at Cité Internationale des Arts, Paris.

Raft works both as a painter and a sculptor. His creations are usually bold, dynamic and colourful and often evoke a powerful mythic quality.

Raft's vision is very individualistic: his mixed-media sculpture *Celebration of the Last Flight* provides a disturbing and ironic commentary on a classical myth. Here is a fragmented Icarus, his wings shredded into lead strips and his body reduced to a timber shaft. On the other hand, his 1987 bronze sculptures, collectively titled *Muses*, project a feeling of totemic spirituality. Despite their small size, their jagged edges and strong, archetypal forms conjure a powerful presence and, as Robert Lawlor has observed, combine 'passion and proportional precision' with a feeling of 'natural geometry'.

In 1964 Raft won the 'Young Contemporaries' Art Prize for painting and in the same year was commissioned to design and execute a series of sculptural architectural panels at Wollongong Teachers College. Between 1969–73 he also experimented with environmental sculptures using straw bales, plastic and glass.

Raft held his first one-person exhibition at Barry Stern Galleries, Sydney, in 1962 and continued to exhibit regularly in the sixties and seventies in Sydney, Melbourne and Adelaide. His last five solo shows, 1986–1992, have been held at Coventry Gallery, Sydney.

The artist is represented in the Art Gallery of New South Wales, the Art Gallery of South Australia, the Australian National Gallery, The National Gallery of Victoria, Parliament House, Canberra, Goldsmiths Hall, London, Bathurst Regional Art Gallery and the Mertz Collection, Texas.

Artist's Comment

The process of a creative act and the finished product have to extend the mind and vision of the creator and the viewer, and elevate to that level of the sublime.

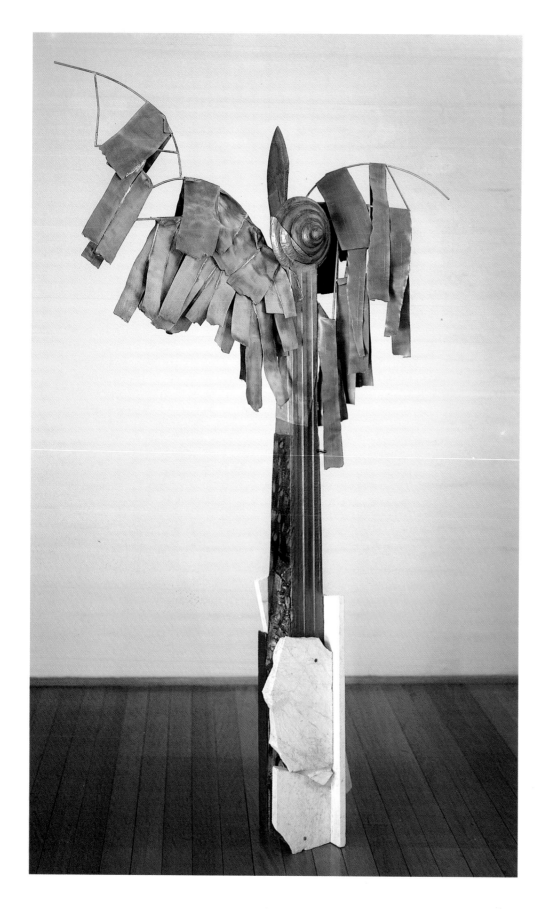

Celebration of the Last Flight, 1988,
Encaustic, lead, marble and timber,
216 x 123 x 38 cm.
Photograph: Fenn Hinchcliffe
Courtesy of Coventry Gallery,
Sydney

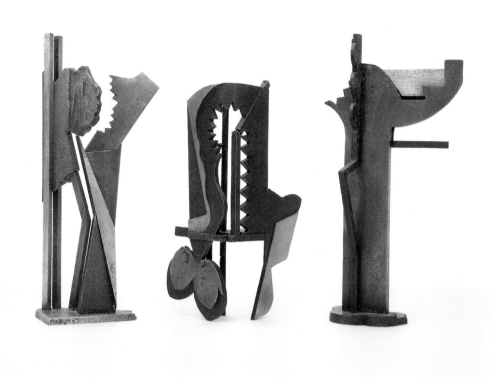

Muses, 1987,
Bronze, average height 28 cm.
Photograph: Fenn Hinchcliffe
Courtesy of Coventry Gallery,
Sydney

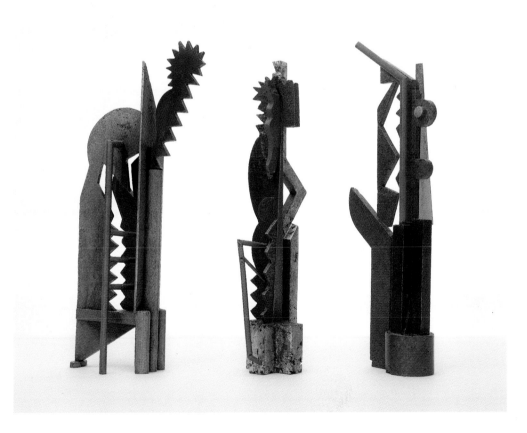

Muses, 1987,
Bronze, average height 28 cm.
Photograph: Fenn Hinchcliffe
Courtesy of Coventry Gallery,
Sydney

PETER RANDALL

PETER RANDALL was born in London, England, in 1961 and arrived in Australia in 1967. He studied at the Prahran campus of the Victorian College of the Arts from 1981–84, obtaining his Bachelor of Arts degree.

One of the most innovative young sculptors to emerge in Australia in recent years, Randall won the Powell Street Gallery Award, 1983, and the inaugural Sarah Weiss Award at the National Gallery of Victoria in 1989. The latter award, aimed at recognising the achievements of emerging sculptors, was given for *Double Archway* — a large expressionistic sculpture fashioned from crumpled and painted steel. While Randall's sculpture at this time focused mainly around the theme of doorways and archways — 'because they are fairly potent things' — his more recent work has been on both a large and miniature scale. *EXP 5*, produced in the same year as *Double Archway*, is one of his more imposing works, while *30 Pieces* consists of a series of small, crafted objects made of painted lead. However, it is difficult to draw Randall into explanations of why his art can be so different. 'I am not a talker, I am a sculptor', he said at the time of gaining the Weiss Award. 'It is easier to show an idea through a progressive series of works rather than trying to form sentences.'

Randall has featured in numerous group shows since first exhibiting at the 9th Mildura Sculpture Triennial in 1985. He was also included in 'Three Sculptors' at 70 Arden Street Gallery, 1987, in the Diamond Valley Art Award Collection, 1988 and 1989, the St Kilda Acquisition Prize Exhibition at Linden Gallery, 1990, and in 'Kangaroo', the Fourth Annual Invitation for Outdoor Sculpture at the Kangaroo Ground, Melbourne, 1990.

In 1992 Randall collaborated with artist Domenico De Clario and architect Greg Burgess to produce a structure for an exhibition dedicated to the late Professor Fred Hollows. He has also produced decorative steel works for Melbourne City Council and on various occasions has created music for art performers.

Randall is represented in Colac Sculpture Park and in various private collections.

Artist's Comment

My sculptures are usually large in scale. I work mainly with steel or cardboard and like the idea of building an object that is its own world. I also enjoy working in a number of different media and attach importance to being able to use my skills as an artist in as many areas as I can.

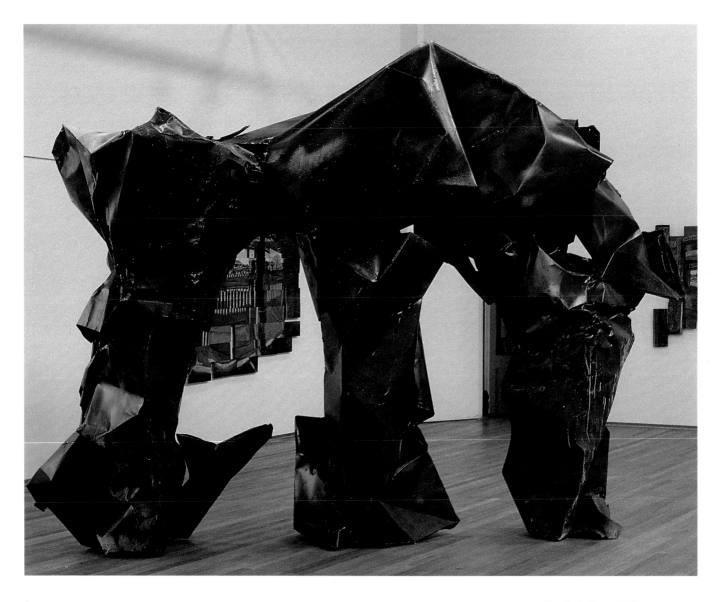

Double Archway, 1989,
Sheet metal, 270 x 322 x 120 cm.
Courtesy of the artist and Judith Pugh
Gallery, Melbourne

EXP 5, 1989,
Sheet metal, 300 x 350 x 80 cm.
Courtesy of the artist and Judith Pugh
Gallery, Melbourne

ANN-MAREE REANEY

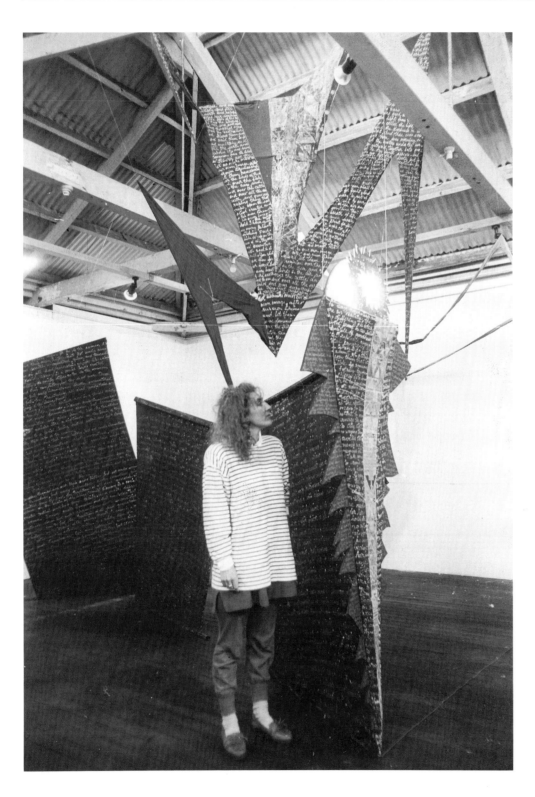

Portrait photograph: G.Gilmour

ANN-MAREE REANEY was born in Maryborough, Queensland, in 1959. She studied for her Diploma in Visual Arts at Darling Downs Institute of Advanced Education, Toowoomba, from 1979–81 and gained a Master of Fine Arts degree from the University of Tasmania in 1985. She tutored in Drawing at the University of Tasmania, and completed her Diploma in Education there in 1987. She was artist-in-residence at Bunbury Regional Art Gallery, Western Australia, in 1987 and was awarded the Cité Internationale des Arts studio residency in Paris in 1988. During the last three years she has been lecturing at Queensland University of Technology, Brisbane, and the University of Southern Queensland.

Reaney's sculptures and installations deal with the symbolic frameworks within a culture or society. Her earlier work was strongly influenced by her contact with women in North Africa and the Middle Eastern countries, and in 1986 with the Aboriginal women of Mornington Island in the Gulf of Carpentaria. Her sculptures have much less to do with any concept of creating monuments or precious forms than with questioning our cultural assumptions about the role of art in society. Her works have even been described as 'anti-sculptures': often seemingly incomplete, they can be flimsy, fragile, confronting and disturbing. Constructed often from the simplest of materials — sticks, bamboo, calico, wire, fibreglass, wax and paint —Reaney's most recent works have also explored new materials such as manicured turf, red roses and coal.

Reaney has been included in a number of group exhibitions since 1981, including 'Early Efforts', the Bicentennial Exhibition at the Chameleon Gallery, Hobart 1988, and two shows in Paris the same year: 'Exposition Collective' at Cité Internationale des Arts Galerie and 'Shards of Consciousness' at Cannibal Pierce Galerie Australienne, St Denis. She also featured in 'Not Another Archibald' at Roz MacAllan Gallery, Brisbane, in 1989, and had a solo show, 'Object d'Art' in 1990. She has had eight one-person shows since 1985, the most recent, 'Epistomology — Manicure/Epicure', at Art Site Gallery, Brisbane 1991, as part of the FULCRUM project assisted by the Victorian Arts and Craft Board of the Australia Council. In this installation questions of viewpoint, framing, perception, and ultimately the subjectivity inextricable from all framing (viewing) practices are questioned with regard to the discourse which has been constructed around installation. The introduction of materials ephemeral in Nature, such as red roses and manicured turf reminiscent of 19th Century picturesque parks in England and Europe, and the introduction of highly decorative elements, suggests that environments, spaces and objects are only ever constituted through a framing action.

Artist's Comment

To paraphrase Marx — women make themselves and their own history, but they do not make them under circumstances chosen by themselves, but under circumstances directly encountered, given and transmitted from the past. Installation work offers me the opportunity of working within a designated space, using the structures of the gallery or site to install figurative work and to fill that space with meaning through the positioning of elements such as walls, corridors, obelisk-like structures and figurative works.

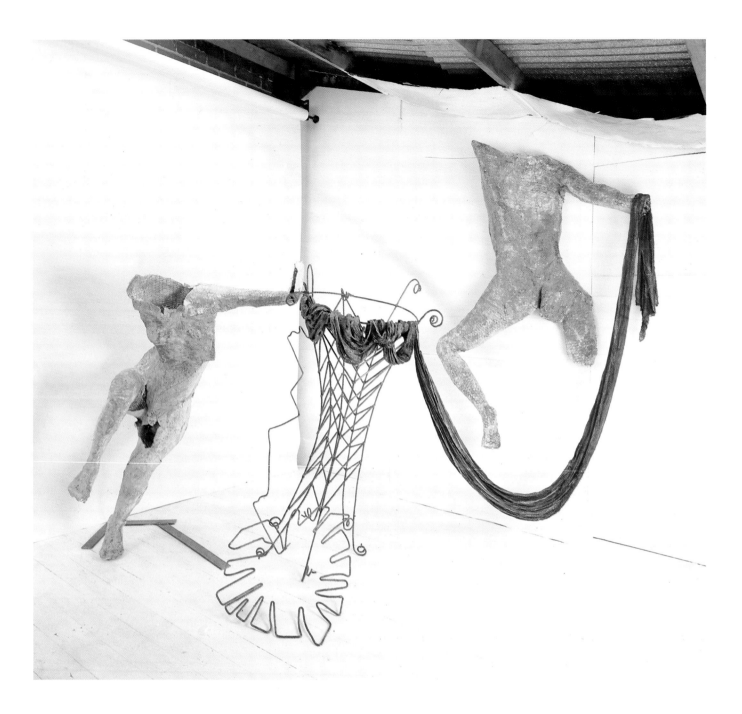

Femina (detail), 1989,
Steel, plaster, shellac, wax, fibre,
resin, fibreglass, dyes and paint
Photograph: Offe Schulz
Courtesy of the artist

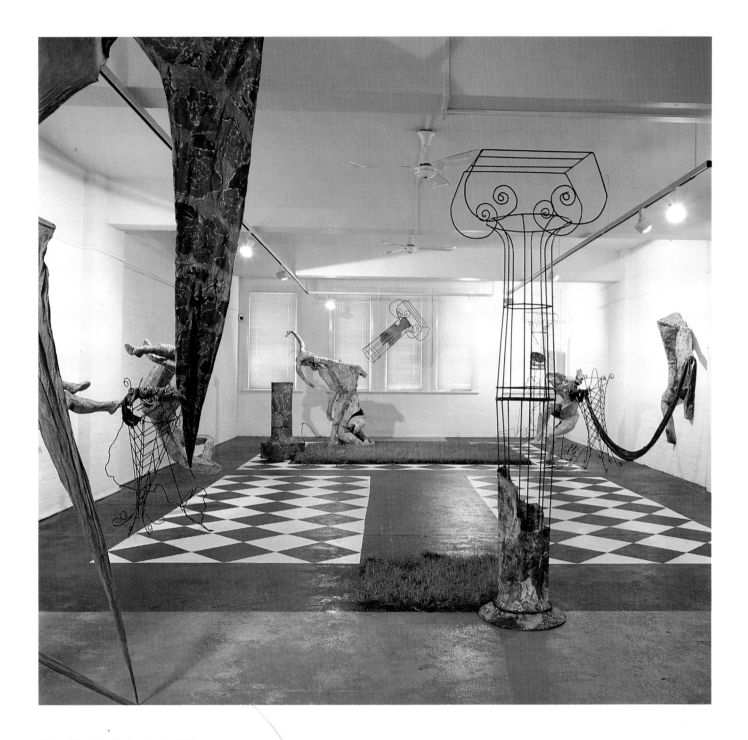

Object d'Art (installation view), 1990,
Steel, plaster, fibreglass, fibre, paint,
wax, dyes, shellac
Photograph: Rod Buchholz
Courtesy of the artist

COLIN REANEY

Portrait photograph: David Sandison

COLIN REANEY was born in Maryborough, Queensland, in 1952. He studied for his Diploma in Visual Arts at Darling Downs Institute of Advanced Education, Toowoomba, from 1980–82 and gained a Master of Fine Arts degree from the University of Tasmania in 1986. He then tutored in Painting at the University of Tasmania. In 1988 he was awarded an overseas studio grant by the Visual Arts/Craft Board of the Australia Council and took up residence at Besozzo, Italy — where he prepared his spectacular installation *L'Effimero Monumentale (Monument Ephemeral)* — illustrated here. He became a lecturer in Sculpture at Darling Downs Institute (now the University of Southern Queensland) in 1989 and while on leave from University duties (1990–93) travelled widely in France, Italy, the United Kingdom and the USA, exhibiting and teaching. It is perhaps this time — which Reaney sees as being an important period, the 'teaching period' — that has seen a consolidation of ideas and concerns and at the same time a broadening of the basis of his works — looking at the effectiveness of his practice within the context of art as a cultural record and as part of the wider pictorial history.

To describe Reaney simply as a painter and sculptor is to do him no justice whatever, for he creates environments. And his particular approach to installations is both innovative and exuberant: his walls, ceilings, doors and columns blaze with an array of bold colours and polka dots.

Reaney installed *L'Effimero Monumentale* in the Gallery Studio at Brisbane's Museum of Contemporary Art for an exhibition in 1988. Here he sought to utilise the formal designs and prolific use of decoration found in European ancestral homes but in a way that was both humorous and idiosyncratic. The result was a surreal blend of formal architectural styles with a zany mix of vivid reds, blues and yellows. If European living rooms and dining halls are a reflection of social identity, Reaney was certainly turning this tradition on its head by creating a room that in every way defied convention.

Reaney followed his MOCA installation with an exterior installation at Cannibal Pierce Galerie, St Denis, Paris, in 1988, and an exhibition titled 'In the Secluded Enclosure of a Domestic Utopia' at Roz MacAllan Gallery, Brisbane, in 1989. His *Madonna of the Rosary*, shown here, was displayed in a Brisbane solicitor's office as part of a drive by Queensland Art Gallery for greater private sector sponsorship of the arts.

Artist's Comment

During the last three years teaching has effectively called into question many of my ideas about art as practice, and one based on pictorial history. I am more conscious of what Geoffrey Batchen has referred to as 'the desire to make visible one's mode of presentation and an emphasis on the importance of the act of looking'. To simultaneously construct and pull apart — enouncement, the act of uttering — representation, presentation.

In the '80s the site and temporality of my works were important. In my latest work I've been looking at what the object is, how we know it and what it means to know it, how things are known — and in a broader sense questioning the Platonic notion of beauty and the historical consequences of this notion of Art History or any reading of Art.

Madonna of the Rosary, 1989,
Canvas, wood and paint
Photograph: David Sandison
Courtesy of the artist

L'Effimero Monumentale, 1988,
Wood, canvas, paint and found objects,
450 x 500 x 500 cm.
Photograph: Rod Buchholz
Courtesy of the artist

JAMES ROGERS

JAMES ROGERS was born in Quirindi, New South Wales, in 1956 and studied for his Diploma of Creative Arts (Sculpture) in 1977–79 at Darling Downs Institute of Advanced Education. He has been teaching sculpture part-time at the National Art School, Sydney, since 1987.

Rogers has attracted attention in recent years for his dramatic and evocative steel sculptures. Influenced, perhaps, by Anthony Caro and David Smith, Rogers hovers somewhere between pure abstraction and semi-representational styles of construction, his works usually consisting of sections of flat sheets of metal, bars, slats or tubing. Sometimes he uses weathered fragments for textural contrast — examples of this are *Pick Up* and *The Bath*, reproduced here — while on other occasions his works feature barbed, jagged forms or rusty blades — as in his powerful work *The Window Box*, which is dominated by large steely petals, bursting forth from a supporting frame. Rogers' constructions have been called 'acrobatic' and 'thrusting' — 'aesthetic weapons that cut down prejudices'. They are certainly confronting and challenging works that have an arresting presence, despite their often simple form.

Rogers has featured in several group exhibitions since 1979, the most significant being 'Seven Sculptors' at A.E.I. Gallery, Sydney, in 1982 and 'Sculptors at the Table' at the Craft Centre Gallery, Sydney, in 1989. He has had five individual exhibitions at Coventry Gallery, Sydney — the most recent in 1993 — and is represented in the Darling Downs Institute of Advanced Education, Macarthur College of Advanced Education, the Robert Holmes à Court Collection and Artbank, as well as in many private collections.

Artist's Comment

My sculpture is mined out of the accumulated pile of influence which arises from living and working in Sydney. It is made to be evocative of things both visual and physical that I have known.

The elements in my work that don't quite summon complete recognition may perhaps be dealt with in terms such as image, proportion, structure or material, but those alone are not the rich strike.

Working on the sculpture is where I dig out the experience. The view may open at any stage. I don't feel the need to document my mental activity as it is the physical testing that keeps me on track.

What survives are pieces where, at the time, I found something sculptural had come about, and that was a surprise for me.

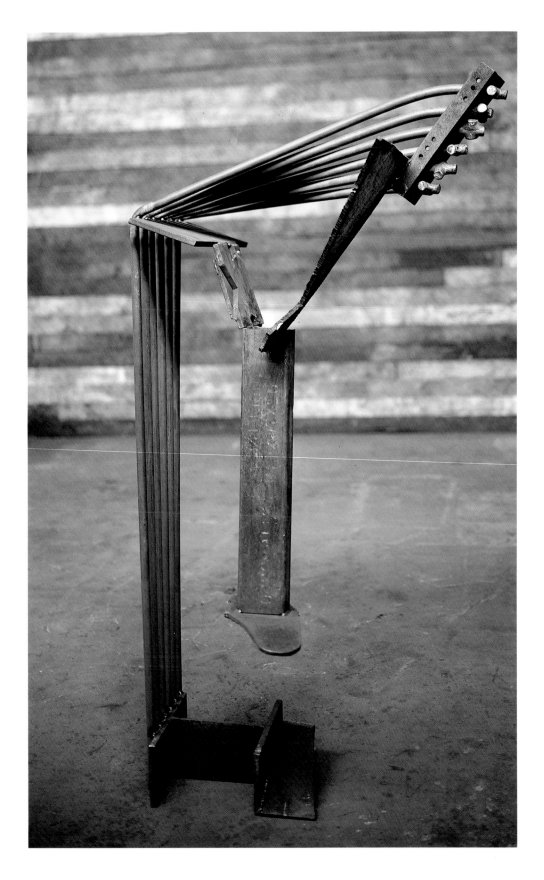

Pick Up, 1987,
Steel, 156 x 75 x 55 cm.
Photograph: Fenn Hinchliffe
Private collection, Sydney
Courtesy of Coventry Gallery,
Sydney

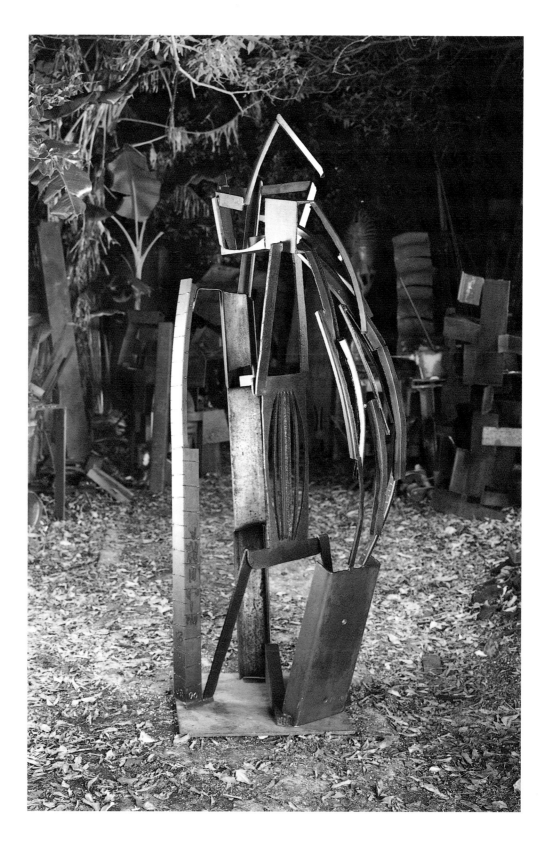

The Bath, 1991,
Steel, 214 x 92 x 49 cm.
Photograph: Paul Green
Collection: University of New South
Wales
Courtesy of Coventry Gallery,
Sydney

MONA RYDER

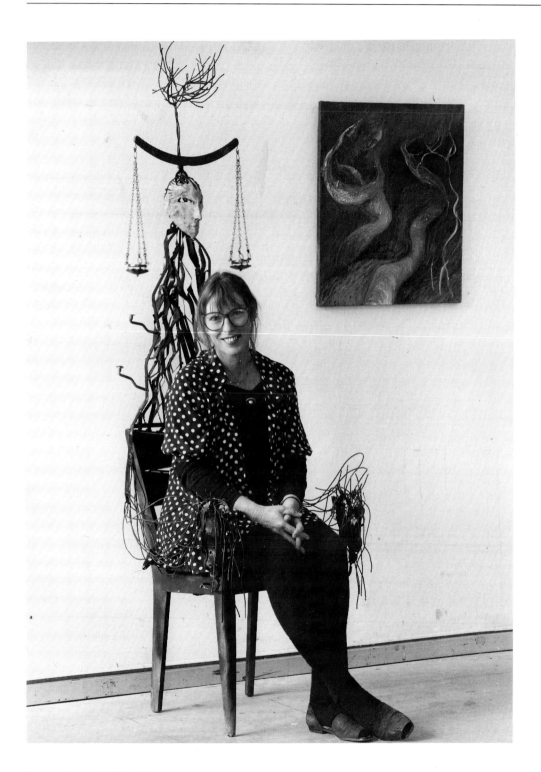

Portrait photograph: Richard Stringer

MONA RYDER was born in Brisbane in 1945. From 1976–80 she studied at the Kelvin Grove campus of the Brisbane College of Advanced Education, gaining an Associate Diploma of Visual Arts (Printmaking). She then taught at Queensland University of Technology from 1981–87 before spending three years in Perth. In 1988–89 she taught Painting and Drawing at Curtin University and in 1989 was also artist-in-residence at Claremont School of Art. She later returned to Queensland and is now a part-time lecturer at Griffith University on the Gold Coast.

Ryder has explored a variety of media, including drawing, painting, sculpture, book illustration, printmaking, embroidery and weaving. In 1985 she was included in *Perspecta*, and as Sarah Follent observed of her art: 'Ryder's works are based on her responses to the people and events of her immediate environment, and are usually handled with a sense of open ended, at times enigmatic, semi-narrative. This, combined with her use of cumulative symbolism, gives the viewer a number of positive ways to read each work.'

Because Ryder has preferred to work at home amidst daily family routines, her art has contained often quite potent references to her views on relations between the sexes and also to perceptions about women and domestic violence as a whole. And yet her work is not without humour. Ryder's sculptural pieces are often quite bizarre and her paintings and etchings are frequently tinged with satire and wit. In the mid-'80s she became well-known for the domestic bric-a-brac she was able to transform into art: rotary hoe blades, axe handles, sieves, broken heaters, dilapidated ironing boards and old soup containers all played a part.

Ryder's most recent mixed-media works utilise a variety of materials, including metals, plastics, chrome, wood, paint and vinyl, and continue to reflect the various roles of women in society. Many of her forms are overtly or subtly sexual, exploring the intriguing undercurrents in human interactions. 'Underneath a veneer of sophistication,' she observes, 'we are often primitive in our behaviour towards each other.'

Paradise Lost and *The Tattooed Man*, shown here, are part of a larger installation and reflect this perspective. 'These pieces,' she says, 'speak of sex, Nature, violence and domesticity — the works have the feeling of being strapped or held back, but ready to strike if set free.'

Ryder has won several awards, including a Visual Arts Board Studio Grant, enabling her to go to Vence in southern France in 1986, and the Andrew and Lillian Pedersen Memorial Prize in 1987. In 1990 her work was included in the Gold Coast Festival of Sculpture at the Centre Gallery and in 1992 she exhibited at Heide Park. She is represented in the Australian National Gallery, Queensland Art Gallery, the South Australian State Library, the Gold Coast City Art Collection and the University of Queensland, as well as in regional gallery collections throughout Australia.

Artist's Comment

My work is a reflection of people and situations — there is a never-ending reinterpretation of my physical and psychological environment.

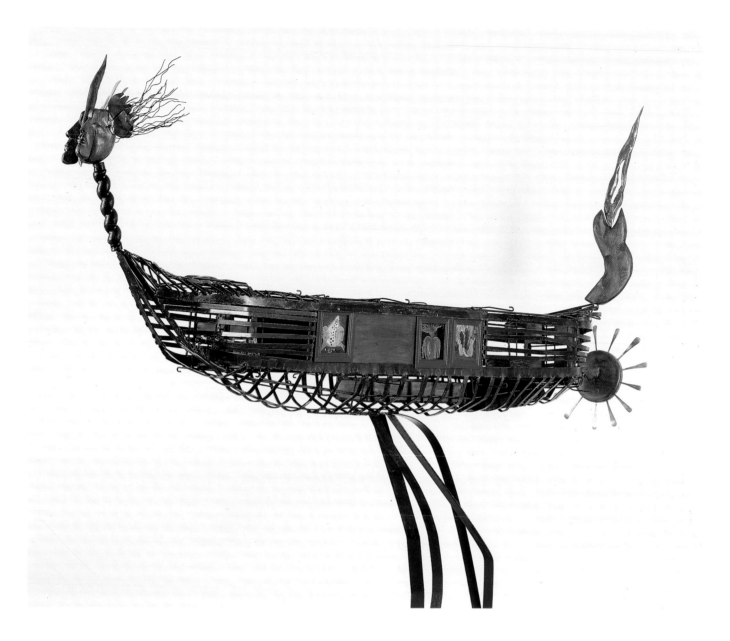

Fluid Passage, 1990,
Steel, wood, glass paintings, gold leaf, lead
book, painted canvas, vegetables, spoons,
250 x 50 x 198 cm.
Photograph: Richard Stringer
Courtesy of the artist

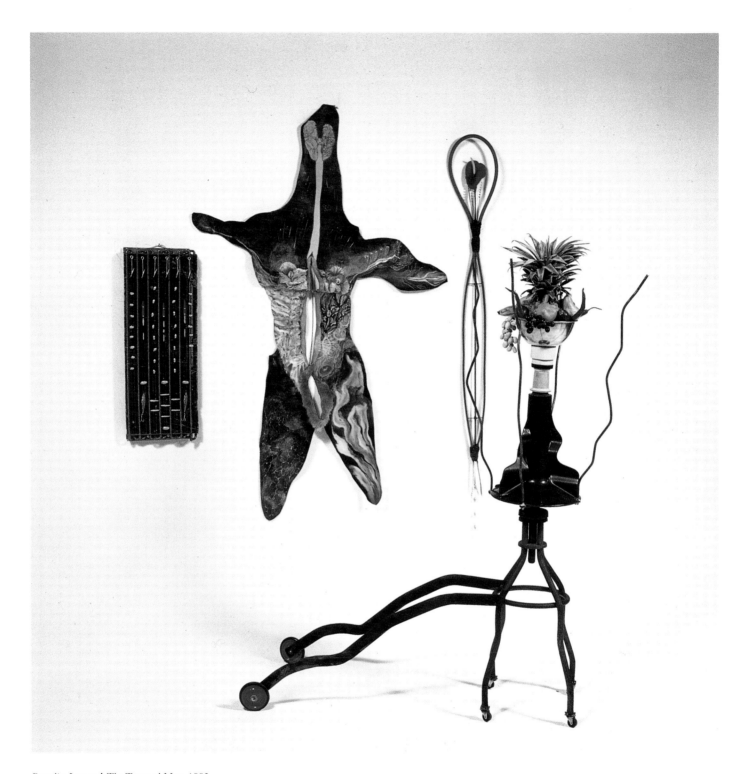

Paradise Lost and *The Tattooed Man*, 1992,
Radiator, car spray paint, fur, hooks, lures,
leather, dye, rubber hose, kitchen tongs, silk
flower, steel, washing machine agitator, plaster,
Approx. 1.9 x 2.1 x 1.8 m.
Photograph: Studio Sept.
Courtesy of the artist

MANNE SCHULZE

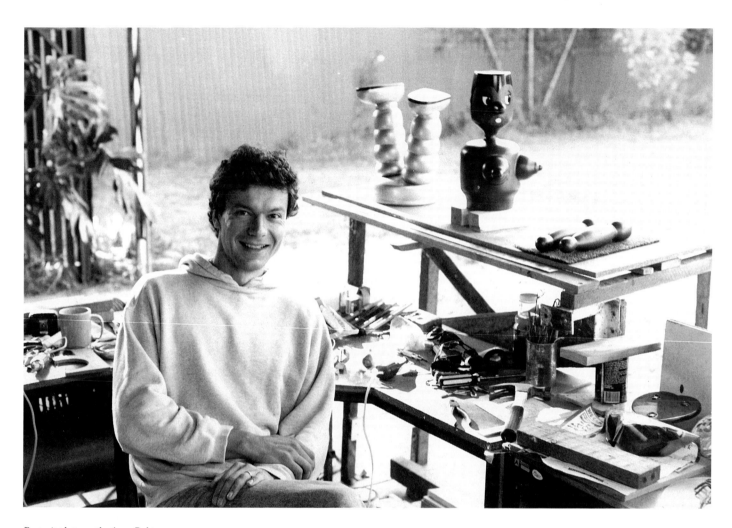

Portrait photograph: Anna Ralston

MANNE SCHULZE was born in Augsburg, Germany, in 1957. He studied biology at the Technical University of Munich from 1980–82 and during this time started painting in a surrealist style. He also took up experimental photography and became involved in running an 'alternative' cinema.

In 1985 Schulze completed a Master of Science degree in neurophysiology and photography, and in 1986 commenced a PhD at the University of Calgary, Canada. However within his first year there his passion for art overtook his interest in science and he left Canada for Australia, to start a new chapter of his life as a full-time artist. Since 1988 he has been based in Adelaide, and has become a member of the South Australian Workshop (SAW) artists' co-operative.

Schulze has moved from producing paintings and photographs to creating three-dimensional wall pieces and free-standing sculptures — all meticulously crafted and brilliantly coloured. His work is cheeky and often provokes spontaneous laughter with its bizarre and ironic juxtapositions of popular images and stereotypes. As one curator has observed, the sculptures are 'sick, slick and very serious'.

The artist's Bavarian origins are betrayed by the Baroque flavour that permeates many of his wall assemblages. In a recent development he has applied his scientific skills to incorporate hi-tech electronics into his figures. This 'Frankensteinian' attempt at animation stems from his fascination with cybernetics and the exchangeability of human for robotic parts.

Schulze hed his first solo exhibition at the Club Foote Gallery, Adelaide, in 1989 and has had one-man shows in Adelaide every year since then, as well as in Melbourne in 1991. A winner of *The Advertiser* Award of Excellence at the Adelaide Festival Fringe, 1990, Schulze has participated in numerous group shows, including the 'South Australia State Exhibition' in Himeji, Japan 1989, and a 'True Love and Other Stories' at Gallery Stendhal, New York 1991. His most recent individual exhibition was at the Greenaway Art Gallery, Adelaide.

Artist's Comment

My work is about the non-linearity, twists and ironies of daily life. These particular sculptures are stereotypical gestures of human behaviour, extending beyond the frame of the traditionally perceived comic-strip genre.

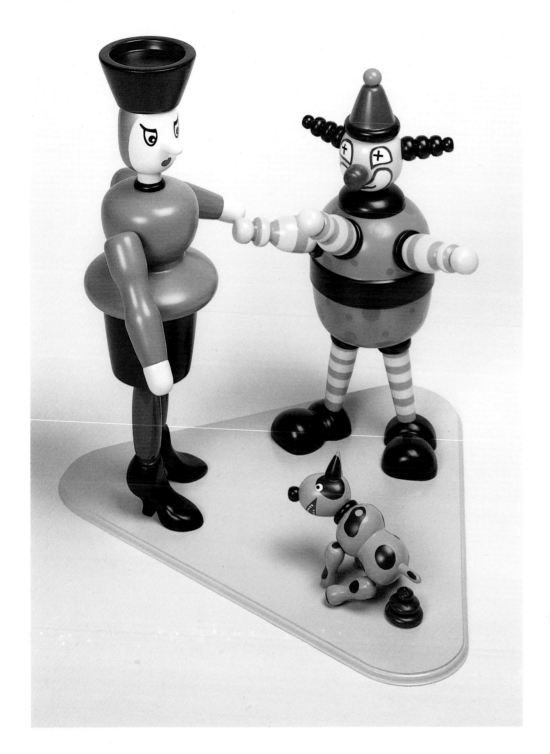

Bye Bye, 1992,
Polychrome wood,
86 x 82 x 76 cm.
Photograph: Michal Kluvanek
Courtesy of Greenaway Art Gallery,
Adelaide

Supamander, 1992–93
Polychrome wood, electronics and
fibreglass,
90 x 46 x 56 cm.
Photograph: Michal Kluvanek
Courtesy of Greenaway Art Gallery,
Adelaide

STEPHEN SKILLITZI

STEPHEN SKILLITZI was born in London, England, in 1947 and arrived in Australia in 1950. A versatile and imaginative artist working with glass, Skillitzi studied at the National Art School, Sydney, 1965–66, and in 1967–68 gained scholarships to attend the Brooklyn Museum Art School in New York and the Haystack School of Crafts in Maine. He subsequently studied for his Masters degree in Fine Art at the University of Massachusetts, 1968–70, under specialist glass teacher Lyle Perkins.

After returning to Australia, Skillitzi played a key role by introducing the American Hot Glass Studio Movement to the local art scene. He later helped develop degree-level glass studies at the South Australian College of Advanced Education and in 1982 established the Glass, Earth and Fire Studios for kiln and furnace glass projects, ceramics and electroplating.

Now considered one of the most influential teachers of glass techniques in Australia, Skillitzi is very much concerned with the important relationship between clay and glass technology and aesthetics. During the 1960s and '70s he worked primarily on clay and melted glass sculptures but in the late 1980s headed in a new direction — producing a three metre-high coloured glass and stainless steel fountain and a monumental 125 kg cast glass panel with human facial images. His current works are almost exclusively symbolic or allegorical figurative works utilising lost wax kiln-cast glass with various metal electroforms.

Skillitzi has held over thirty solo exhibitions since his first one-man show at Aladdin Gallery, Sydney, in 1967. Since then he has had further individual exhibitions in Sydney, Melbourne, Adelaide, Perth, Hobart, Brisbane, Canberra, New York and Houston. He has also featured in important international group exhibitions in London, New York, Canada and Japan and participated in the 18th and 19th Annual Invitational Exhibitions at Habatat Gallery, Detroit, in 1990 and 1991. Skillitzi is represented in the Australian National Gallery, Canberra, and in regional, institutional and private collections in Australia and overseas.

Artist's Comment

The specific inspiration for Monument to a Lost Culture *was a Central American ziggurat — a platform of veneration. The gods are impassive: here is an ancient site in a state of decay, yet radiant still! And for the work* War Zone — Kristallnacht revisited — *history's lesson is relived. Society's indifference to suffering allows destructive values free rein. Noble gold is enduring, base copper encroaching. Time softens the impact. Thus diaphanous glass and textural metal are seen to be ideal for these issues of society and spirit.* War Zone *was given a Silver Award in a 1992 International Competition which attracted over one thousand artistic works.*

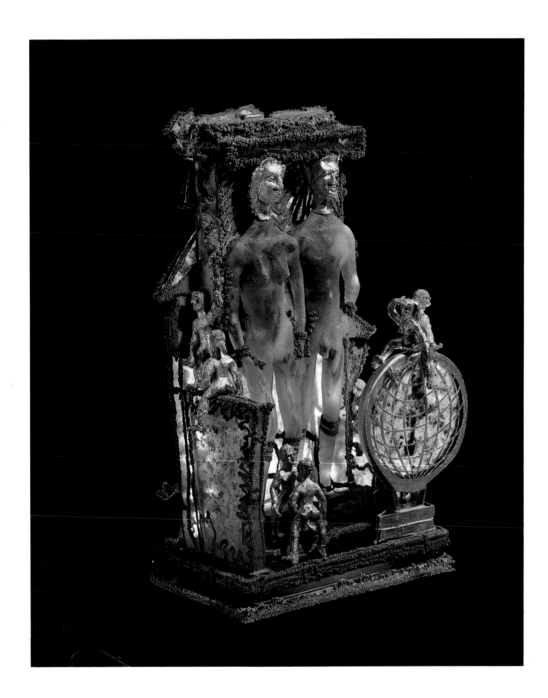

War Zone, 1990,
Lost wax kiln-cast glass, copper
electroforming, nickel, gold,
80 x 50 x 30 cm.
Photograph: Michal Kluvanek
Collection of the artist
Courtesy of the artist and Kensington
Gallery, Adelaide

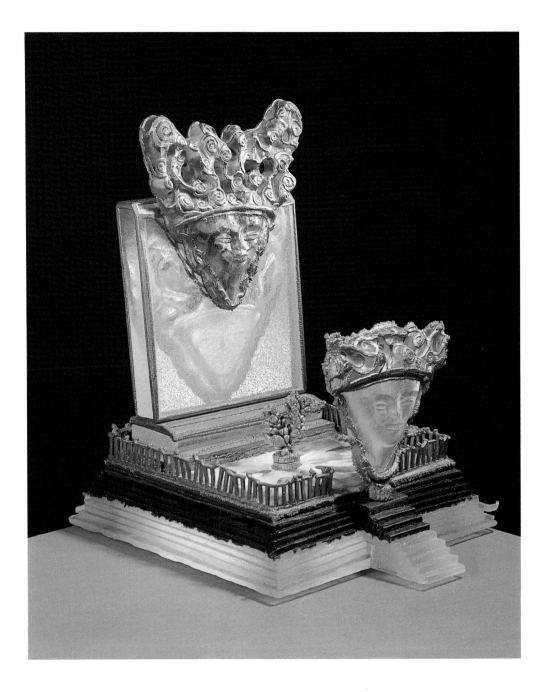

Monument to a Lost Culture, 1990,
Lost wax kiln-cast glass, copper
electroforming, lighting,
76 x 55 x 67 cm.
Collection of the artist
Photograph: Michal Kluvanek
Courtesy of the artist and Kensington
Gallery, Adelaide

MARY STIMSON

MARY STIMSON was born in Eye, Norfolk, England, in 1947 and arrived in Australia in 1984. She studied at Chelsea College of Art and Camberwell College of Art and Craft, London, and the Chisholm Institute of Technology, Melbourne.

Stimson has covered a wide field of artistic endeavour as background training for her present work. This includes working as an art-therapist for St Bernard's Hospital, Middlesex; restoration of original archetraving for Camden Council, London; with five other artists being a founding member of Camden Lock Arts Complex, London; a lecturer in drawing and sculpture for Salisbury College of Art, England; a landscape artist and teacher of landscape painting, Newchurch, Kent; a commercial sculptor of animals and figurines for Minerva Fine Art, London; a mural artist and portrait artist with Applied Arts Studio, Bethnal Green and a freelance animal sculptor in Melbourne. She worked briefly with David Bratby on murals in East London and as an assistant to Lyndall Milani on her installation at Brisbane Art Gallery. Also, she has worked as a scenic artist for the Festival Theatre Company in Melbourne, and has travelled extensively in Europe, painting and selling landscapes en route to pay for her travels.

Stimson says that the purpose of her work over the past few years has been to unite sculpture and painting in coloured and tinted bas-relief. Recently she has discovered the versatility of painted bronze, and importance is given to the linear quality of each piece. Her subject matter often stems from poetry she writes, which in turn relates to modern metaphysical ideas. There is a strong element of portraiture and archetypal imagery, using a modern painting and drawing style. Her inspiration comes especially from Egyptian, Assyrian, Etruscan, Roman, Medieval and Papua New Guinean bas-relief work.

Stimson has been included in numerous group exhibitions since her first show at the Young Sculptors Exhibition sponsored by Fortnum and Mason, London, in 1971. She exhibited at Chisholm College and Watermark Gallery, Melbourne, in 1988, has been included in three group shows at Coventry Gallery — the most recent in 1990 — and exhibited at the 3rd Australian Contemporary Art Fair in 1992. She also held two solo shows in Melbourne in 1992, one an exhibition of drawings, the other sculptural reliefs.

Artist's Comment

Female Guardian *represents an imaginary persona of the plant kingdom's goddess: the nurturing fecund feminine earth principle. Her stick twists and turns with the cosmic spiral; it commands that mankind lives in accordance with Nature. Her facial features are sad because mankind is polluting the plant kingdom and she may find it necessary to use her cosmic stick.*

One Man's Identity: *What forms each person at a deeper level are dark corners of fear which imprison him, and highlights of great and desperate passion where his loved ones appear like a god from the skies, a beautiful ballerina, or a prince of darkness. Half-forgotten memories of old loves are embedded in their flesh. At the heart of each of us is the plant kingdom's gift — the oxygen that we breathe. Our lungs are our alter-ego, mankind's own form of plant. Behind all this, at the back of the sculpture, are symbols taken from the first ancient language, symbolising Everyman's link with his distant past.*

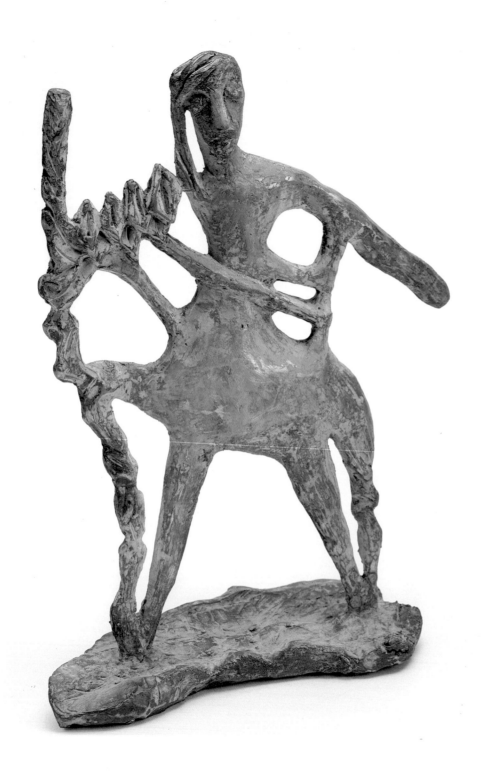

Female Guardian, 1989,
Bronze (edition of five),
28 x 18 x 8 cm.
Photograph: Paul Green
Courtesy of Coventry Gallery,
Sydney

One Man's Identity, 1990,
Bronze (edition of five),
30 x 19 x 8 cm.
Photograph: Paul Green
Courtesy of Coventry Gallery,
Sydney

ALICK SWEET

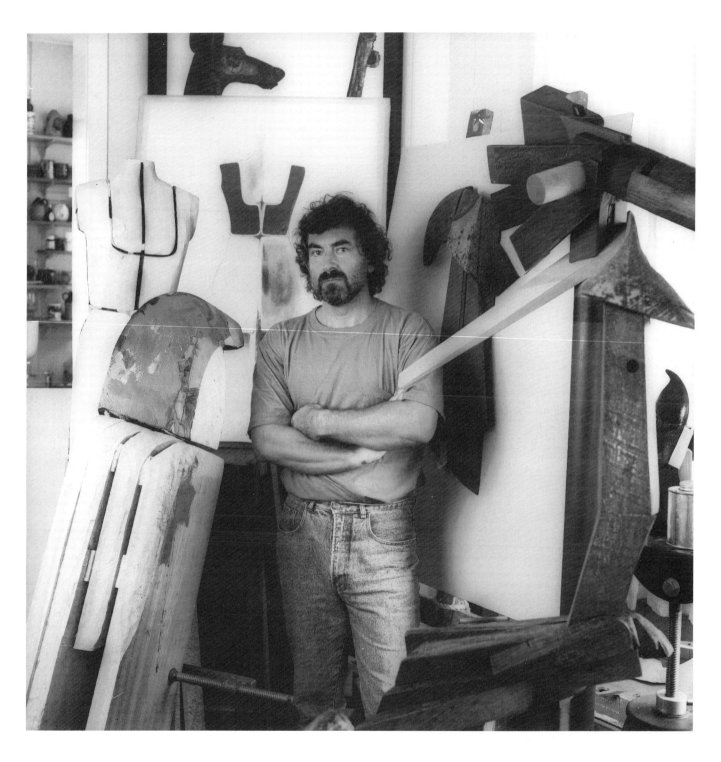

Portrait photograph: David Seeto

ALICK SWEET was born in Yealmoton, Devon, England in 1947 and arrived in Australia in 1951. He studied at Queensland College of Art, Brisbane, from 1975–78 for his Diploma of Art, and completed his Bachelor of Art (Fine Art) there in 1978. He also attended Brisbane College of Advanced Education in 1979–80 and 1988–89, gaining his Diploma of Teaching and Bachelor of Education degree. The artist is currently employed as a lecturer in Fine Art at the Queensland College of Art and completing a Masters degree at James Cook University.

Sweet has travelled extensively throughout Europe, Asia, the Soviet Union and Japan and his sculptures reflect a range of cultural influences. At times totemic, on other occasions reminiscent of mythic Egyptian forms, his various creations employ a variety of materials, including stone, wood, ceramics and metal. And although his sculpted forms may be based on birds, dogs, human figures or crocodiles, his works are generally highly abstracted. Component parts of his sculptures are individually manufactured: polished bronze, aluminium or wooden beaks, solid shapes, elongated canine capita, smooth cylindrical rods and sculpted piers are assembled to form bold fractured constructions.

Some observers have seen in his work the influence of the Constructivists Naum Gabo and Antoine Pevsner, and the experimental assemblage artists Kurt Schwitters and Laszlo Moholy-Nagy, and there is no doubt that Sweet likes to experiment with his sculptures. They are often the result of happy accidents, rearranged shapes, spontaneous blendings of form and texture. His creative use of colour and his ability to evoke a sensuous quality through his tactile surfaces give his works considerable appeal.

Sweet has won several awards for his sculpture, including the Warana Award in 1978 and the Caloundra Award in 1978 and 1981. In 1988 he also gained both the City of Cairns Art Award for Sculpture and the Gold Coast Sculpture Award. Works were purchased for the Queensland Art Gallery and the Museum of Contemporary Art, Brisbane, in 1988, and for Stanthorpe Regional Gallery in 1990.

The artist has featured in numerous group exhibitions since 1976, among them shows at Queensland Art Gallery, Brisbane Community Arts Centre and the Queensland College of Art. He has also had six one-man shows to date, the most recent at Ipswich City Council Regional Art Gallery in 1992. Highly regarded also for his painting and drawing, Sweet is represented in private and public collections both in Australia and overseas — including a large sculptural commission for Heilon Jiang Province in China in 1991.

Artist's Comment

My particular method of working allows me to develop my keen interest in construction and explore an element of experimentation in composition, often lacking in production oriented sculpture. Colour adds a dramatic element to the work and helps amplify the dynamics of the form.

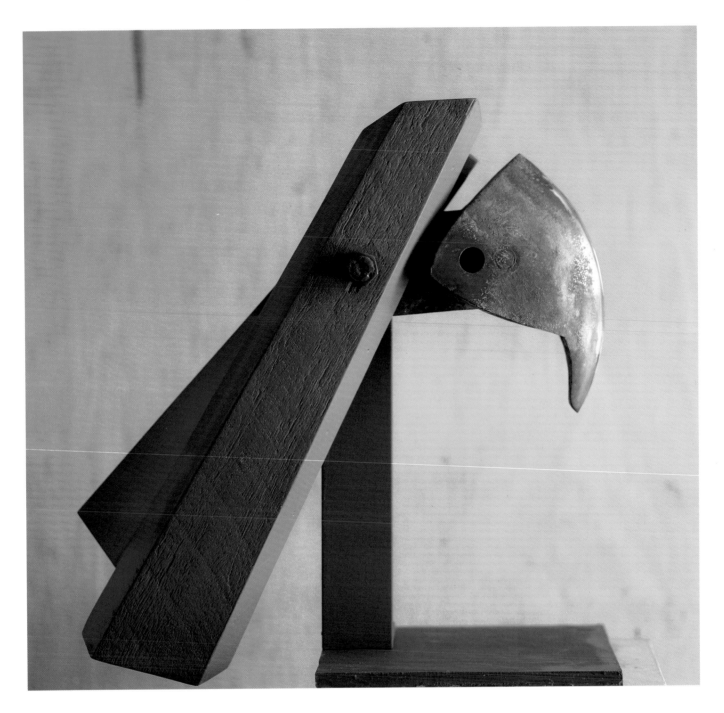

Untitled, 1987,
Bronze, hardwood, 55 x 21 x 19 cm.
Photograph: David Seeto
Courtesy of the artist

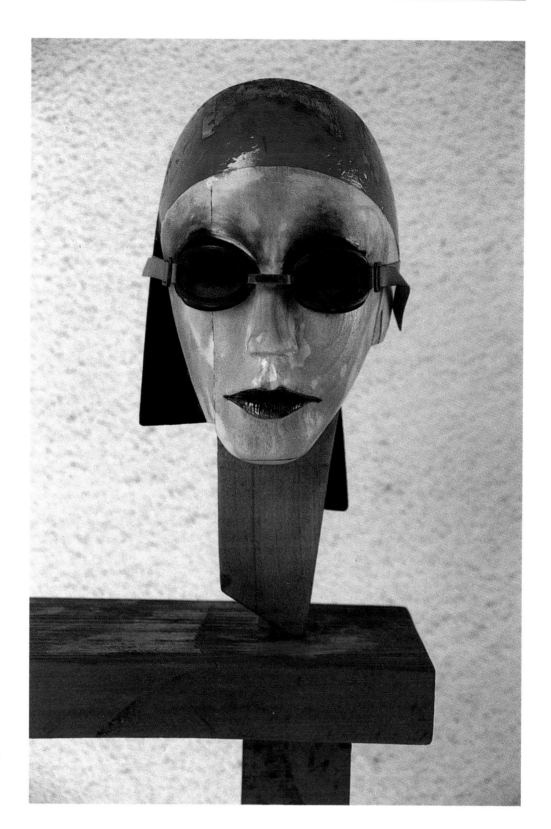

Swimmer, 1992,
Wood, paint, graphite and rubber,
450 x 300 x 180 cm.
Collection of the artist
Courtesy of the artist

PETER TILLEY

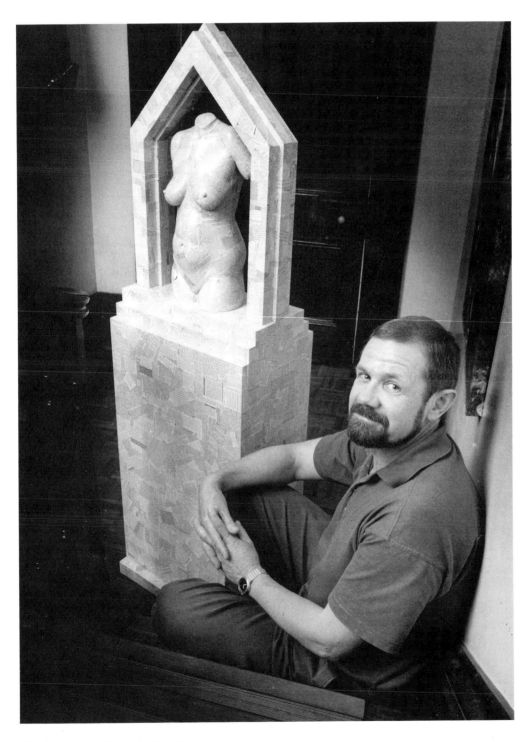

Photograph courtesy Newcastle Herald

PETER TILLEY was born in Williamstown, Victoria, in 1946. He studied ceramics part-time at Newcastle School of Art and Design, 1973–75, and sculpture part-time with a private tutor from University Sains Malaysia, 1975–77. He completed his Certificate of Art at Newcastle School of Art and Design in 1979 and since then has worked full-time as an artist.

Tilley's sculptures reflect what he calls his 'non-archaeological interest in ancient civilisations' and, in particular, the tendency of cultures in different historical epochs to have 'unquestioning faith in tenets even when they don't function effectively'. Tilley despairs of the fact that cultures everywhere seem happy to perpetuate power and ignorance 'as the polarised levels on which society operates' and that social groups so often fail to maintain the standards they proclaim. His sculptures, therefore, frequently contain allusions to religious rites and to the formal and institutional aspects of culture — but his perspective is essentially that of the iconoclast. He wants us to take note of the customs and traditions that fragment different cultures and in turn separate humanity from Nature.

Tilley is interested in objects of veneration and in humanity's universal quest for salvation and spiritual rebirth. However he is generally distrustful of society's intent in catering to these needs. Tilley's *Ritual Vessels* series, for example, was inspired by ancient Egyptian civilisation but, as he points out in an article in *Artemis*, the ancient Egyptians 'changed the rules of religion as the need arose' and used their funerary cult to provide comfort for the masses while manipulating them at the same time.

Another instance where Tilley employs universal religious motifs for ironic effect is provided by his sculpted eggs — eggs being a symbol of life and rebirth. Tilley's eggs are fashioned from coal and equine thigh bones: they have a superb surface quality but are doomed to be infertile and are therefore symbols of misplaced trust. So Tilley, it has to be said, remains deeply cynical. He is very much aware of humanity's spiritual sensibilities while ever mindful of mankind's tendency to subvert them in the name of power and control.

Tilley held his first one-man show in Sydney in 1984 and featured in major group exhibitions at the Newcastle Region Art Gallery and Newcastle Contemporary Gallery in 1986 and 1988. He has had three individual exhibitions with Access Contemporary Art Gallery, Sydney — the most recent in 1992 — and is represented in the collections of the Newcastle Region Art Gallery; Warrnambool Art Gallery; Campbelltown Regional Gallery; Maitland City Art Gallery; Stanthorpe Art Gallery, Muswellbrook Regional Gallery and in corporate and private collections around Australia.

Artist's Comment

The thematic content of my sculptures has been influenced by a broad and varied range of issues including consumerism, environmental damage, warfare, religion and other factors that determine the human condition. My works attempt to interpret an enigmatic, fragmented world where culture and society are not unified and humanity is separate from Nature. (Our actions are part of, and affect, the environment, but conventional thinking ignores this responsibility.)

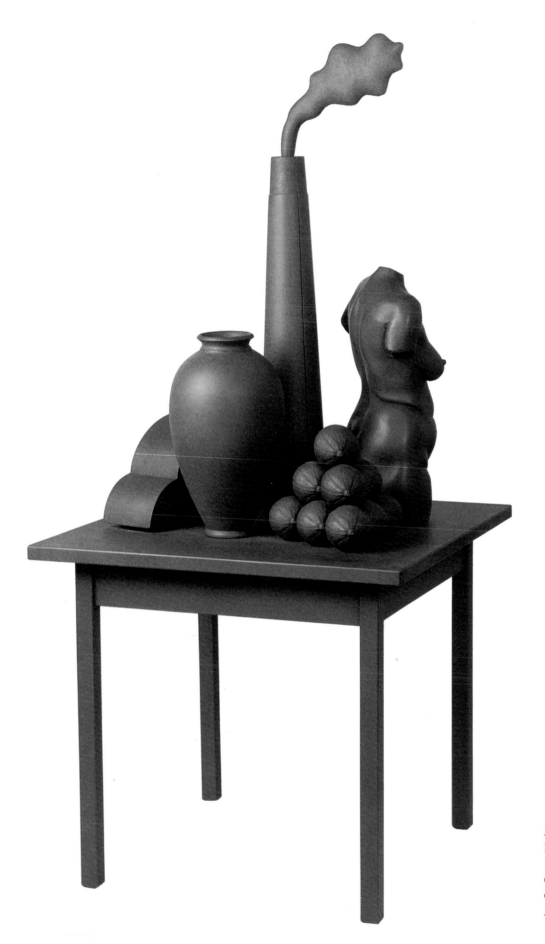

Nature Morte, 1991,
Plaster, wood, clay, paint,
169 x 81 x 79 cm.
Collection of the artist
Courtesy of Access Contemporary
Art Gallery, Sydney

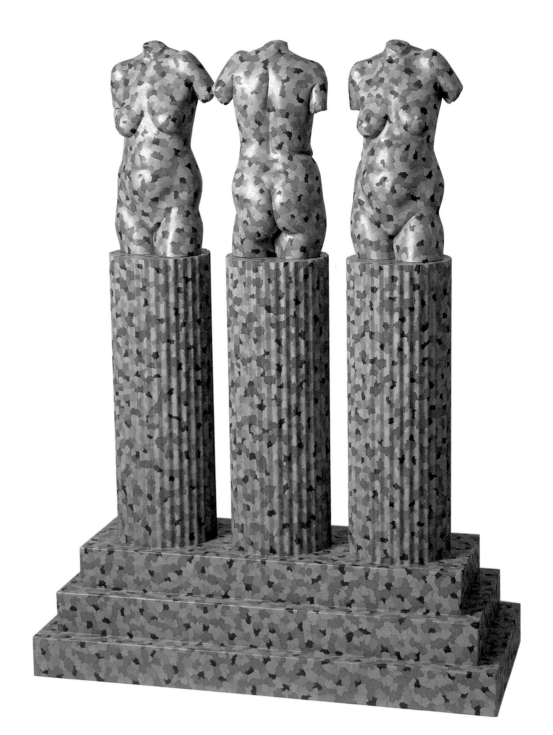

Three Graces, 1991,
Plaster, wood, corrugated iron, paint,
173 x 122 x 55 cm.
Collection of the artist
Courtesy of Access Contemporary
Art Gallery, Sydney

TONY TREMBATH

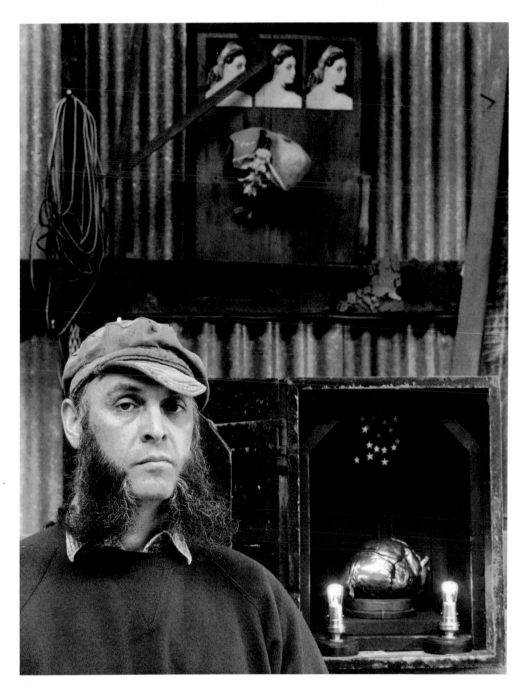

Portrait photograph: Brian Gilkes

TONY TREMBATH was born in Sale, Victoria, in 1946. From 1964–71 he studied Applied Biology at the Royal Melbourne Institute of Technology while working as a research technician in CSIRO's Division of Animal Health. He then switched his attention from the microscope to the hammer in 1973, studying art full-time at Caulfield Institute.

As a sculptor Trembath has been influenced by minimalism and the move away from monumentality in sculpture but more specifically by research processes and first-hand experience of research on live animals in laboratories. He also draws strongly on forms derived from rural buildings and equipment — sheds, pavilions, ramps, barns and haystacks. One of his most distinctive works of 1980, *Pavilion*, featured 35 cast aluminium sheep aligned in formal parade on plastic grass in front of a weatherboard country grandstand, while another characteristic work, *Six Haystacks*, produced in the same year and exhibited at the Art Gallery of New South Wales in 1984, consisted of six identical galvanised steel structures stuffed brim-full with baled straw. However, his sculpture is often confronting — stuffed chickens wired to electrodes or paraded in artificial light, an oversized hammer constructed from oregon and steel as a parody of function or the scrapping skills. At other times he inverts familiar forms to produce an ambiguous reading — roof tops turned upside down, a tree that becomes a lighthouse, pieces of human anatomy presented in an unusual manner, or pipes which emerge from structures in unexpected ways.

Trembath has been included in several group exhibitions, among them the Australian Sculpture Triennials; Australian Perspecta at the Art Gallery of New South Wales, 1981; '3+3+9' — an Australian/Canadian exhibition in Toronto, 1981; 'ARX '89' in Perth, and national travelling exhibitions.

He held his first individual exhibition in 1977 at Caulfield Institute, and in 1984 a survey of his sculptures and related work — 'Project 45' — was shown at the Art Gallery of New South Wales. The most recent exhibitions were developed from his Paris residency in 1987. 'Some Pictures from a Somniloquist's Diary', held at William Mora Galleries, Melbourne, in 1992 was installed as a museum of electricity and electro-medical treatments. The same year, 'Some Souvenirs of Paris' at Greenaway Art Gallery, Adelaide, featured sacred anatomical relics in a French Gothic setting.

Artist's Comment

The narrative relief panels Valesians *and* Queen of Sheba *were assembled as 'colour plates' to Gustave Flaubert's* The Temptation of St. Anthony *and each imagined as a mural in a Gothic chapel. The text assisted with the logic and narrative entry to the works. However, these assemblages represent a more complex layering of experiences and issues than the mere illustration of a text, and were presented as elements within a unified installation of religio-medical assemblages — 'Some Souvenirs of Paris'.*

S.E.C. Ladder was presented as a curio from an electrical museum in an installation called 'Some Pictures from a Somniloquist's Diary'. Here I indulged a growing fascination for the museum and archive as the subject of my work or field for research, where I investigate personal and common experience, power, surrender, presentation of information, and the metamorphosis of the serious into the ridiculous.

Valesians, 1988,
Mixed-media relief assemblage with gold leaf,
oil painting, found objects and text,
157 x 83 x 9 cm.
Photograph: Grant Hancock
Courtesy of Greenaway Art Gallery, Adelaide

Queen of Sheba, 1992,
Mixed-media relief assemblage with mattress
fabric, postcards, gold leaf, anatomical model
and text,
157 x 83 x 20 cm.
Photograph: Grant Hancock
Courtesy of Greenaway Art Gallery, Adelaide

S.E.C. Ladder, 1992
Mixed-media assemblage with step-
ladder and electric lights,
176 x 91 x 45 cm.
Photograph: John Brash
Courtesy of William Mora Galleries,
Melbourne

STEPHEN TRETHEWEY

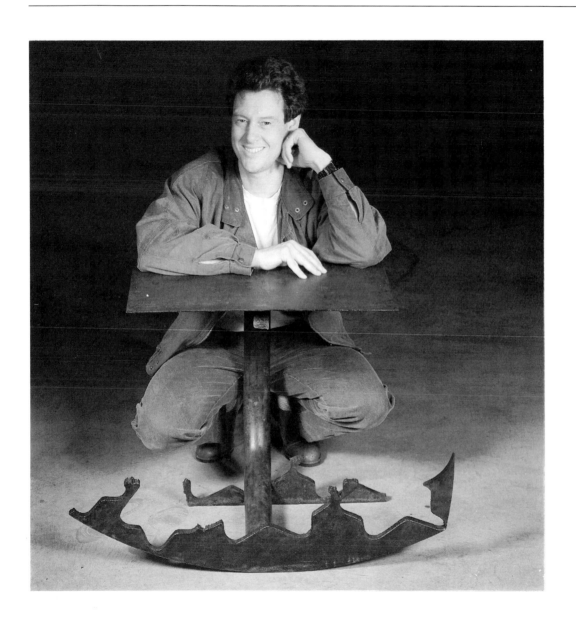

STEPHEN TRETHEWEY was born in Leeton, New South Wales, in 1955 and is now based in Sydney. In 1973 he began painting and drawing, selling privately until 1977 when he travelled to Europe. Trethewey lived and worked in Paris with the American painter Ike Muse and Swedish sculptor Siv Holme and returned to Australia in 1979. He then began producing figurative wood and ceramic sculpture, but moved increasingly towards abstraction. In 1986–87 he completed an Associate Diploma at Canberra School of Art.

Trethewey is now attracting critical acclaim for his elegant 'sculptural furniture', fashioned in metal from pipes and industrial fragments retrieved from the scrapbins of engineering shops and foundries. His works include sculptural tables and chairs — handmade pieces produced using traditional techniques while also following the same principles as non-functional sculpture. The intriguing thing about them is that they combine physical function with aesthetic design — a work like *Badinage* can be used as a table and a sculpted chair like *Pedal* can actually be sat on. 'I like to demonstrate the unlikely, the surprising and the paradoxical possibilities inherent in steel,' he says. 'I approach each piece as I would a piece of sculpture. At the same time each piece has to function perfectly as furniture.'

The artist has exhibited since 1984, featuring initially in a two-man photographic exhibition at Images Gallery, Sydney, and subsequently in group shows at CSA Gallery, Canberra; Gallery 460, Gosford; Access Contemporary Art Gallery, Sydney, and BMG Fine Art, Adelaide. He has had four solo exhibitions at Access Contemporary Art Gallery since 1988, the most recent — 'Intimations' — in February/March 1993. He is represented in private and corporate collections around Australia and has completed several private commissions.

Artist's Comment

My major influences are Miro and Klippel. They express the uplifting and the humouresque, which is so important in my approach to making sculpture. I describe movement — the quirky, the theatrical, the heroic gestures of living things are what I draw into the elastic, tenacious and unpredictable medium of steel.

Pedal (my first seat) and Badinage represent the integration of my lyrical approach to sculpture and the integration in which I invite the viewer to participate, interpreting and enjoying this stimulating, timeless medium.

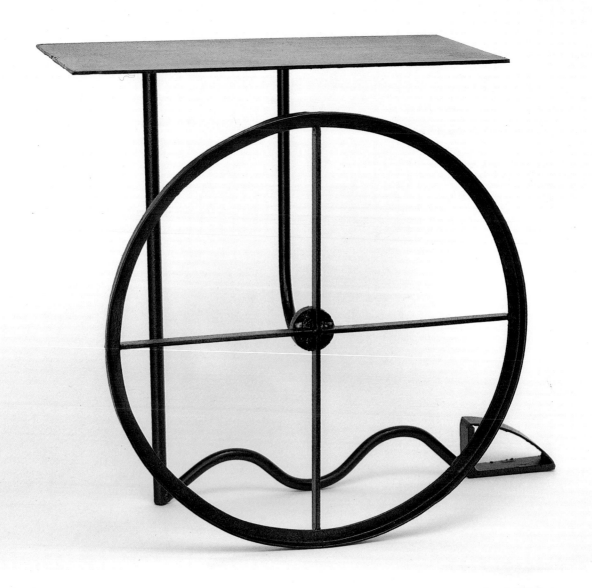

Badinage, 1992,
Painted steel, 61 x 70.5 x 34.5 cm.
Collection of the artist
Courtesy of Access Contemporary Art
Gallery, Sydney

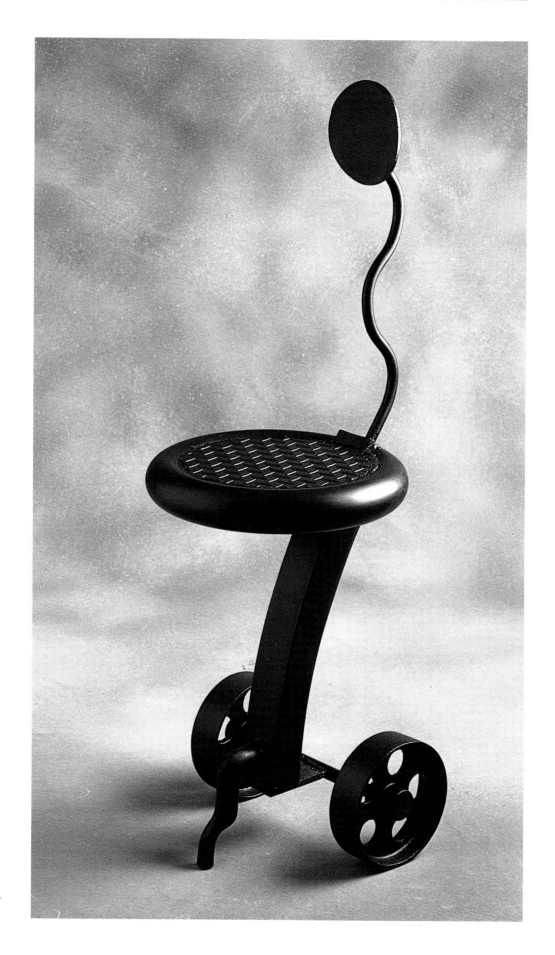

Pedal, 1992,
Painted steel, 108 x 37 x 41 cm.
Collection of the artist
Courtesy of Access Contemporary
Art Gallery, Sydney

GEORGE TURCU

GEORGE TURCU was born in Braila, Romania, in 1945 and arrived in Australia in 1982. He studied sculpture at the Academy of Fine Art, Bucharest, gaining his Diploma in Fine Art (Sculpture) in 1970. Prior to leaving his native country he won the National Prize for Monumental Sculpture Projects in Romania in 1973 and the Gold Medal of the Fourth International Biennial Exhibition and Competition for Sculpture in Bronze, in Ravenna, Italy, in 1979.

Turcu's sculptures are carefully crafted works, usually containing carved and cast elements in wood and bronze. In writing of Turcu's blend of organic and manufactured elements in his sculpture, art critic Ronald Millar noted recently: 'Turcu makes trees of knowledge that sprout astrolabes and scientific hardware; towers and rainbows, strange presses and portals; nudes trapped behind lattices, odd anatomical lessons; a bronze brain and a smart toe, an off-centre picture frame with no picture. This is high-class stuff, with a metaphysical centre that is worth pondering.'

Between 1970 and 1982 Turcu was included in more than 50 exhibitions, mainly in Europe, and these works were mostly in bronze. Prior to 1982 Turcu also produced nine public commissions in stone or metal placed in various public locations. These works ranged in size from between 2.5 and 4 metres, the most important being a memorial some 16 metres high and incorporating a 5-metre bronze cast.

Since arriving in Australia, Turcu has shown in sculpture exhibitions in Melbourne and Florence and was also included in the Seventh International Biennial Exhibition and Competition for Sculpture and Bronze in Ravenna, 1985. His most recent local exhibition was at Pinacotheca, Melbourne, in 1990.

Turcu won the 1991 Shire of Eltham Art Award for Sculpture and is represented in national, public and private collections in Europe, USA and Australia.

Artist's Comment

I see sculpture as an adventure of the spirit, endeavour with a purpose, superior play, invention of a different piece of reality. The newly created object of art comes into light to enlarge the human experience in its poetic realm. This new reality tries to be a meaningful one, even when its morphology seems to be an abstruse structure. It is the result of my effort to understand existence, starting from nothing in particular, like a nebula of impressions emanating palpable shapes.

Lacustrian City is a bronze and ironbark structure, a dwelling for the spirit, suspended in no definite space or time. The Little Watching Tower is an example of metaphoric architecture — a beaming place for the inquisitive mind, scrutinising the unknown.

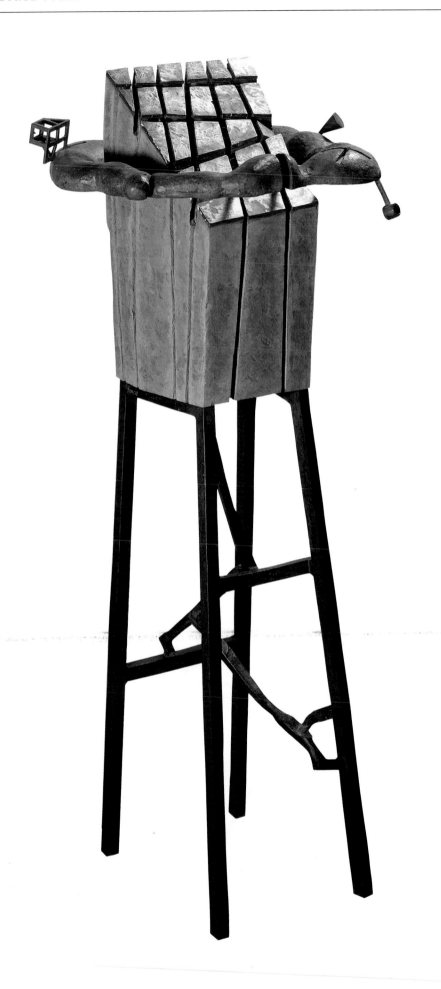

Lacustrian City, 1988,
Bronze and wood, 136 x 56 x 56 cm.
Photograph: Henry Jolles
Collection of the artist
Courtesy of the artist

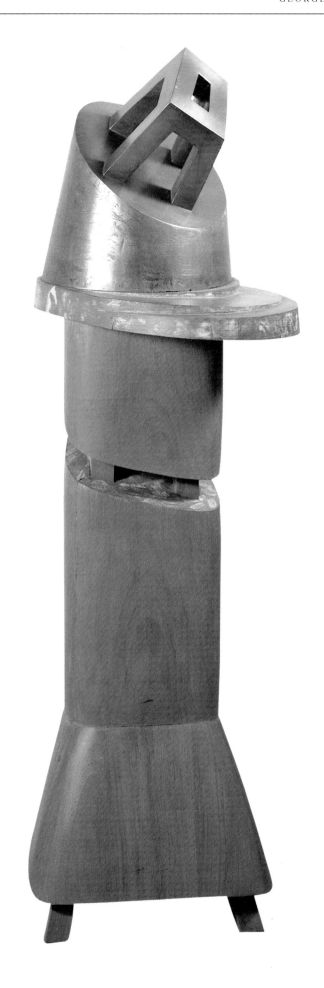

The Little Watching Tower, 1988,
Bronze and wood, 127 x 46 x 40 cm.
Photograph: Henry Jolles
Collection: Richard and Manlee
Harper
Courtesy of the artist

JOHN TURIER

Portrait photograph: Carl Hensell

JOHN TURIER was born in Sydney in 1954 and has attracted acclaim both as a painter and as a sculptor. He commenced painting in 1972 while working as a plumber's apprentice and on completion of his apprenticeship travelled in Indonesia, India and Nepal. On his return he settled in Newcastle where he went into business, pursued a professional interest in music and commenced sculpting. As the business world offered little creative or intellectual stimulation he undertook a Bachelor of Arts (Visual Arts) at the Hunter Institute of Higher Education in 1986, completing his Graduate Diploma in Painting in 1989. During his final year he had his first solo exhibition with Coventry Gallery, Sydney, was a recipient of the William Fletcher Trust Scholarship and was highly commended in that year's Blake Prize. While studying he also participated in a number of group exhibitions in the Hunter region and at Coventry, where he has also since held several solo exhibitions — the most recent in 1993. He is currently teaching sculpture and painting part-time at Newcastle TAFE College and the University of Newcastle, while also spending as many hours as possible in his studio.

Turier's sculptures and paintings evince a strong Asian influence gained from his early travels and strengthened by a visit to Japan in 1989. His sculptures, in particular, utilise collage at a highly sophisticated level and combine materials as disparate as wood, stone, paper, shells, canvas, bones, perspex, leather, cricket balls and paint: they are also characterised by an intense attention to detail. In addition to his acknowledged Asian influences — much of his visual humour being inspired by the paradoxical qualities of Zen Buddhism — Turier also works with imagery drawn from contemporary culture, architecture, the landscape and the archetypal properties of stone. Through his materials he conveys a fine balance between aesthetics, insight and humour, and two fine examples of this are illustrated here — both works somehow treading that delicate line between philosophical meaning and creative frivolity.

Turier has received several commissions and was included in the 1992 Adelaide Biennale. He is represented in the Newcastle Region Gallery, the Bilu and Coventry Gallery Collections, and in a number of private collections in Sydney and Melbourne.

Artist's Comment

Inspiration for me lies in the materials themselves and the puzzle of their successful marriage into essentially iconic works. This is born of a frustration with our decadent culture and the limitations of 'political' art. I strive for a cultural significance at a personal level through images and objects that are deeply pleasing in aspect and meaning.

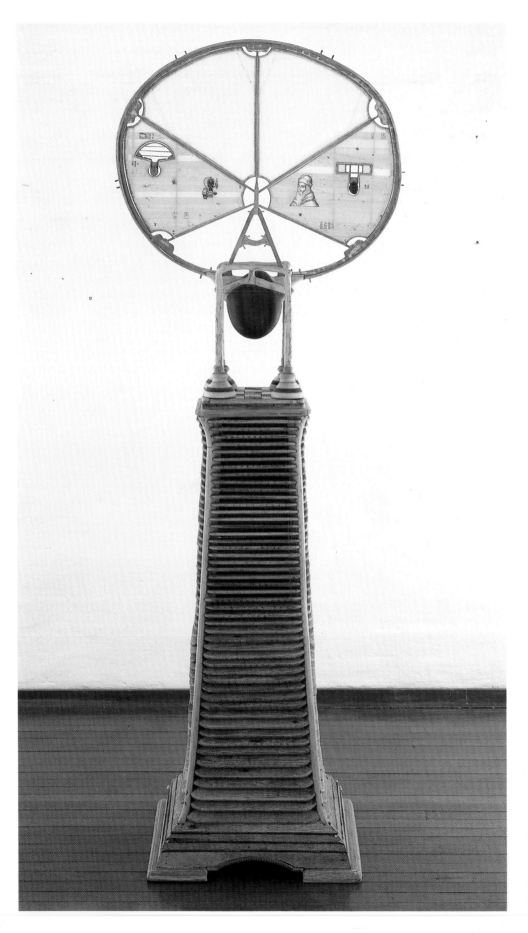

*The gravity of shadow and the ever heeling
self propel all handsome men through space
and time*, 1990,
Mixed media, 190 x 60 x 52 cm.
Photograph: Paul Green
Private collection, Melbourne
Courtesy of Coventry Gallery, Sydney

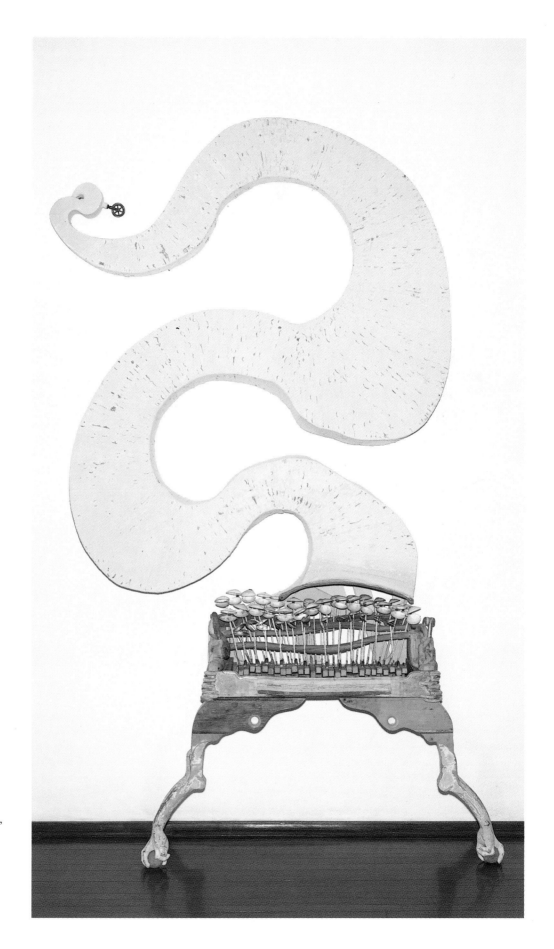

The Lone Piano of the Apocalypse, 1991,
Mixed media, 295 x 155 x 40 cm.
Photograph: Paul Green
Collection: Newcastle Region Art
Gallery
Courtesy of Coventry Gallery,
Sydney

HOSSEIN VALAMANESH

Portrait photograph: Michal Kluvanek

HOSSEIN VALAMANESH was born in Tehran, Iran, in 1949 and studied at the Tehran School of Fine Art, graduating in 1970. Initially he produced figurative paintings dealing primarily with power and social hierarchies — works substantially different to his more reflective and simpler work of recent years.

Valamanesh arrived in Australia in 1973 and soon afterwards spent time exploring Aboriginal culture and painting with the Papunya artists. He subsequently graduated from the South Australian School of Art in 1977 and now lives and works in Adelaide.

Valamanesh held his first solo Australian exhibition at the Experimental Art Foundation, Adelaide, in 1977 and has had 21 further individual shows since, the most recent in May 1993 — an installation at the Centre for Contemporary Art, Ujazdowski Castle, Warsaw. He has served as an artist-in-residence in Perth, Mt Gambier and Rockhampton and received an Australia Council Fellowship Residency at Kunstlerhaus Bethanien in Berlin. He has also received several major commissions, among them a sculpture for the atrium of the Commonwealth Centre, Festival Centre Plaza, ASER Complex, Adelaide and Rockwood Necropolis, Sydney. He is represented in the Australian National Gallery, the National Gallery of Victoria, the Art Gallery of South Australia, Queensland Art Gallery, the Art Gallery of Western Australia and Artbank, as well as regional collections.

Artist's Comment

In December 1990 I had started my one-year residency in Berlin. It must have been two weeks after Christmas while walking in snow to my studio that I noticed a few discarded Christmas trees on the footpath. Over a period of a week the footpaths were full of them. Not knowing what I would do with them I collected many and carried them to the studio. They still had a strong smell of the pine forest and this filled my studio. These discarded trees became a metaphor for our relationship with Nature. Through the Christmas celebration we had made a token gesture in memory of our connection to Nature and afterwards discarded them like daily rubbish. Later on that year I felt that it was appropriate to use these trees in the making of my work.

The two pieces shown here were made during this period. Untitled, 1991, *is constructed from the trunks of these trees. It alludes to the original shape of the pine tree and also to the architectural structure of a church spire which I could see through my window. With the charred shape of my head on the lower part of the work it became like a candle with its burning black wick. The second piece,* Skin and Bone, *uses the natural symmetrical growth pattern of the trees. By bringing together selected segments of the main trunk and smaller branches, I attempted to make a piece reminiscent of the remains of a corpse or skeleton but on closer viewing one could recognise the tree branches sitting on a large sheet of scorched paperbark. This work could be a reminder of our interconnection with Nature in survival and destruction.*

Untitled, 1991,
Pine wood, earth, red iron oxide,
40 x 197 x 9 cm.
Photograph: Artworks/Peter Fischer
Courtesy of Macquarie Galleries, Sydney

Skin and Bone, 1991,
Pine wood, burnt bark of Melaleuca tree,
70 x 70 x 8 cm.
Photograph: Artworks/Peter Fischer
Courtesy of Macquarie Galleries, Sydney

TREVOR WEEKES

Portrait photograph: Anthony Browel

TREVOR WEEKES was born in Orange, New South Wales, in 1951. He studied part-time at the National Art School, Sydney in 1972, spent a year at Canberra Art School in 1974, returned to the National Art School in 1975 and completed his studies at Alexander Mackie College of Advanced Education in 1976–78. Weekes is an extraordinarily diverse artist who paints, draws, sculpts and also works in leather, wood and metal.

In one of his early shows Weekes explored the romance of man's desire to fly and once commented that 'the old planes with their wooden skeletons were obviously attempts to create birds'. Especially fond of Leonardo's drawings of flying machines, Weekes paid homage to the great artist and inventor in his 1980 exhibition 'Flight, Man and Machine'. Featured in the exhibition was a sandal said apocryphally to have been taken from the foot of Icarus after his fatal plunge from the heavens! This particular show also presented spoofs on a large scale, the centrepiece being a life-size recreation of the crash of Charles T. Icarus through the roof of London's Crystal Palace during a Handel performance …

Weekes followed this dramatic exhibition with 'Project Pelican, The Flight Show' and 'Teach Your Chicken to Fly Kit' in 1981 and 1982 respectively. However two subsequent exhibitions revealed a quite different passion — the quest for the perfect Trojan Horse. In 1984 at Sydney's Macquarie Galleries — the venue for all his major exhibitions — he portrayed the Trojan Horse as a symbol of 'our inability to see past the surface of the imagery we are bombarded with'. His sculptures explored different dimensions of this theme and included representations of horses bound with ropes and others partly hollowed out — their internal machinery exposed. In a subsequent show in 1987 he went on to convert the whole gallery space into an impression of 'Trojan Life', featuring a large Trojan horse made of wood and several smaller works suggestive of the world of myth.

Weekes has recently shifted his focus yet again. His 1989 exhibition 'The Lost Sea Wolves' examined the notion that the sea could be every bit as hostile as predatory wolves. Featured in the show were some 22 paintings and objects dealing with perils of the sea and associated imagery — including portraits of wolves and bearded seafarers (some of them named 'Wolf') as well as memory plaques and nameplates (one from *HMS Terror*). Also included, by way of symbolic relief, was a meticulously constructed white wooden lifeboat which seemed intended as an icon of hope. However the tone of Weekes' exhibition was hardly optimistic: one of his works carried the following commentary: 'As the winds come and the day fades into darkness, we exist as memories and dust …'

Weekes has received several sculpture commissions, among them works for the Araluen Art Centre in 1983, the State Bank of New South Wales in 1984 and the Hyatt Hotel, Melbourne, in 1986. He is represented in the collections of the Australian National Gallery, the Newcastle Region Art Gallery, Burnie Art Gallery, the Visual Arts Board, the City Art Institute, Sydney, and Artbank. He is also the author of six limited edition publications — *Wolf Journal* coinciding with his 1989 show.

Artist's Comment

For me, the idea is the most important part of the process. I then decide whether it would work better in 2-D or 3-D, then what medium to use.

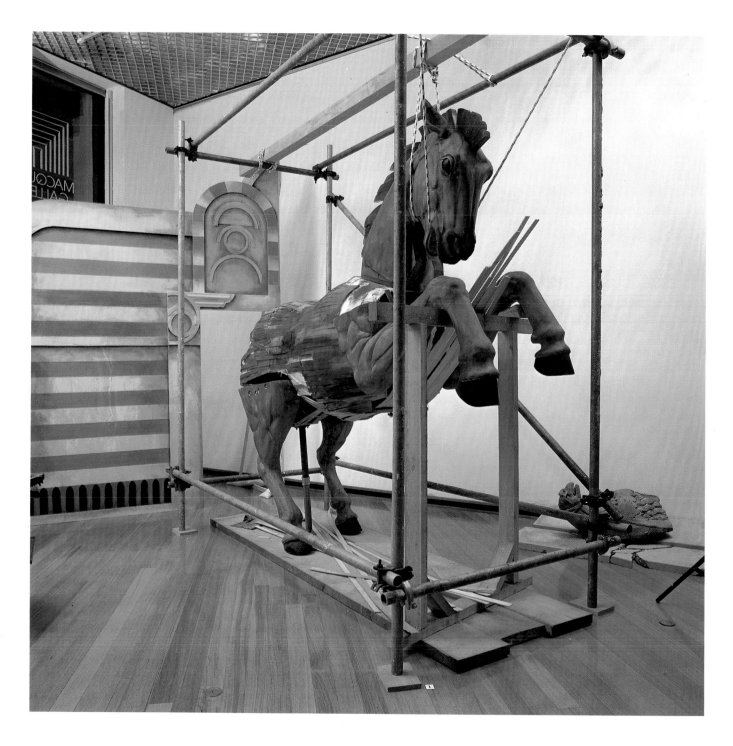

Trojan Horse, 1987,
Huon pine, white beech and oregon,
300 x 300 x 120 cm.
Photograph: Anthony Browell
Courtesy of Macquarie Galleries, Sydney

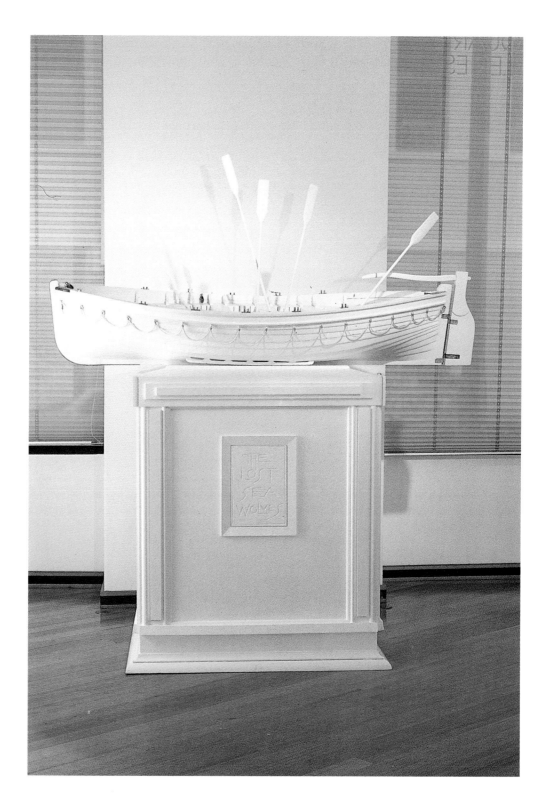

The Lifeboat, 1989,
Timber, brass and copper,
700 x 180 x 90 cm.
Courtesy of Macquarie Galleries,
Sydney

LIZ WILLIAMS

LIZ WILLIAMS was born in Adelaide in 1942 and studied at the South Australian School of Art from 1972–75, under Milton Moon. In 1976 she worked at the Jam Factory, producing a range of functional pots and one-off decorated pieces, and the following year entered into an apprenticeship with Gwyn Hanssen-Pigott, in Kingston, Tasmania. This experience increased her technical knowledge and also developed her skills in clay and glaze preparation.

After a further period at the Jam Factory, 1978–79, Williams enrolled in the Graduate Programme at Goldsmiths College, London, but found it too limiting. She decided to transfer instead to Scripps College, Los Angeles, on a 'special student' basis. Here she was able to work alongside students in the Masters course, under the direction of Paul Soldner, himself a former pupil of experimental ceramist Peter Volkous. Williams says that Soldner fired everyone's imagination and that here she was 'given total freedom to find my own thread and develop my own work'. This commitment to individual self-discovery has stayed with her ever since.

Williams returned to Adelaide in 1982, began exhibiting, and for a brief period taught Ceramics at Darwin Institute of Technology. She now teaches part-time History of Ceramics and Ceramic Sculpture at the University of South Australia.

Williams says that form is the major vehicle of her work 'and has appeared as the most appropriate means by which I can express the sensation of my feelings and ideas'. Her sculptures are characterised by a purity of line at times reminiscent of ancient Egyptian art. While this might seem surprising, the sculptor recognises 'a sacred relationship between humans and earth': to this extent her work is an exploration of eternal dualities resolved in harmonious balance. The most exciting part of the creative process, she says, 'remains not realising the full implication of the work until it is complete'.

Williams held her first exhibition at Scripps College in 1981. She was included in the National Contemporary Figurative Exhibition, Sydney 1988, and in an exhibition in the Adelaide Festival Centre in 1990, and had her most recent one-person exhibition at Adelaide Town Hall in 1992. She is represented in the Fred Marer Collection, Los Angeles, the Art Gallery of South Australia, and a number of private collections.

Artist's Comment

For me working is a discovery, it's like going on a journey. Once my work dealt with harmony, wholeness and independence of human spirit. Now it deals with disharmony, human failures, incompleteness and isolation. Perhaps this simply represents two aspects — two views — of the same journey.

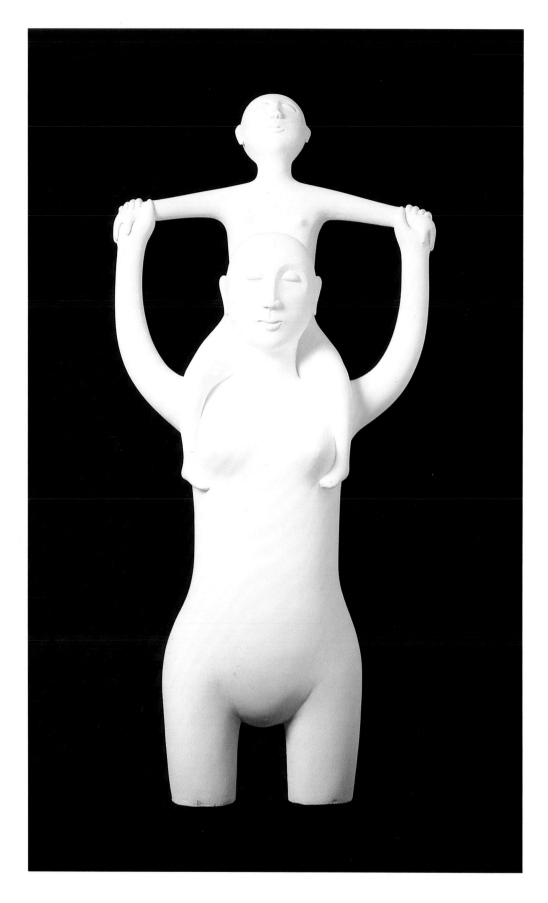

Mother with Child II, 1988,
Clay, 120 x 33 x 33 cm.
Photograph: Michal Kluvanek
Collection of the artist
Courtesy of the artist

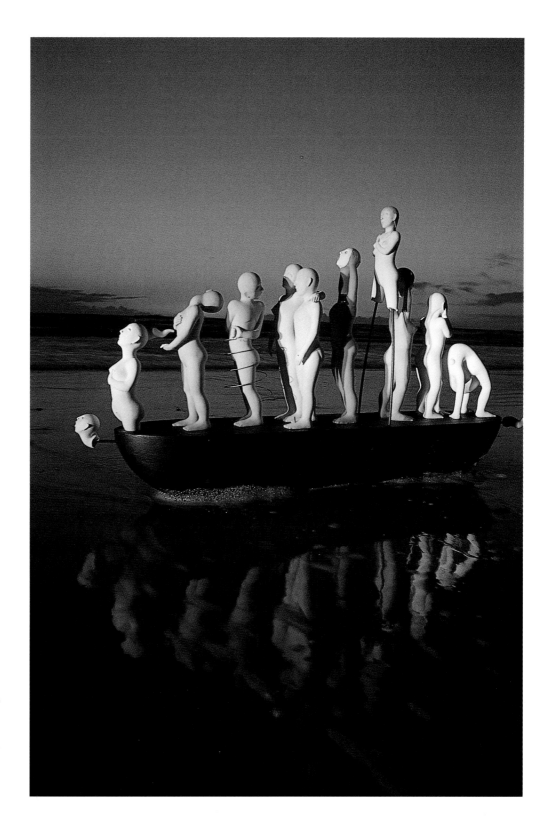

Ship of Lost Souls, 1992,
Clay, metal, wood and bitumen,
Length: 2.4 m.
Height: 1.3 m.
Location: Grange Beach, South
Australia
Photograph: David Campbell
Courtesy of the artist

DAN WOLLMERING

Portrait photograph: Chris Ryan

DAN WOLLMERING was born in St Paul, Minnesota, in 1952 and emigrated to Australia in 1975. He studied at St John's University, Minnesota, from 1970–74, graduating with a Bachelor of Arts degree in Fine Arts, and subsequently qualified as a teacher at the College of St Benedict, Minnesota, in 1975. After arriving in Victoria, he taught art and craft at a Melbourne secondary school and then lectured at Coburg State College, 1977–81. He completed a Master of Arts (Fine Art) degree at Royal Melbourne Institute of Technology in 1990 and is currently lecturing in Sculpture and Drawing at the Gippsland campus of Monash University.

Wollmering's sculptures are elegant, abstract works in bronze and steel which utilise space as much as solid form. The sculptor's interest in physics, and in the relationship between particles and waves, has influenced many of his sculpted forms and not surprisingly has also contributed to the titles of several of the works — including *Every Rhythm Has Its Day*, *The Uncertainty Forecast*, and *Testing a Hypothesis* (illustrated here). As gallery director David Hansen has written: '… the sculptures address Stephen Hawking's discoveries relating to the singularity of space-time and his investigations of related phenomena such as the existence of black holes and the expansion of the universe. Wollmering's circular wholes and sections can thus be taken to represent the curvature of space-time or of the fields, orbits and galaxies within it, while his erratic irregularity and precarious connections convey the shifting allegiances of elementary particles.'

Wollmering has participated in several major sculptural exhibitions, including the Mildura Sculpture Triennials in 1982, 1985 and 1988, and the Australian Sculpture Triennials held in Melbourne in 1981 and 1987. He was selected for an exhibition of Australian Contemporary Art at the A-Z Gallery, Tokyo, in 1990 and also featured in an exhibition of Contemporary Gippsland artists which toured eleven regional art galleries in Victoria, New South Wales, Queensland and South Australia in 1990–92. He held his first individual exhibition at the Ewing and George Paton Galleries Galleries at the University of Melbourne in 1979 and since then has held regular one-person shows in Victoria, his most recent at Mildura Arts Centre in 1992.

The artist is represented in the collections of the Chisholm Institute, Caulfield; the Latrobe Valley Arts Centre, Morwell; Caulfield Arts Complex; Mildura Arts Centre; Phillip Institute/Coburg Campus, and Sale Regional Art Gallery, as well as in private collections in Australia, Japan, Canada and the United States.

Artist's Comment

At the moment I am working on a form of research which examines some conditions of our existence. The notion of 'blind faith' stumbles into this at times which weaves a pattern of consistency that argues for a number of shapes which I'm developing. These revolve around reflections associated with our origins and various theories which attempt to locate new links connecting the very, very large with the very, very small. This huge task that scientists are working on holds a particular fascination for me, albeit in a limited way, through the wealth of information which promotes further concepts, inspirations and an 'unpredictability' in the final results.

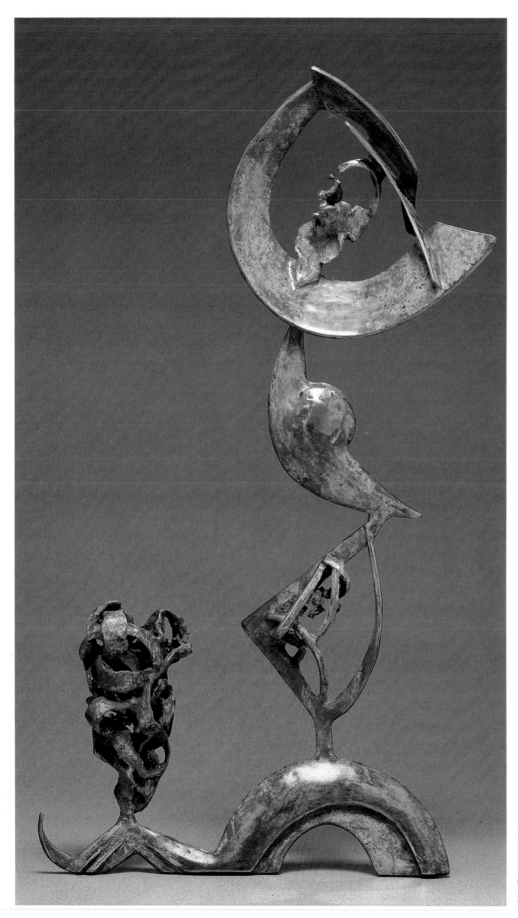

Testing a Hypothesis, 1991,
Patinated bronze, 67 x 36 cm.
Photograph: David Staley
Courtesy of Flinders Lane Gallery,
Melbourne

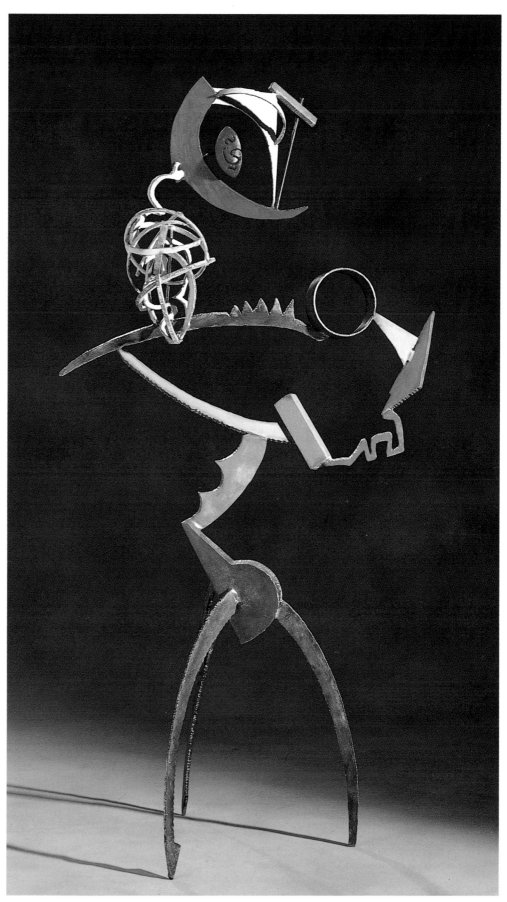

Terra Incognita, 1991,
Painted steel,
200 x 95 x 72 cm.
Photograph: David Staley
Courtesy of Flinders Lane Gallery,
Melbourne

BIBLIOGRAPHY

ARTHUR ASHBY

Hill, Mark, 'The Arthur Ashby Exhibition in Melbourne', *The Australian Woman*, Vol. 1 No. 3, Christmas 1989
Belle, February/March 1989

RODNEY BROAD

Sturgeon, Graeme, *Contemporary Australian Sculpture*, Craftsman House, Sydney 1991
Backhouse, Sue, *Tasmanian Artists of the Twentieth Century*, 1988
Drury, Nevill, *New Art Two*, Craftsman House, Sydney 1988
Sourgnes, Michele, *Painters and Sculptors*, Catalogue to exhibition, Queensland Art Gallery, 1987
Sturgeon, Graeme, *The New Romantics*, Catalogue, Macquarie Galleries, 1987
Sturgeon, Graeme, *Craft Arts*, No. 6, May/July 1986
Sturgeon, Graeme, *Craft Arts*, No. 7, October/December 1986
Sturgeon, Graeme, *Perspecta '85*, Catalogue, 1985
Sturgeon, Graeme, *Australian Sculpture Now* (Second Australian Sculpture Triennial), Melbourne, National Gallery of Victoria, 1984
Taylor, Paul, *Tasmanian Sculpture and Three-Dimensional Art*, 1981
Scarlett, Ken, *Australian Sculptors*, Melbourne, Thomas Nelson, 1980
Davies, John, Earth and Steel, 7th Sculpture Triennial, Mildura, *Art and Australia*, Volume 16, No. 1, September 1978, p. 46
Moffat, Trevor, *Recent Sculpture in Christchurch*, Ascent, Caxton Press, 1969

PETER D. COLE

Catalogue, Macquarie Galleries, Sydney 1991
Fern, Lynn, *Sydney Morning Herald*, 1991
On-Site Sculpture Catalogue, 1990
The Age, 28 September 1990, p. 14
Index magazine, 1990
Drury, Nevill, *New Art Two*, Craftsman House, Sydney 1988
World Expo '88 Collection, 1988
Interior Design, 1987
Craft Arts, Vol. 5, Autumn Issue, 1986
Graeme Sturgeon, *Sculpture at Mildura*, 1985
Art Network, 1982
Australian Sculpture Triennial Catalogue, 1981
The Age, 13 May 1980

Art and Australia, 1970 (photograph)

BRIGID COLE-ADAMS

Catalano, Gary , 'Art', *The Age*, 20 May 1987
The Age, 27 February 1987
The Age, 3 December 1986
Coleman, Nicole, ' Rooms with a Point of View', *The Washington Post*, 7 February 1985
Baltimore Sun, 9 August 1984
Baltimore Sun, 19 July 1984

MICHAEL ESSON

Gentle, Christopher, *Vesalian Interpretations*, University of New South Wales, Sydney 1992
Kemp, Martin, 'Michael Esson — Our Identity is our Discomfort', April 1990
Gray, Robert, 'Ornate Physicians and Learned Artisans', Coventry Gallery, Sydney, November 1988

JUTTA FEDDERSEN

Feddersen, Jutta, *Soft Sculpture: An International Perspective*, Craftsman House, Sydney 1993
de Boer, Janet, 'Fibre in Three Dimensions', *Craft Australia*, No. 2 Winter Supplement, 1984, pp. 23–25
Conroy, Diana, 'Future Fibre', *Craft NSW*, December 1983, p. 6
Australian Crafts, (cat. Crafts Board), 1978
Hersey, April, 'Women in Australian Crafts', *Weaving, the Distaff Side*, 1977
Art and Australia, March 1975, p. 258
Ramson, Bill, (ed.), *Craft '75*, (cat. Australian National University), 1975, pp. 34–35
Bottrell, Fay, (ed.), *The Australian Craftsman in Australia*, 1972, pp. 46–47

JOHN GARDNER

Fern, Lynette, review, *Sydney Morning Herald*, 14 October 1991
Sydney Morning Herald — Good Weekend Magazine, 12 October 1991
Germaine, Max, *Artists and Galleries of Australia*, Craftsman House, Sydney 1990

MAREA GAZZARD

Artfile, Craft Arts International, Sydney 1992
'Symbols and Ceremony', *Belle*, March/April 1986
Borlase, Nancy, 'Back to Basics', *Sydney Morning Herald*, 6 October 1979
Lynn, Elwyn, review, *The Weekend Australian*, 29 September 1979

Borlase, Nancy, review, *The Bulletin*, 17 February 1973

GARRY GREENWOOD

Artfile, Craft Arts International, 1992, p. 38, pp. 106–107
Leatherwood, No. 1, Spring 1991, p. 26, 27, 28
Ita, September 1992, p. 98
Design Journal, No. 20, October 1988, Korea, p. 53
Drury, Nevill, *New Art Four*, Craftsman House, Sydney 1990
'Heavily into Leather', *Regent Magazine*, No. 39, Regent International Hotels 1990, pp. 94–97
Annual Report (cover), Tasmanian Development Authority, 1988, p. 1, pp. 13–14
Asia Pacific Leather Yearbook, 1988, p. 25
Barclay, Alison, 'From Macrame to Musical Leather', *The Weekend Australian*, 16 April 1988
Gottschalk, Dr. S., *Craft Arts*, No. 11, February/March 1988, pp. 34–39
Art Network, No. 16
Vader, Sue, *Pol International*, June/July 1985, p. 36
Vanstone, Michael, *The Adelaide Review*, No. 15, July 1985, p. 8
Wings of Gold, Vol. 10, No. 6, Malaysian Airlines, pp. 32–35
Moult, Allan, *Craft in Australia*, Reed, pp. 90–97
Craft Australia Year Book, 1984, p. 38, 40, pp. 44–45
Geo, Vol. 5, No. 1, p. 108, 116
Belle, September/October 1983, p. 219
The Tasmanian Review, No. 4, 1980, pp. 10–13
Art and Australia, Vol. 22, No. 4, pp. 528–530
Art and Australia, Vol. 17, No. 1, p. 35
Scarlett, Ken, *Australian Sculptors*, Nelson, 1980, pp. 228–229
Craft Australia, 1983, No. 4, pp. 88–92
Craft Australia, 1983, No. 3, p. 104
Craft Australia, 1982, No. 3, pp. 42–43
Craft Australia, 1979, No. 2, pp. 33–34
Craft Australia, 1978, No. 1, pp. 28–29
Craft Australia, 1975, No. 2, p. 28

ANTON HASELL

Catalano, Gary, review, *The Age*, 30 April 1988
Holloway, Memory, 'Recent Themes in Melbourne Art', *Art and Australia*, Vol. 24 No. 4, Winter 1987

JOY HENDERSON

Germaine, Max, *Women Artists of Australia*, Craftsman House, Sydney 1991

Germaine, Max, *Artists and Galleries of Australia*, Craftsman House, Sydney 1990

Australian Contemporary Art Fair 2, catalogue, Melbourne, June 1990

GREG JOHNS

Greg Johns: Sculpture 1978–1990, catalogue, Adelaide 1990

Lynn, Elwyn, review, *The Australian*, 23–24 May 1987

Catalogue of Inaugural Exhibition, Carrick Hill Sculpture Park, 1986

'Greg Johns — Selected Maquettes', *Art and Australia*, Autumn 1984

INGE KING

Ward, Peter, review, *The Australian*, 4 September 1985

Inge King: Sculpture 1945–82, catalogue, University of Melbourne Gallery, 1982

Sturgeon, Graeme, 'Inge King — an Obdurate Certainty', *Art and Australia*, Vol. 16, No. 2, December 1978

Sturgeon, Graeme, *The Development of Australian Sculpture 1788–1975*, Thames & Hudson, London 1978

Hitch, John, 'The Sculpture of Inge King', *Architecture in Australia*, December 1969

MARIA KUCZYNSKA

McMiles, K., *V*, 1988

Hollister, V., *Contemporary Australian Figurative Ceramics*

Hammond, Victoria, *Craft Australia*, various

Hammond, Victoria, *Craft Arts*, No. 8, February/April 1987

Hammond, Victoria, *20th Century Art*, International Art Fair, Basel, 1986

Hammond, Victoria, *Ceramics in Australia*, Vol. 24, No. 3, 1985

Hammond, Victoria (ed.), *Australian Ceramics*

Speight, Charlotte, *Hands in Clay*, USA

Lane, Peter, *Studio Ceramics*, William Collins Sons Co., London 1983

Preud, Tamare, *Porcelain of the 20th Century*, France 1982

POLLY MacCALLUM

McIntyre, Arthur, *Contemporary Australian Collage and its Origins*, Craftsman House, Sydney 1990

Art and Australia, Spring 1985

Art International, May 1982

MICHAEL NICHOLLS

Lynn, Elwyn, 'Freud's cold, naked truth', *The Australian*, 21 November 1992

Germaine, Max, *Artists and Galleries of Australia*, Craftsman House, Sydney 1990

Chanin, Eileen, *Contemporary Australian Painting*, Craftsman House, Sydney 1990

McIntyre, Arthur, *Contemporary Australian Collage and its Origins*, Craftsman House, Sydney 1990

Drury, Nevill, *New Art Three*, Craftsman House, Sydney 1989

McDonnell, J., 'Mike Nicholls', *Interior Design*, Issue 19, 1989, pp. 176–81

Barclay, A., 'Who's Who in the 1990s', *The Weekend Australian*, 25 March 1989, p. 23

Lynn, Elwyn, 'Of the blood culture', *The Australian*, 4 June 1988

Lynn, Elwyn, 'Ecstasy amid the muddle', *The Australian*, 14 February 1987

Adams, B., 'Twisted figures play in theatre of the absurd', *Sydney Morning Herald*, 30 January 1987

Grishin, Sasha, 'First look of high quality', *The Canberra Times*, 14 October 1986

Maloon, Terence, 'The pursuit of eccentricity and risky glitz', *Sydney Morning Herald*, October 1986

Lynn, Elwyn, 'A show that became a tribute to donorship', *The Australian*, October 1986

LESLIE OLIVER

Kidd, Courtney, 'The Pivotal Surface', *State of the Art*, Issue 1, November 1991–March 1992, p. 9

Lynn, Elwyn, review, *The Weekend Australian*, 30 November 1991

Fern, Lynette, review, *Sydney Morning Herald*, 29 November 1991

Belle Magazine, November 1991, p. 10

Exhibition Commentary, *Art and Australia*, Vol. 28, No. 2, 1990

ROBERT PARR

Paroissien, Leon, (ed.), *Australian Art Review*, Warner, 1982

Sturgeon, Graeme, *The Development of Australian Sculpture 1788–1975*, Thames & Hudson, London 1978

Scarlett, Ken, *Australian Sculptors*, Nelson, Melbourne 1980

Legge, Geoffrey, 'Robert Parr's Sculpture', *Art and Australia*, Vol. 17, No. 1, 1979

LYN PLUMMER

Drury, Nevill, *New Art Six*, Craftsman House, Sydney 1992

Thompson, Isabel, *In Position*, The Exhibitions Gallery, Catalogue Essay, February 1992

Sourgnes, Michel, *The Manipulation of Tradition*, Queensland Art Gallery Catalogue, Endgame: A Simple Matter of Balance, April 1990

Richards, Michael, 'Women on Women on Public Display', *The Courier Mail*, 2 May 1990

Ruinard, Elizabeth, 'Redressing the Balance:

Lyn Plummer at the QAG', *Eyeline*, Issue 13, December 1990

Adam, Rosemary, 'Art as an Issue of Place', *Art in Form Newsletter*, June 1989

Richards, Michael, 'Womens Roles are Questioned', *The Courier Mail*, 15 October 1988

Cramer, Sue, 'Clenched Fist of the Mass Media', *The Age*, 14 November 1984

Rainbird, Stephen, 'Commercial Galleries Lead the Way: (The Visual Arts in Brisbane)', *Australian Art Review*, No. 2, 1983

Cramer, Sue, *Sculpture Siege*, Heide Park and Art Gallery Catalogue, November 1983

Holloway, Memory, *The Age*, 18 December 1983

Langer, Dr. Gertrude, 'Transient Tranquillity', *The Courier Mail*, 14 July 1982

Follent, Sarah, 'Women's Art on the March in Queensland', *The Australian*, 11 October 1982

Olsen, John, *Post Courier*, Port Moresby, 28 October 1974

EMANUEL RAFT

Drury, Nevill, *New Art Five*, Craftsman House, Sydney 1991

Germaine, Max, *Artists and Galleries of Australia and New Zealand*, Craftsman House, Sydney 1990

McCulloch, Alan, *Encyclopedia of Australian Art*, Hutchinson, Melbourne 1984

Scarlett, Ken, *Australian Sculptors*, Nelson, Melbourne 1980

Bonython, Kym, *Australian Painting 1960–70*, Rigby, Adelaide 1971

Hughes, Robert, *Art of Australia*, Penguin, Melbourne 1966

ANN-MAREE REANEY

Hawker, 'Fulcrum', *Eyeline*, No. 18, Autumn, pp. 40–41

Drury, Nevill, *New Art Six*, Craftsman House, Sydney 1992

MOCA Bulletin, No. 49, Museum of Contemporary Art, Brisbane 1991, p. 8

The Courier Mail, Brisbane, 18 April 1990

Art and Australia, Vol. 28, No. 1, p. 119

Vale-Slattery, Thomas, and Hoare, John (eds.), *Where Are They Now*, University of Southern Queensland, 1990, pp. 64–67

Harley, Ross (ed.), *Outer Site: Five Contemporary Art Space Projects*, May–June 1988, pp. 57–71

The Mercury, Hobart, December 1988

The Mercury, Hobart, December 1988

Reviews, Australia's Bicentennial Arts Programme Publication, 1988, pp. 512–516

Art Monthly, June 1988

The Southwest Times, Bunbury, WA, October 1987

The Mercury, Hobart, 5 August 1987

The Mercury, Hobart, 1 August 1987
The Southwest Times, Bunbury, WA, August 1987
The Courier Mail, Brisbane, 14 October 1986
The Courier Mail, Brisbane, 11 October 1986

COLIN REANEY
Fulcrum, catalogue, Artsite, Brisbane 1991
MOCA Bulletin, Brisbane, December 1989
MOCA Media Release, Brisbane, February 1988

JAMES ROGERS
Allen, Christopher, review, *Sydney Morning Herald*, 18 April 1989
Lynn, Elwyn, review, *The Australian*, 18 April 1989

MONA RYDER
Art Acquisitions 1990–1992, Queensland University of Technology, 1992
Jakuis, J., and Hudson, M., *Fine Words, Fine Print, Fine Books*, Australian Book Collector's Magazine, 1992
Stanford, Leone, 'Mona's Art Draws on Personal Experience', *Bulletin*, 15 February 1992
Chapman, Audrey, 'In Mona's Case it's Art for Life Sake', *Gold Coast Bulletin*, 6 February 1992
Kirby, Sandy, *Sight Lines: Women's Art and Feminist Perspectives in Australia*, Craftsman House, Sydney 1992
Drury, Nevill, *Images in Contemporary Australian Painting*, Craftsman House, Sydney 1992
Drury, Nevill, *New Art Six*, Craftsman House, Sydney 1992
Kinsella, John, *The Book of Faces: PICA*, 1989
Winter-Irving, Celia, 'Australian Perspecta', *Craft Arts*, February–April 1986
Follent, Sarah, 'The Brisbane Scene', *Art and Australia*, Vol. 24, No. 1, 1986
Follent, Sarah, Text in exhibition catalogue, Australian Perspecta '85, Art Gallery of New South Wales
Airo-Farulla, J., 'Mona Ryder: A Survey', *Art Network*, No. 4, 1985
Woolcock, P., 'The Talent of Mona Ryder — in the World of Woman', *The Courier Mail*, 19 November 1985
Follent, Sarah, 'Mona Ryder: A Survey', *The Australian*, 5 October 1984
Douglas, Craig, 'The Art of Mona Ryder', *Arts Queensland*, Vol. 1, No. 5, August 1984

STEPHEN SKILLITZI
Craft Victoria, December/January 1990–91
Roberts, Julie, *Glass Sculpture*, exhibition catalogue, Blaxland Gallery, Melbourne, September/October 1990
SA Crafts, Issue No. 2, Adelaide 1990
Fourth National Studio Glass Exhibition, catalogue, National Gallery of Victoria, Melbourne 1988

MANNE SCHULZE
Schulze, Manne, 'Documenta IX: Art in Crisis?', *Broadsheet*, September 1992
Schulze, Manne, 'A Fairy Tale: The Story of Jeff and Ilona', *Broadsheet*, December 1991
McNeil, Shane, 'Dabbling with the Daubists', *Broadsheet*, December 1992
Meyer, Peter, 'Die Froschkönigin von Diedorf', *Augsburger Allgemeine*, 4 August 1992
Bolton, Ken, 'Blowing Raspberries at Store Landscapes', *The Adelaide Advertiser*, 24 June 1992
Merrit, Alan, *On Dit*, 15 June 1992
Goers, Peter, 'Festival and Fringe Reviews', *The Sunday Mail*, 8 March 1992
Bolton, Ken, 'A Crackle of Electricity', *Broadsheet*, March 1992
Bolton, Ken, 'Pair in Fine Form', *The Adelaide Advertiser*, 24 February 1992
Harris, Samela, 'Get Knickered', *The Adelaide Advertiser*, 21 February 1992
Osborne, Margot, 'Provoking a Huge Success', *The Adelaide Advertiser*, 3 October 1991
Art Almanac, June 1991, editorial pages
Neylon, John, 'Mickey Mouse Mutates', *The Adelaide Review*, May 1991, pp. 21–22
Radok, Stephanie, *Art Monthly*, May 1990, p. 13
Morrell, Tim, 'Nice Ideas and Nasty Tricks', *Broadsheet*, March 1990, pp. 18–19
Emery, John, 'Descent into Dreams Transformed into Images', *The Adelaide Advertiser*, 20 February 1990

ALICK SWEET
Richards, Michael, review, *Brisbane Courier Mail*, 11 April 1990
Stanford, Leone, *MOCA Bulletin*, Issue No. 32, Brisbane, May 1990
Treacy, Megan, *Eyeline*, Issue 6, Brisbane, September 1988
Treacy, Megan, catalogue essay to accompany the exhibition 'Twenty Six Birds, Three Dogs and a Foot', June 1988

PETER TILLEY
Stowell, Jill, review, *The Newcastle Herald*, 28 October 1991
'Recent works featuring Hunter Valley Sculpture', *The Maitland Herald*, 23 October 1991
Raper, Maria T., 'Warpaint', *Art City*, No. 10, July 1991
Stowell, Jill, review, *The Newcastle Herald*, 8 April 1991
Stowell, Jill, review, *The Newcastle Herald*, 7 January 1991
Germaine, Max, *Artists and Galleries of Australia*, Craftsman House, Sydney 1990

Art City, Vol. 2, September 1990
Stowell, Jill, review, *The Newcastle Herald*, 22 August 1990
Shifting Ground, exhibition catalogue: Newcastle Artists at the Art Gallery of New South Wales, August 15–19, 1990
Chesterfield-Evans, Jan, 'What if When', *Artemis*, Newcastle Gallery Society magazine, Vol. 20, No. 3, July/September 1990
Thompson, Isabel, 'Iconic Assemblage', *Craft Arts*, No. 18, March/June 1990
Eley, Margaret, review, *The Newcastle Herald*, 25 January 1988

STEPHEN TRETHEWEY
Lloyd, Tim, review, *The Advertiser*, Adelaide, 5 February 1992
Bogle, Michael, 'A Fusion of Art and Artifice', *The Sydney Review*, August 1991
Home Beautiful, December 1991, p. 11
'Style in Steel', *Interiors*, Vol. 5, No. 4, p. 17

TONY TREMBATH
Plant, Margaret, 'Tony Trembath's Electrical Museum and Other Circuitries' (in press)
Edgar, Ray, 'Images of Dream Worlds', *Melbourne Times*, 26 February 1992, p. 38
Hardwick, Deane, 'No Place Like Home', *Agenda*, No. 5, 1989
Murray, Kevin, 'John Lethbridge, Robert Owen, Tony Trembath: Europe and Back', *Eyeline*, No. 10, Brisbane 1989
Heathcote, Christopher, *Art Monthly*, July 1989
Duncan, Jenepher, 'Passages and Wells' in Europe and Back: Australian Artists' *Installations*, Monash University Gallery, Melbourne 1989
Ian Howard, *Introduction to Europe and Back* (see above)
Catalano, Gary, review, *The Age*, 7 September 1988
Millar, Ronald, review, *Melbourne Herald*, 7 September 1988
Rooney, Robert, review, *The Weekend Australian*, 17 September 1988
Scarlett, Ken, 'Contemporary Sculpture from Australia' in *Ikebana Ryusei* (ed. Hohji Haijama), No. 10, February 1986
Dover, Barbara, 'Animals for Art's Sake, Art for Animal's Sake', *Animal Liberation* magazine, 1984
Trembath, Tony, *Singular and Plural*, artist's statement, 1985
Sturgeon, Graeme, *Australian Sculpture Now — Second Australian Sculpture Triennial*, National Gallery of Victoria, Melbourne 1984
Murphy, Bernice, *Project 45*, Art Gallery of New South Wales, 1984
Short, Susanna, review, *Sydney Morning Herald*, 13 July 1984
Duncan, Jenepher, 'Acquisitions and

Alternatives', Monash University Gallery, Melbourne 1984

Trembath, Tony, artist's statement, Ivan Dougherty Gallery, Sydney 1984

Murphy, Bernice, *Australian Perspecta*, catalogue, Art Gallery of New South Wales, Sydney 1981

McCullough, Tom, *The First Australian Sculpture Triennial*, Melbourne 1981

Bentley, John, review, *Globe and Mail*, Toronto, 13 June 1981

Oille, Jennifer, 'A Question of Place', *Vanguard*, Vol. 10, No. 8, Vancouver Art Gallery, 1981

GEORGE TURCU

Catalano, Gary, review, *The Age*, 15 June 1988

Millar, Ronald, review, *Melbourne Herald Wednesday Magazine*, 22 June 1988

JOHN TURIER

Geissler, Marie, 'Spatial Harmonics', *Craft Art International*, No. 24, 1992, pp. 68–70

Fonteyn, Zephyr, Catalogue Essay, *Unfamiliar Territory: Adelaide Biennial of Australian Art*, Art Gallery of South Australia, 1992

Drury, Nevill, *New Art Five*, Craftsman House, Sydney 1991

HOSSEIN VALAMANESH

Delaruelle, Jacques, *The Sydney Review*, August 1992

Allen, Christopher, *Asian Art News*, July/August 1992

South Australian Advertiser, 7 May 1992

Earthly Shadow, Catalogue, Kunstlerhaus Bethanien, Berlin 1992

Sturgeon, Graeme, *Contemporary Australian Sculpture*, Craftsman House, Sydney 1991

Hossein Valamanesh, 1980–90 Catalogue, Catalogue, Contemporary Art Centre of South Australia, 1990

Transition, Discourse on Architecture, No. 32, Autumn 1990

Delaruelle, Jacques, *The Sydney Review*, April 1990

Sydney Morning Herald, 24 February 1990

Art Monthly, No. 26, November 1989

Artlink, Vol. 9, No. 2, Winter, 1989

South Australian Advertiser, 15 July 1989

South Australian Advertiser, 31 May 1989

Sydney Morning Herald, 11 June 1988

Drury, Nevill, *New Art Two*, Craftsman House, Sydney 1988

Metro Mania, Catalogue, Australian Regions Artists' Exchange, Perth, WA

South Australian Advertiser, 21 October 1987

CAC Broadsheet, Vol. 16, No. 2, June 1987

Painters and Sculptors, Catalogue, Queensland Art Gallery, 1987

Third Sculpture Triennial, Catalogue, National Gallery of Victoria, 1987

Australian Contemporary Art, Catalogue, Museum of Modern Art, Saitama, Japan 1987

Some Provincial Myths, Catalogue, Contemporary Arts Centre of South Australia, 1987

Ikebana Ryusei (Japan), No. 315, July 1986

Financial Review, 16 August 1985

The Australian, 10 August 1985

Sydney Morning Herald, 3 August 1985

The Australian, 25 April 1985

South Australian Advertiser, 13 April 1985

Australian Perspecta, Catalogue, Art Gallery of New South Wales, 1985

Singular and Plural, Catalogue, South Australian School of Art, 1985

Common Earth, Alive and Unfired, Catalogue, University of Tasmania, School of Art Publication, 1985

Artlink, Vol. 3, No. 5, 1984

On Site, Catalogue, University of Tasmania, School of Art Publication, November 1984

Art and Australia, Vol. 21, No. 3, 1984

Sydney Morning Herald, 3 August 1984

Aspect, No. 29/30, Autumn 1984

The Australian, 19 May 1984

Words & Visions, No. 13/14, Summer 1983

South Australian Advertiser, 5 October 1983

The Australian, 5 October 1983

Art and Australia, Vol. 20, No. 3, 1983

Ikebana Ohara (Japan), No. 393, August 1983

Artlink, Vol. 2, No. 2, 1983

Artlink, Vol. 1, No. 4, 1982

South Australian Advertiser, 26 June 1982

Art and Australia, Vol. 19, 1981

Art Network, Vol. 3–4, 1981

The Australian, 17 July 1981

First Australian Sculpture Triennial, Catalogue, La Trobe University, 1981

Australian Perspecta, Catalogue, Art Gallery of New South Wales, 1981

South Australian Advertiser, 20 August 1980

South Australian News, 20 August 1980

South Australian Advertiser, 5 March 1980

South Australian Advertiser, 19 July 1978

The Australian, 19 July 1978

TREVOR WEEKES

Cochrane, Peter, 'Flights of Fancy Land in a Gallery', *Sydney Morning Herald*, 25 November 1992

'Dreams of Flight at Macquarie Galleries', *Nine to Five*, 23 November 1992

Lynn, Elwyn, 'We Must Go Down to the Sea Again', *The Weekend Australian*, 2–3 September 1989

Watson, Bronwyn, 'Review', *Sydney Morning Herald*, 14 August 1987

Nicklin, Lenore, 'To Trevor Weekes, chooks are birds — and art', *The Bulletin*, 10 December 1985

Artworks Glass, Catalogue, Craft Council Gallery, January 1985

McDonald, John, 'Proof There's More to Glass Than Holding a Beer', *The Australian*, 5 February 1985

'Trevor Weekes', *Australian Artists*, November 1984

McCulloch, Alan, *Encyclopedia of Australian Art*, Hutchinson Group, Victoria 1984

Short, Susanna, 'Exhibition Looks Beyond Surface of Imagery', *Sydney Morning Herald*, 22 June 1984

McGrath, Sandra, 'In Search of the Perfect Horse for the Perfect Betrayal', *The Weekend Australian*, 6 June 1984

Mendelssohn, Joanna, 'Andean Condor', *Art Network*, No. 11, Spring 1983

Animal Imagery in Contemporary Art, Catalogue, Ballarat Art Gallery, 1983

'The Andean Condor Expedition', *Artworks*, Winter 1983

O'Brien, David, 'The Man Who Tossed a Dead Condor at the Art World', *Magazine*, 2–8 June 1983

McGrath, Sandra, 'Flights of Condor Fantasy from Fanciful Expedition', *The Weekend Australian*, 28–29 May 1983

Short, Susanna, 'Art', *Sydney Morning Herald*, 26 August 1982

McGrath, Sandra, 'Dazzling Days of the Condor', *The Weekend Australian*, 21–22 August 1982

McGrath, Sandra, 'Fare is Fowl and Fowl is Fair', *The Weekend Australian*, 17 April 1982

Neylon, John, 'Astonishing Work Leaves One Hanging', *The News*, 10 March 1982

Short, Susanna, 'Earth-bound Flight Show takes off', *Sydney Morning Herald*, 3 July 1981

'Charles T Icarus', *Sydney Morning Herald*, 22 November 1980

McGrath, Sandra, 'Precisely', *The Weekend Australian*, 15–16 November 1980

Coleman, Richard, 'Artist Takes Off in the Style of Leonardo da Vinci', *Sydney Morning Herald*, 12 November 1980

Spiers, John, 'Art Show is a Flight of Fancy', *The Australian*, 12 November 1980

Australian Comic Collector, Vol. 4, No. 11, June 1980

Ingram, Terry, *Financial Review*, 7 March 1980

Borlase, Nancy, 'Terra Firma — Dreams of Flight', *Sydney Morning Herald*, 21 July 1979

Sykes, Jill, 'Interpreting a Devoted Fascination to Flight', *Sydney Morning Herald*, 18 July 1979

LIZ WILLIAMS

Pottery in Australia, Vol. 27, No. 4, December 1988

'Liz Williams', *Contemporary Australian Figurative Ceramics*, May 1988

DAN WOLLMERING

Drury, Nevill, *New Art Eight*, Craftsman House, Sydney 1993

Hansen, David, *Continuous Functions*, Catalogue, Mildura Arts Centre, June 1992

Art and Australia, Vol. 29, No. 5, Autumn 1992

Geisser, Marie, 'Australian Art in Japan', *Craft Arts International*, No. 21, 1991

Muldoon, Aileen, 'Sculptures Mark Time for Wollmering', *Monash Reporter*, May 1990

Bensley, Karen and Hansen, David, *Contemporary Gippsland Artists*, La Trobe Valley Arts Centre, August 1990

Imai, Terry, *Australian Contemporary Art*, AZ Gallery, Tokyo 1990

Scarlett, Ken, 'Sculpture for Melbourne', *Art Monthly*, October 1989

Heynatz, Jeannie, 'Dan Wollmering — A'Beckett on Swan', *La Trobe Valley Express*, August 1988

The October Show, Catalogue, La Trobe Valley Arts Centre, 1988

Murray, Michael, *Tenth Mildura Sculpture Triennial*, Catalogue, Mildura Arts Centre, 1988

Griffiths, Anna, 'You Can't Knock Wood', *La Trobe Valley Express*, October 1987

Edwards, Geoffrey, 'Sculpture in Wood', *Third Australian Sculpture Triennial*, National Gallery of Victoria, Melbourne 1987

Catalano, Gary, 'Six Independents in Search of and Audience', *The Age*, July 1986

Green, Janina, 'Elegant and Satisfying', *The Melbourne Times*, July 1986

Scarlett, Ken, *Sculpture for Melbourne*, Catalogue, Melbourne University, 1986

Kennedy, Heather, 'Chance Meeting Led to Joint Work', *The Age*, July 1985

Murray, Michael, *Ninth Mildura Sculpture Triennial*, Catalogue, Mildura Arts Centre, 1985

Newman, Judy, 'Around the Galleries', *The Age*, April 1981

McCulloch, Alan, 'Parade of the Pre-Columbians', *The Melbourne Herald*, April 1981

McCullough, Thomas, *The First Australian Sculpture Triennial*, Catalogue, First Australian Sculpture Committee, Melbourne 1981

Forster, Deborah, 'A Well Bread Couple', *The Age*, June 1979

Eagle, Mary, 'Journey Through a Brave New World', *The Age*, June 1979

McCulloch, Alan, 'Shows Gathers Momentum', *The Melbourne Herald*, June 1979

ONE-PERSON EXHIBITIONS

ARTHUR ASHBY

1973	Gallery 88, Rome
1976	Gallery Orly, Basel
1977	Heritage Gallery, Cheltenham, England
1978	The Studio Gallery, Rome
1979	La Zecca Privata di Roma, Rome
1981	The Studio Gallery, Rome
1983	Gallery Orly, Basel
1988	Coventry Gallery, Sydney
1989	De Gruchy, Melbourne
1992	School of Architecture, University of Melbourne

RODNEY BROAD

1970	Contemporary Art Society Gallery, Christchurch
1972	Sculpture and Woodcut Prints, Fine Arts Gallery, University of Tasmania
1973–74	Print exhibitions, Little Gallery, Devonport
1974	Exhibition of Woodcut Prints, Bowerbank Mill Gallery, Deloraine
1986	Macquarie Galleries, Sydney
1987	Macquarie Galleries, Sydney
1988	Macquarie Galleries, Sydney
1989	Macquarie Galleries, Sydney
1990	Macquarie Galleries, Sydney
1991	Macquarie Galleries, Sydney

PETER D. COLE

1969	Flinders University, Adelaide
1970	Solo installation at Pinacotheca, Melbourne
1980	Ewing Gallery, Melbourne
1983	United Artists, Melbourne
1984	Macquarie Galleries, Sydney
1985	Macquarie Galleries, Sydney
1986	Macquarie Galleries, Sydney
1986	Realities Gallery, Melbourne
1987	Macquarie Galleries, Sydney
1988	Macquarie Galleries, Sydney
1989	Macquarie Galleries, Sydney
1990	Macquarie Galleries, Sydney
1990	William Mora Galleries, Melbourne
1991	Macquarie Galleries, Sydney
1992	Chicago International New Art Forms Exposition, Chicago

BRIGID COLE-ADAMS

1985	Gallery 10, Washington DC (installation)
1987	70 Arden Street Gallery, Melbourne

	(sculpture)
1989	70 Arden Street Gallery, Melbourne (drawing, painting, sculpture)
1991	Judith Pugh Gallery, Melbourne
1991	'Underlay', Installation, Port Fairy Spring Festival
1992	'The Golden Echo', Installation for performance by soloists from the Praetorius Wind Quintet, Port Fairy Spring Festival

MICHAEL ESSON

1986	Coventry Gallery, Sydney
1988	Coventry Gallery, Sydney
1990	Crawford Art Centre, St Andrews, Scotland
1990	Artspace, Aberdeen, Scotland
1991	Coventry Gallery, Sydney
1993	Coventry Gallery, Sydney

JUTTA FEDDERSEN

1967	Hungry Horse Gallery, Sydney
1968	The Johnstone Gallery, Brisbane
1970	Bonython Gallery, Sydney
1971	Realities Gallery, Sydney
1972	McClelland Gallery, Melbourne
1972	Bonython Gallery, Sydney
1974	Realities Gallery, Melbourne
1975	Bonython Gallery, Sydney
1977	Realities Gallery, Melbourne
1981	Roslyn Oxley9 Gallery, Sydney
1987	Coventry Gallery, Sydney
1988	Ivan Dougherty Gallery, Sydney
1988	New England Regional Art Museum, Armidale
1989	New England Regional Art Museum, Armidale
1989	Coventry Gallery, Sydney
1991	Coventry Gallery, Sydney

JOHN GARDNER

1970	Mulhern Townhouse, Brooklyn, New York
1976	Sculpture Centre, Sydney
1976	Toorak Gallery, Melbourne
1980	ANZ Bank, Martin Place, Sydney
1986	Council Chambers, Katoomba
1991	Access Contemporary Art Gallery, Sydney

MAREA GAZZARD

1960	Westmount Gallery, Montreal
1963	Hungry Horse Gallery, Sydney

1965	Johnstone Gallery, Brisbane
1966	Gallery A, Sydney
1967	Johnstone Gallery, Brisbane
1969	Gallery A, Sydney
1970	South Yarra Gallery, Melbourne
1973	'Clay and Fibre' (with Mona Hessing), National Gallery of Victoria, Melbourne
1973	Bonython Gallery, Sydney
1979	Coventry Gallery, Sydney
1987	Coventry Gallery, Sydney
1990	Coventry Gallery, Sydney

GARRY GREENWOOD

1972	Shearin' Shed Gallery, Sydney
1973	Little Gallery, Devonport, Tasmania
1975	Bowerbank Mill Gallery, Deloraine, Tasmania
1976	Narek Gallery, Cuppacumbalong, Canberra
1976	Saddlers Court Gallery, Richmond, Tasmania
1977	Bowerbank Mill Gallery, Deloraine, Tasmania
1978	Gryphon Gallery, Melbourne State College, Melbourne
1979	University of Tasmania, Fine Arts Gallery, Hobart
1979	Art of Man Gallery, Paddington, Sydney
1980	Craft Centre Gallery, South Yarra, Melbourne
1981	Distelfink Gallery, Hawthorn, Melbourne
1983	'Stepping Out', Australian Craftworks, Sydney
1984	Narek Gallery, Cuppacumbalong, Canberra
1985	Bonython-Meadmore Gallery, Adelaide
1985	Handmark Gallery, Hobart
1985	Distelfink Gallery, Hawthorn, Melbourne
1988	Holdsworth Contemporary Galleries, Sydney
1989	Tamworth City Gallery
1989	Launceston/Ikeda Japan Cultural Exchange Exhibition, Ikeda, Japan
1989	Distelfink Gallery, Melbourne
1991	Decorex '91, Melbourne
1991	Distelfink Gallery, Melbourne
1992	Holdsworth Gallery, Sydney

ANTON HASELL

| 1990 | 'Hung, Drawn and Scupted, Ju'dith Pugh Gallery, Melbourne |

JOY HENDERSON

| 1988 | Access Contemporary Art Gallery, Sydney |
| 1989 | Access Contemporary Art Gallery, Sydney |

GREG JOHNS

1980	Bonython Gallery, Adelaide
1981	Roundspace Gallery, Adelaide
1983	Robin Gibson Galleries, Sydney
1983	Bonython Gallery, Adelaide
1987	Bonython-Meadmore Gallery, Adelaide
1987	Robin Gibson Galleries, Sydney
1991	BMG Fine Art, Adelaide, Survey exhibition
1992	BMG Fine Art, Adelaide
1992	Bridge St Gallery, Sydney
1993	Greenaway Gallery, Adelaide

TED JONSSON

1986	Contemporary Art Centre, Adelaide
1988	'Bull Ring Space', Jam Factory Gallery, Adelaide
1989	Chesser Gallery, Adelaide
1990	Chesser Gallery, Adelaide
1992	Greenaway Gallery, Adelaide

INGE KING

1949	London Gallery, Brook Street (carvings and drawings)
1969	Powell Street Gallery, Melbourne (steel sculpture)
1973	Chapman, Powell Street Gallery, Melbourne (marquettes for monumental sculptures)
1977	'Sculptures 77', Realities Gallery, Melbourne
1978	Coventry Gallery, Sydney
1978	Victor Mqace Gallery, Brisbane
1980	'Sculptures 80', Realities Gallery, Melbourne
1982	'Inge King Sculpture, 1945–82 a survey', University Gallery, Melbourne University
1985	Realities Gallery, Melbourne (sculpture)
1985	Bonython-Meadmore Gallery, Adelaide
1987	Bonython-Meadmore Gallery, Sydney
1988	Australian Gallery, Melbourne (sculptures in steel and bronze)
1989	Australian Gallery, Melbourne (works on paper)
1989	BMG Fine Art, Adelaide

MARIA KUCZYNSKA

1979	Gallery of Modern Art (BWA) Gdansk, Poland
1980	Premio Faenza 1979, Faenza, Italy
1982	Gallery Schneider, Frieburg, Germany
1982–83	Major touring exhibition throughout Australia
1983	Dusseldorf Gallery, Perth
1983	Cooks Hill Gallery, Newcastle, New South Wales
1984	Christchurch Art Festival, New Zealand
1986	International Art Fair, Basel, Switzerland
1986	Macquarie Galleries, Sydney
1986	Christine Abrahams Gallery, Melbourne
1986	Grosser Bachem Galleries, Cologne, Germany
1988	Macquarie Galleries, Sydney
1988	Christine Abrahams Gallery, Melbourne
1989	Allrich Gallery, San Francisco, USA
1992	Poland
1992	Galerie Leonelli, Lausanne, Switzerland

POLLY MacCALLUM

1980	Holdsworth Galleries, Sydney
1983	Fremantle City Art Gallery
1985	Coventry Gallery, Sydney
1986	Wollongong City Art Gallery
1986	Coventry Gallery, Sydney
1988	Coventry Gallery, Sydney
1990	Coventry Gallery, Sydney
1992	Coventry Gallery, Sydney

ALEXIS McKEAN

1987	70 Arden Street, Melbourne
1990	Judith Pugh Gallery, Melbourne
1991	Judith Pugh Gallery, Melbourne

MICHAEL NICHOLLS

1986	Coventry Gallery, Sydney
1987	13 Verity Street, Melbourne
1988	Coventry Gallery, Sydney
1989	13 Verity Street, Melbourne
1990	Coventry Gallery, Sydney
1991	13 Verity Street, Melbourne
1991	Coventry Gallery, Sydney

ROGER NOAKES

1977	'Seascape III + IV', Floatile sculptural installation, Sough Glenelg Beach, South Australia
1979	'Seascape V + VI', Floatile sculptural installation, Maslins Beach, South Australia
1982	'Fenced', Sculptural installation in East Adelaide parklands, Adelaide Festival or Arts

| 1983 | 'Beyond the Bath', Roundspace Gallery, Adelaide |
| 1988 | Open Studio, VA/CB Australian Studio, Space Studios, London |

LESLIE OLIVER

1990	Access Contemporary Art Gallery, Sydney
1991	Access Contemporary Art Gallery, Sydney
1993	Access Contemporary Art Gallery, Sydney

ROBERT PARR

1964	Barry Stern Gallery, Sydney
1965	Argus Gallery, Melbourne
1966	Watters Gallery, Sydney
1968	White Studio Gallery, Adelaide
1970	Watters Gallery, Sydney
1972	Watters Gallery, Sydney
1972	'Mini Retro', Macquarie Galleries, Sydney
1974	Watters Gallery, Sydney
1977	Abraxas Gallery, Canberra
1978	Watters Gallery, Sydney
1980	Watters Gallery, Sydney
1981	Solander, Canberra
1982	Watters Gallery, Sydney
1984	Pinacotheca Gallery, Melbourne
1985	Watters Gallery, Sydney
1986	Pincacotheca Gallery, Melbourne
1987	Watters Gallery, Sydney
1988	Pinacotheca Gallery, Melbourne
1989	Watters Gallery, Sydney
1991	Watters Gallery, Sydney
1991	312 Lennox Street at Pinacotheca, Melbourne

LYN PLUMMER

1974	Arts Council of Port Moresby, Papua New Guinea (painting)
1976	Arts Council of Port Moresby, Papua New Guinea (painting)
1977	Arts Council of Port Moresby, Papua New Guinea (painting)
1977	Susan Gillespie Galleries, Canberra
1981	Graduation Exhibition, Canberra School of Art Gallery (sculpture)
1982	'Transient Extensions', Ray Hughes Gallery Downtown, Brisbane (sculpture)
1982	'After Images', Gallery A, Sydney (sculpture)
1986	Enshrined Spoils, Albury Regional Art Gallery, Albury (sculpture and drawings)
1988	'Adroit Performers', Roz MacAllan Gallery, Brisbane (sculpture and drawings)
1990	'Recent Sculpture and Drawings', Artel Studio Workshop, Albury

EMANUEL RAFT

1990	'Endgame: A Simple Matter of Balance', Queensland Art Gallery
1991	'Her Appropriate Sphere', Artel Studio Workshop, Albury (installation)

EMANUEL RAFT

1962	Barry Stern Gallery, Sydney
1962	Douglas Gallery, Brisbane
1963	Marian Best Design Studio, Sydney
1963	Gallery A, Melbourne
1963	White Studio, Adelaide
1963	Hungry Horse Gallery, Sydney
1964	Hungry Horse Gallery, Sydney
1965	Hungry Horse Gallery, Sydney
1966	Bonython Gallery, Adelaide
1966	Bonython Gallery, Sydney
1968	Bonython Gallery, Sydney
1969	Bonython Gallery, Sydney
1973	Bonython Gallery, Sydney
1977	Electrum Gallery, London
1978	Robin Gibson Gallery, Sydney
1978	Bonython Gallery, Adelaide
1978	Makers Mark Gallery, Melbourne
1979	Robin Gibson Gallery, Sydney
1986	Coventry Gallery, Sydney
1987	Coventry Gallery, Sydney
1989	'Celebration of the Last Flight', Coventry Gallery, Sydney
1990	Coventry Gallery, Sydney
1992	Coventry Gallery, Sydney

ANN-MAREE REANEY

1985	'Structures and Infrastructures', School of Art Gallery, University of Tasmania
1986	'From the Margins', THAT Contemporary Art Space, Brisbane
1987	'Filia/Soror/Femina', Bunbury Regional Art Gallery, Western Australia
1987	Chameleon Contemporary Art Space, Hobart, Tasmania
1988	'Shards of Consciousness', Galerie Cannibal Pierce, St Denis, Paris
1990	'Object d'Art', Roz MacAllan Gallery, Brisbane
1991	'Still Life, No Vacancy', Civic Arcade, Brisbane (collaboration with Colin Reaney)
1991	'Fulcrum: Epistemology, Manicure/ Epicure', Artsite, Brisbane

COLIN REANEY

1984	'Previews', Red Hill Gallery, Brisbane
1985	'Grace and the Sharks', Avago Gallery (Chameleon Gallery), Hobart, Tasmania
1986	'From Exile', Centre for the Arts Gallery, University of Tasmania,

	Hobart, Tasmania
1987	'Return from Exile', Roz MacAllan Gallery, Brisbane
1988	'L'effimero Monumentale', Museum of Contemporary Art, Brisbane
1988	Exterior Installation, Cannibal Pierce Galerie, Saint Denis, Paris
1989	'In the Secluded Enclosure of a Domestic Utopia', Roz MacAllan Gallery, Brisbane
1991	Big Small Gallery, University College of Southern Queensland, Toowoomba
1991	'No Vacancy', Civic Arcade, Brisbane
1991	Fulcrum Project 'Folly', Site Gallery, Fortitude Valley, Brisbane
1992	'The Poverty of Brute Perception', Cannibal Pierce Galerie, St Denis, Paris

JAMES ROGERS

1985	Coventry Gallery, Sydney
1987	Coventry Gallery, Sydney
1989	Coventry Gallery, Sydney
1991	Coventry Gallery, Sydney
1993	Coventry Gallery, Sydney

MONA RYDER

1980	Queensland University of Technology, Kelvin Grove
1984	'Mona Ryder: A Survey', University Art Museum, University of Queensland
1985	Michael Milburn Galleries, Brisbane
1985	'Mona Ryder: A Survey Travelling Exhibition', Queensland Arts Council
1986	'Mona Ryder: A Survey Travelling Exhibition', Queensland Arts Council
1986	'Mona Presents Circus Follies of Exasperating Subtlety', Queensland Performing Arts Centre
1987	'Mona Ryder: Recent Works', The Centre Gallery, Surfers Paradise
1987	'Passing On', Michael Milburn Galleries, Brisbane
1990	'The Heart of the Matter', Roz MacAllan Gallery, Brisbane

STEPHEN SKILLITZI

1967	Aladdin Gallery, Sydney
1971	Bonython Gallery, Sydney
1971	Potters Gallery, Sydney
1972	Realities, Melbourne
1972	Potters Gallery, Sydney
1973	Macquarie Galleries, Sydney
1974	Aldgate Gallery, Adelaide
1974	Waterways Gallery, Perth
1974	Cottage Gallery, Hobart

1975	Festival Centre, Adelaide
1976	Collectors Gallery, Perth
1976	Playhouse Gallery, Adelaide
1976	Narek Gallery, Canberra
1977	Potters Gallery, Sydney
1978	Holdsworth Galleries, Sydney
1979	Gallery 180, Melbourne
1980	Beaver Gallery, Canberra
1981	Bonython Gallery, Adelaide
1981	Holdsworth Galleries, Sydney
1982	Quentin Gallery, Perth
1983	Von Bertouch Gallery, Newcastle
1984	Glass Artists, Sydney
1985	Virtu Gallery, Brisbane
1986	Studio 20, Adelaide
1988	Bethany Gallery, Tanunda
1991	Judy Youens Gallery, Houston, Texas
1992	Miller Gallery, New York City

MANNE SCHULZE

1989	'HA!', Club Foote Gallery, Adelaide
1990	'Fragments', Chesser Gallery, Adelaide
1991	'Life, Black Holes and all that Stuff', Chesser Gallery, Adelaide
1991	'Life, Black Holes and all that Stuff (modified version)', Terra Australis Gallery, Melbourne
1992	'Downstairs', Chesser Gallery, Adelaide

ALICK SWEET

1978	Queensland College of Art, Brisbane
1980	Mount Gravatt College of Advanced Education, Brisbane
1985	Michael Milburn Galleries, Brisbane
1988	Roz MacAllan Gallery, Brisbane
1990	Roz MacAllan Gallery, Brisbane
1992	Ipswich Regional Art Gallery, Brisbane

PETER TILLEY

1984	'The Blue Water Wonderland Show', The Butchers Exhibit, Sydney
1985	'A Collection of Objects', Gabriel Gallery, Footscray Community Arts Centre, Melbourne
1987	Von Bertouch Galleries, Newcastle
1989	Access Contemporary Art Gallery, Sydney
1990	'Small Sculptures', Melbourne Contemporary Art Gallery, Melbourne
1990	'Iconic Assemblages', Access Contemporary Art Gallery, Sydney
1992	'Subjective Objects', Access Contemporary Art Gallery, Sydney

STEPHEN TRETHEWEY

1988	'Simple Gestures', Access

Contemporary Gallery, Sydney
(sculpture)

1989 'Leaps and Bounds', Access
Contemporary Gallery, Sydney
(sculpture)

1991 'The Steel Room', Access
Contemporary Gallery, Sydney
(sculptural furniture)

TONY TREMBATH

1977 Works in Progress, Caulfield
Institute of Technology, Melbourne

1979 Documentation of Works, Third
International Community Education
Conference, Melbourne

1980 Pinacotheca, Melbourne

1983 Avago, 13 McDonald Street,
Paddington, Sydney

1984 Project 45, Art Gallery of New
South Wales

1984 Avago, 13 McDonald Street,
Paddington, sydney

1988 'Some Souvenirs of Paris', 312
Lennox Street Gallery, Melbourne

1992 'Pictures From a Somniloquist's
Diary', William Mora Galleries,
Melbourne

1992 Greenaway Art Gallery, Adelaide

GEORGE TURCU

1979 Sculpture exhibition, Art Gallery,
Nuremburg, Germany

1981 Sculpture exhibition, Frankische
Gallery, Nuremburg, Germany

1981 Sculpture exhibition, International
Gallery, Cologne, Germany

1983 Sculpture exhibition, Makers Mark
Gallery, Melbourne

1983 Sculpture exhibition, TECNO,
Collins Place, Melbourne

1983 Sculpture exhibition, Art Centre-
Concert Hall, Melbourne

1988 Sculpture exhibition, Pinacotheca,
Melbourne

1990 Sculpture exhibition, Pinacotheca,
Melbourne

JOHN TURIER

1989 Coventry Gallery, Sydney
1991 Coventry Gallery, Sydney
1993 Coventry Gallery, Sydney

HOSSEIN VALAMANESH

1972 Shiraz University, Shiraz, Iran
1977 Experimental Art Foundation,
Adelaide

1980 Festival Centre Gallery, Adelaide
1981 Bonython Gallery, Adelaide
1981 Praxis Gallery, Perth
1981 'Execution' Installation, Roundspace
Gallery, Adelaide

1983 Bonython Gallery, Adelaide

1984 Macquarie Galleries, Sydney
1985 Macquarie Galleries, Sydney
1986 Gryphon Gallery, Melbourne
1986 Walter Reid Art Centre,
Rockhampton

1987 Bonython-Meadmore Gallery,
Adelaide

1988 Macquarie Galleries, Sydney
1990 Macquarie Galleries, Sydney
1990 'Survey of Recent Work 1980–90',
Contemporary Art Centre of South
Australia

1990 Luba Bilu Gallery, Melbourne
1991 Kunstlerhaus Bethanien, Berlin
1992 Greenaway Art Gallery, Adelaide
1992 Macquarie Galleries, Sydney
1992 Luba Bilu Gallery, Melbourne
1993 Centre for Contemporary Art,
Ujazdowski Castle, Warsaw

TREVOR WEEKES

1979 'Sopwithicus, Snipus, Species
Extinctus', Macquarie Galleries,
Sydney

1980 'Flight, Man and Machine, the
Society for Man-Made Flight,
Established 1485', Macquarie
Galleries, Sydney

1981 'Project Pelican, the Flight Show',
Macquarie Galleries, Sydney

1982 'Teach Your Chicken to Fly Kit',
Macquarie Galleries, Sydney

1983 'Charlotte Darling's Andean Condor
Expedition of 1830–1833',
Macquarie Galleries, Sydney

1984 'The Perfect Trojan Horse',
Macquarie Galleries, Sydney

1985 'The Art of Fowlconry', Macquarie
Galleries, Sydney

1987 'Trojan Life — City of Dreams',
Macquarie Galleries, Sydney

1988 'And the Wolf Shall Devour the
Moon', touring exhibition of
Regional Galleries in New South
Wales and Victoria

1989 'The Lost Sea-Wolves', Macquarie
Galleries, Sydney

1990 'The Horse's Head', Macquarie
Galleries, Sydney

1992 'Dreams of Flight Exhibition,
Trilogy: Part 1', Macquarie
Galleries, Sydney

LIZ WILLIAMS

1981 Scripps College, Los Angeles
1983 Jam Factory Gallery, Adelaide
1985 Devise Gallery, South Melbourne
1986 Bonython-Meadmore Gallery,
Adelaide

1988 BMG Fine Art, Adelaide
1990 Adelaide Festival Centre Foyer

1992 'This Mortal Flesh', Adelaide Town
Hall

DAN WOLLMERING

1979 'In Search of One Modern Jet That
Can Generate World Views About
Getting Ahead', Ewing and George
Patton Galleries, Melbourne
University (with Gingie Johnson)

1980 Mildura Arts Centre, Mildura,
Victoria (with Gingie Johnson)

1981 Powell Street Gallery, Melbourne
(collaboration with Gingie Johnson)

1985 'Valley Geist', ROAR Studios,
Fitzroy, Victoria

1986 'Sculpture for Melbourne', Gryphon
Gallery, Melbourne University

1988 'A' Beckett on Swan', La Trobe
Valley Arts Centre, Morwell,
Victoria

1988 Caulfield Arts Complex, Caulfield,
Victoria

1990 'Master's Exhibition', Faculty
Gallery, RMIT

1990 Switchback Gallery, Monash
University College, Gippsland,
Victoria

1990 'Recent Sculpture', Flinders Lane
Gallery, Melbourne

1991 'Recent Sculpture', Flinders Lane
Gallery, Melbourne

1992 'Hardcuts/Softcuts', Mildura Arts
Centre, Mildura, Victoria